D0686707

ART CENTER COLLEGE OF DESIGN LIBRARY
1700 LIDA STREET
PASADENA, CALIFORNIA 91103

ART CENTER COLLEGE OF DESIGN

3 3220 00069 9251

285

DATE DUE

FEB - 4 1992			
NOV 3 0 1992			
GAYLORD			PRINTED IN U.S.A.

ART CENTER COLLEGE OF DESIGN
PASADENA 3220

ZURBARÁN

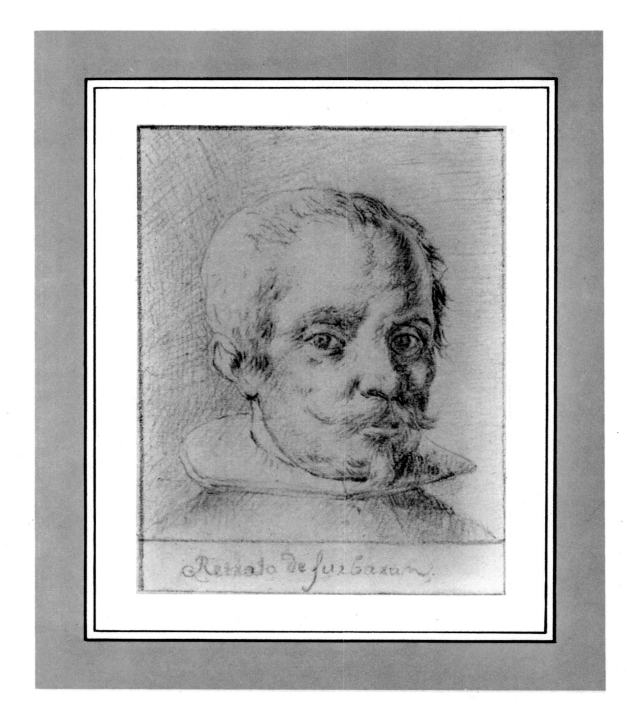

Retrato de Zurbaran.

759.6
Z96
B878

FRANCISCO DE
ZURBARÁN

TEXT BY

JONATHAN BROWN

Associate Professor and Acting Director, The Institute of Fine Arts, New York University

THE LIBRARY OF GREAT PAINTERS

HARRY N. ABRAMS, INC., *PUBLISHERS*, NEW YORK

LIBRARY
ART CENTER COLLEGE OF DESIGN
PASADENA, CALIF.

FRONTISPIECE. Francisco de Goya. SUPPOSED PORTRAIT OF ZURBARÁN.
c. 1798. Red chalk, 5 × 3 3/4". *The Louvre, Paris*

Library of Congress Cataloging in Publication Data

Brown, Jonathan.
 Francisco de Zurbarán.
 (The Library of great painters)
 1. Zurbarán, Francisco, 1598–1664.
ND813.Z85B76 759.6 73–10481
ISBN 0-8109-0549-3

Library of Congress Catalogue Card Number: 73–10481
All rights reserved. No part of the contents of this book may be
reproduced without the written permission of the publishers
HARRY N. ABRAMS, INCORPORATED, New York

Printed and bound in Japan

759.6
Z96
B878

CONTENTS

FRANCISCO DE ZURBARÁN by Jonathan Brown 11

Biographical Outline 57

COLORPLATES

1. Saint Bruno and the Miracle of the Uneaten Meat

 Museo Provincial de Bellas Artes, Seville 61

2. Saint Bruno and the Miracle of the Uneaten Meat *(detail)* 63

3. The Virgin Shows a Dominican the True Portrait of Saint Dominick

 Church of the Magdalena, Seville 65

4. Crucifixion *The Art Institute, Chicago. Robert Alexander Waller Fund* 67

5. Saint Serapion *Wadsworth Atheneum, Hartford. Ella Gallup Sumner and*

 Mary Catlin Sumner Collection 69

6. Saint Peter Nolasco's Vision of the Crucified Saint Peter *The Prado, Madrid* 71

7. Saint Bonaventure on His Bier *The Louvre, Paris* 73

8. Saint Bonaventure on His Bier *(detail)* 75

9. The Vision of Saint Alonso Rodríguez *Academia de San Fernando, Madrid* 77

10. The Vision of Saint Alonso Rodríguez *(detail)* 79

11. The Virgin and Christ in the House at Nazareth *The Cleveland Museum of Art.*

 Purchase, Leonard C. Hanna, Jr. Bequest 81

12. The Virgin and Christ in the House at Nazareth *(detail)* *83*

13. The Vision of Saint Anthony of Padua *Kresge Art Center,*
 Michigan State University, East Lansing. Gift of Friends of the Gallery *85*

14. The Apotheosis of Saint Thomas Aquinas *Museo Provincial de Bellas Artes,*
 Seville *87*

15. The Archangel Gabriel *Musée Fabre, Montpellier* *89*

16. The Immaculate Conception with Two Young Noblemen *Museo de Arte de Cataluña,*
 Barcelona *91*

17. The Immaculate Conception with Two Young Noblemen *(detail)* *93*

18. The Young Virgin Praying *The Metropolitan Museum of Art, New York City.*
 Fletcher Fund, 1927 *95*

19. The Young Virgin Praying *(detail)* *97*

20. Still Life with Oranges, Lemons, and a Cup of Water
 The Norton Simon Foundation *99*

21. Brother Jerónimo Pérez *Academia de San Fernando, Madrid* *101*

22. The Death of Hercules *The Prado, Madrid* *103*

23. Saint Margaret *The National Gallery, London* *105*

24. Saint Margaret *(detail)* *107*

25. Alonso Verdugo de Albornoz *Dahlem Museum, West Berlin* *109*

26. Still Life with Jars *The Prado, Madrid* *111*

27. The Veil of Saint Veronica *National Museum, Stockholm* *113*

28. The Battle of Christians and Moors at El Sotillo *The Metropolitan Museum of Art,*
 New York City. Kretschmar Fund, 1920 *115*

29. The Annunciation *Musée de Peinture et de Sculpture, Grenoble* *117*

30. The Adoration of the Magi *Musée de Peinture et de Sculpture, Grenoble* *119*

31. The Adoration of the Magi *(detail)* *121*

32. Saint Lawrence *Museo Provincial de Bellas Artes, Cadiz* *123*

33. Bishop Gonzalo de Illescas *Sacristy, Monastery of Guadalupe* *125*

34. Bishop Gonzalo de Illescas *(detail)* *127*

35. The Temptation of Saint Jerome *Chapel of Saint Jerome, Monastery of Guadalupe* *129*

36. The Temptation of Saint Jerome *(detail)* *131*

37. Saint Francis Meditating *The National Gallery, London* *133*

38. Saint Francis in His Tomb *Museum of Fine Arts, Boston. James Pratt Fund* *135*

39. The Blessed Henry Suso *Museo Provincial de Bellas Artes, Seville* *137*

40. Saint Casilda *Collection Mrs. William Van Horne, Montreal* *139*

41. The Annunciation *Philadelphia Museum of Art. The W. P. Wilstach Collection* *141*

42. The Annunciation *(detail)* *143*

43. Christ Carrying the Cross *Cathedral, Orléans* *145*

44. Saint James of the Marches *The Prado, Madrid* *147*

45. A Doctor of Laws *Isabella Stewart Gardner Museum, Boston* *149*

46. Saint Francis in Meditation *Alte Pinakothek, Munich* *151*

47. The Immaculate Conception *Parish church, Langon* *153*

48. The Virgin and Child with Saint John the Baptist *Museo de Bellas Artes, Bilbao* *155*

Bibliographical Note *157*

ZURBARÁN

F. ÐZVRBARAN

THE CRITICAL FORTUNES OF FRANCISCO DE ZURBARÁN form one of the most dramatic chapters in the history of artistic taste. In the 1630s and 1640s, he was one of Spain's most famous painters. But at his death in 1664, his reputation had already seriously declined, and by 1700, he was approaching the status of an unknown. In 1724, his fall from favor was recorded by Antonio Palomino, Spain's first biographer of artists, who concluded his life of Zurbarán by saying, "He did many pictures for the king's hunting lodge and other royal buildings, as well as for private individuals and various churches, but now they are not recognized as his work." The reason for this ignorance was not simply that Zurbarán's powerful, monumental style held no appeal for a Rococo audience, but also that many of his best works were hidden from public view in the monasteries and churches that had commissioned them. And there they remained until the nineteenth century, when two violent acts of history pried them loose and set them adrift in the mainstream of European art. First came the Peninsular War (1808–14), during which French generals looted the churches, monasteries, and convents of Andalusia and appropriated paintings for their private collections. Even more catastrophic was the Secularization Act of 1835, which disestablished Spain's monasteries and caused the dispersal of their artistic fittings and decorations. Private collectors, native and foreign alike, seized the oppor-

tunity to enrich their holdings of Spanish art. The most notable among them was the French king, Louis Philippe, who formed his remarkable collection during this period. It was exhibited from 1838 to 1848 as the Galerie Espagnole of the Louvre.

The Galerie Espagnole contained no less than four hundred paintings, of which eighty were attributed (forty with reason) to Zurbarán. The sudden revelation of a virtually unknown major artist—only one of his paintings has been traced in France before the Revolution—sparked the beginning of a revival of interest that has culminated in the twentieth century. By a paradox of taste, Zurbarán became increasingly comprehensible as art became increasingly abstract, and as the traditional standards of artistic excellence were replaced by new canons of judgment. Zurbarán's unaffected style, his lack of concern with "correctness," his simple and direct way of expressing feeling seem to fit the requirements of the modern aesthetic. But if modern art has brought Zurbarán's paintings closer to us, it should be remembered that they were produced by a man firmly rooted in the traditions of his time and place, by a man who continually sought to express the religious convictions of his contemporaries in the artistic language of the day. Both historical and modern interpretations are needed if we wish to explore the artistic personality of this complex painter.

During Zurbarán's lifetime, the principal artistic patron was the Catholic church and its dependent organizations. Until 1640, the artist received most of his commissions from the churches and religious orders of Andalusia, which employed him to decorate their altarpieces and monasteries. His secular works comprise only a few portraits and still lifes, plus a group of ten "Labors of Hercules" and two battle scenes ordered by Philip IV in 1634. Much of Zurbarán's art, then, is religious in content and often didactic in intent. Frequently he received detailed instructions about the content of his paintings from ecclesiastical patrons who were understandably concerned about doctrinal and historical accuracy. For example, in the contract signed on August 29, 1628, with the Order of the Merced Calzada (Shod Mercedarians), he agreed to "make twenty-two paintings of the life of Saint Peter Nolasco to adorn the second cloister where the refectory is, putting in each painting the figures and other things that the abbot orders me to do, be they few or many . . . " Zurbarán accepted these prescriptions not as a limitation but as a framework in which he could deepen and intensify the expression of their values.

Figure 2. Schelte à Bolswert. Scene from the *Life of Saint Augustine.* 1624. Engraving, 6 1/4 × 8 1/4″

Figure 3. THE VIRGIN OF THE CARTHUSIANS. c. 1625. Oil on canvas, 8′ 9 1/8″ × 10′ 6″. *Museo Provincial de Bellas Artes, Seville*

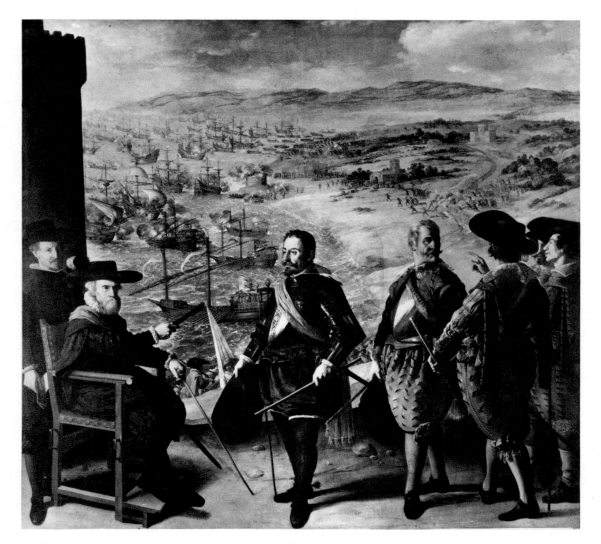

Figure 4. THE DEFENSE OF CADIZ. 1634. Oil on canvas, 9′ 10 7/8″ × 10′ 7 1/8″.
The Prado, Madrid

The numerous paintings for religious orders have caused Zurbarán to be called the "painter of monks"; he was, more accurately, an artist who captured, as few have done, the glory and spirit of a sober, profound faith. His means of expression may at first sight seem to be not only direct but also unvaried—large, stable forms are defined by sharp outlines and enlivened only by a harsh, clear light that falls suddenly into shadow. The almost sculptured figures have set, serious expressions that mask their emotions. These preliminary observations are only partly true because they omit both the formal complexities and intricacies of Zurbarán's art and because they neglect his power to express animated states of the soul and mind. Zurbarán was a painter who, like the author of a sonnet, elected a form that required subtlety and compression in order to achieve a concentrated effect. From humble beginnings as an artist, he slowly wrought a style with which he could express or repress feelings with an equally powerful result.

Zurbarán has on occasion been called a "primitive" or "rustic" painter, a term that should be used advisedly. If by primitive one means naive and unsubtle, then it does not apply to the painter, who was neither. However, it is clear that Zurbarán was inadequately trained in some of the standard painterly conventions of the day. His mastery of linear perspective was not achieved until maturity. His ability to draw the nude also developed slowly, primarily because his ecclesiastical and monastic commissions offered few opportunities to represent this subject. Zurbarán also appears to have been uncertain about his ability to compose multifigured scenes. As a result, he sometimes had recourse to prints, often by Northern sixteenth-century engravers, as sources for this type of composition. Such borrowings were a standard practice of the period, and Zurbarán often made use of them. A typical example is *The Virgin of the Carthusians* (fig. 3), which adapts the composition of Schelte à Bolswert's 1624 engraving from the *Life of Saint Augustine* (fig. 2). His preference for older, rather than contemporary, sources, while not apparent in this example, indicates a conservative strain in his taste that often appears in his paintings.

Usually these problems did not diminish the quality of his paintings which, in any case, were based on a different set of preconceptions. However, on rare occasions he was asked to paint a subject that required action and movement, and then his imperturbable, monumental style became a handicap instead of an asset. *The Defense of Cadiz* (fig. 4), painted in 1634 as part of a

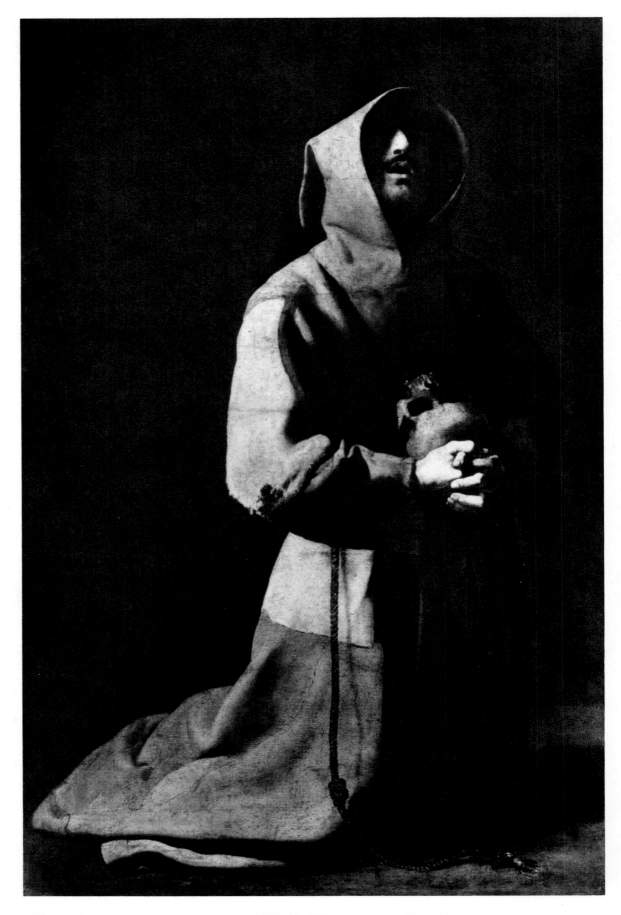

Figure 5. SAINT FRANCIS MEDITATING. 1635–40. Oil on canvas, 60 × 39″.
The National Gallery, London

series that required the use of a compositional pattern with a high foreground and a low, wide background, does not fully convey the action and excitement of the command post. The figures are stiffly posed and interact only by gestures of their hands. The background is lacking a well-integrated scale. Clearly the panoramic battle scene posed problems for Zurbarán's laconic style, though a few years later, in a different kind of commission, he was able to find a more satisfactory solution (colorplate 28).

But with the right subject, Zurbarán could paint multifigured compositions that are alive with fascinating tensions and dissonances. In *Saint Bonaventure on His Bier* (colorplate 7), the sense of disjunction between the event and its observers creates the effect of men who are privately reflecting on the meaning of a sad and transcendental event. Only two pairs of onlookers actively comment on what they see; the rest stand in mute isolation, removed from one another despite their physical proximity. The somber gallery of faces sets off the eloquent pose of restrained grief assumed by the young Franciscan who kneels at the lower right. Here the absence of fluent compositional rhythm abstracts the event from the realm of the ordinary, though Zurbarán has taken care to observe the smaller details of costume and appearance accurately. And the brilliant, individual use of color and texture heightens the richness of this moment preserved.

Whenever Zurbarán worked within his self-defined style, his genius was expressed unalloyed. He was consistently excellent, for example, when he painted a favorite theme—a standing or kneeling saint. The most admired painting of the Galerie Espagnole was Zurbarán's *Saint Francis Meditating* (fig. 5), one of his most intense works. Saint Francis has been released from the constraints of time and place by the rigorous suppression of detail and space. Against a black, impenetrable background the kneeling saint prays, one side of his body in light, the other in darkness. The strong contrast between light and dark, which Zurbarán consistently favored, occurs most effectively on the face, where the hood blocks the passage of light to the eyes but allows it to strike the nose and mouth. A literally "hooded" emotion is the result of this economical artistic understatement. Light and silhouette, together with the monotonal brown of the robe, underscore a depth of feeling that only the clasped hands and the open mouth explicitly convey. In this static, highly controlled painting, Zurbarán's strengths come into view—his gift for expressing charged, yet restrained, feeling, his command of the effects of light and color, his ability to realize truly monumental forms, and his uncanny grasp of realistic detail.

Zurbarán reached the height of expressive power when depicting man in contact with divinity. During these exalted moments of fusion with the supernatural, Zurbarán's art becomes eloquent and moving. In *Christ Appearing to Brother Andrew Salmerón* of 1639 (fig. 37), Christ manifests Himself as a reward to the Jeronymite monk who had vowed to walk perpetually on his knees as an expression of devotion to Him. Here Zurbarán realizes his effect

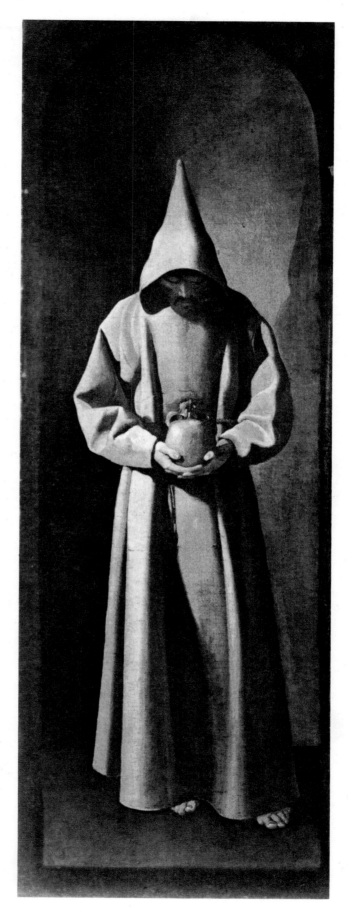

Figure 6. SAINT FRANCIS IN MEDITATION.
c. 1630. Oil on canvas, 36 × 12".
The St. Louis Art Museum, Missouri

15

Figure 8. THE IMMACULATE CONCEPTION. 1616.
Oil on canvas, 76 × 61 3/8".
Collection Felix F. Valdés, Bilbao

Figure 7. Domenico Campagnola.
TWELVE DANCING CHILDREN. 1517.
Engraving, 3 3/4 × 4 7/8"

Figure 9. Zurbarán's birthplace,
Fuente de Cantos.
Photo by Sandra Brown

through the massive corporeality of the robed figures, whose weight and volume make the vision tangible. Emotional intensity is generated by the enraptured looks on the faces and reinforced by the orange and brown clouds that swirl like a tornado in the background. In the midst of this heavenly turbulence, the gesture of Christ laying His hand upon Brother Andrew's brow becomes the calm spiritual center and focal point of the painting (fig. 36). By compressing emotion into large, meticulously observed surfaces, Zurbarán forged a deep and restrained spirituality that made him the quintessential religious painter of Spain.

Christ Appearing to Brother Andrew Salmerón demonstrates how Zurbarán found a personal means of expressing the religious sentiment of the Baroque age. If his art is free of exaggerated states of feeling typical of the period, it nonetheless covers a wide spectrum of emotion. A gentle vein is found in *The Young Virgin Praying*, painted in the early 1630s (colorplate 18). In its subject, the picture follows a prevalent international trend toward humanizing the Christian divinities, a trend that Zurbarán was the first to adopt regularly in Seville. Although the parted curtains in the corners suggest a theatrical representation, the painting portrays the charm and innocence of a young girl at prayer and contrasts with the reserved monumentality of his large-scale paintings of the same period.

The most vibrantly expressive moment in Zurbarán's career occurred during the late 1630s and is brilliantly represented in the imaginary portraits of Carthusian saints painted for the Cartuja of Jerez de la Frontera (1638–39). *Cardinal Nicholas Albergati* (fig. 41), with his enraptured gaze, is the embodiment of religious ecstasy whereas *The Blessed John Houghton* (fig. 42), his body gently inclined forward, shows a more contained but no less profound devotion. In its entirety, this portrait gallery illustrates Zurbarán's gift for sensing and realizing subtle emotional distinctions. Yet at the same time that he painted these animated portraits he was also completing the calm and mighty Nativity scenes for the Cartuja's altarpiece. The contrast between these two groups of paintings indicates that Zurbarán was a versatile artist who could adapt his mode and manner of painting. He was able at a given moment to capture the easy elegance of *Saint Margaret* (colorplate 23) and the lean asceticism of *Saint Francis in Meditation* (fig. 6). In his earlier years, he favored a severe mode of expression, but with the passing of time he gradually sought a softer, gentler style. The grace and warmth of his paintings after 1645 represent the resolution of the tensions that enliven the works of his maturity, an equilibrium that was attained only after years of artistic growth. But the later phases of Zurbarán's development can only be understood after a careful study of the special conditions in which he began his life as a man and as a painter.

A central fact of Zurbarán's artistic training, insofar as it can be determined, is that it was somewhat deficient by the standards of the day. Zurbarán began a formal three-year apprenticeship with the Sevillian artist Pedro Díaz de Villanueva on January 15, 1614. His prior training is a mystery, but the circumstances of his earliest life and the evidence of his earliest paintings indicate that it must have been limited. Zurbarán was born and grew up in the small Extremaduran village of Fuente de Cantos (fig. 9). In 1598, the year of his birth, the village had about seven hundred inhabitants, most of them farmers. This remote and isolated town offered few opportunities to learn the art of painting, at least from a qualified master, but Zurbarán progressed to the point where his father, a shopkeeper, agreed to sponsor his formal education in the art. By the time Zurbarán sought conventional schooling and the stimulus of a major artistic center, he was just over fifteen years old, some three or four years older than the usual beginning apprentice.

None of his master's works has been identified and thus there is no way to assess his role in Zurbarán's foundation beyond the elementary practical training that he would have offered. Within the constellation of Sevillian art, Díaz de Villanueva's star is almost invisible—he is rarely mentioned in the documents and writings of the time. Zurbarán may have observed the subtleties of the art by studying works of other painters. The lessons he learned from them must be judged by his later work, for only one painting from the period survives, *The Immaculate Conception* of 1616 (fig. 8). This painting raises more questions than it answers because it resembles pictures done by Zurbarán fifteen years later. Its most significant clue is found in the frieze of *putti* below the Virgin; almost certainly they were inspired by an Italian sixteenth-century print such as Domenico Campagnola's *Twelve Dancing Children* (fig. 7). At an early moment in his career,

Figure 10. Zurbarán's house in Llerena.
Photo by Sandra Brown

Figure 11. THE INTERVIEW OF POPE URBAN II AND SAINT BRUNO. c. 1625. Oil on canvas, 8' 11 1/8" × 10' 8 3/8".
Museo Provincial de Bellas Artes, Seville

Zurbarán had begun to stimulate his artistic imagination by reference to other works of art. Another motif that would recur frequently is the cluster of *putti* heads that seem to materialize from the golden orange clouds that surround the Virgin. Zurbarán also appears to have invented his characteristic type of young girl, with a full, oval face and small mouth. On the evidence of this single painting, it is nearly impossible to draw conclusions about Zurbarán's youthful style, especially because it did not test his ability to deal with the construction of pictorial space.

The opportunity to examine a representative body of paintings does not occur until almost ten years later, when Zurbarán was already twenty-seven years old. At the time, he was living in Llerena, a small city about sixty miles northwest of Seville, where he had gone at the conclusion of his apprenticeship in 1617. The return to Extremadura is in itself suggestive; was it based on a decision to obtain a secure living without the competition offered in a large city? Indications that Zurbarán may have had a somewhat timid personality can be found in the two marriages he entered into while living in Llerena. The first, occurring in 1617, was to María Páez Jiménez, who was nine years his senior. After her death in 1623 or 1624,

Zurbarán married Beatriz de Morales in 1625. She was almost thirteen years older than he. A well-to-do woman, she brought to the marriage the handsome townhouse where they lived and where Zurbarán worked for the next four years (fig. 10). The consecutive marriages to older women may have been a coincidence but they may also be interpreted as evidence of a personality that sought motherly comfort and reassurance. His strategy for success, if it may be so called, was certainly effective for his personal life; whether it worked artistically is hard to judge except in a general way. No paintings from the period between 1616 and 1624 have yet been identified, though a few are recorded in documents. However, by 1626 there were assistants in Zurbarán's atelier, which indicates a reasonable volume of work.

Another measure of success is that his reputation had traveled to Seville, especially to its monasteries, which became his principal clients during the next fifteen years. The first surviving contract with a religious order, the Dominicans of San Pablo el Real in Seville, was signed on January 17, 1626. But there is a group of three large pictures painted for the Cartuja of Santa María de las Cuevas, in the suburb of Triana, which may have come first. The date of these paintings has been a matter of

debate; were they painted about 1625 or about 1635? Indirect documentary evidence weighs in favor of the later date. In the first place, the commission was omitted from a list of Zurbarán's works for Sevillian monasteries that was read in the historic motion, made at the meeting of the city council on June 27, 1629, when it was resolved to invite Zurbarán to reside in Seville. Zurbarán himself failed to mention it in a letter to the aldermen of Seville dated May 24, 1630, though he cited two other commissions that he had received from local monasteries while still a resident of Llerena. The only outside support for the early date arises from the fact that Saint Bruno, founder of the Carthusian order, was canonized in 1623, and this event would have supplied a logical impetus for two of the paintings, *The Interview of Pope Urban II and Saint Bruno* (fig. 11) and *Saint Bruno and the Miracle of the Uneaten Meat* (colorplate 1). The third painting, *The Virgin of the Carthusians* (fig. 3), could not have been done before 1624, the date when its engraved source was published (fig. 2). Stylistic evidence, however, tends to offset the inconclusive documents.

The argument from the point of view of style rests on two fundamental assumptions about Zurbarán's artistic evolution: namely, that he was slow to overcome certain formal problems and that his adoption of strong contrasts of light and shadow did not occur until after 1626. *The Interview of Pope Urban II and Saint Bruno* (fig. 11), which once hung in the abbot's office, is clearly the most tentative of the three works. The figures are mute and almost petrified; the customary device of communication by gesture is absent. They are also out-of-scale with their surroundings. And finally, the perspective is drawn so that an illusion of unified space is denied. The room is seen from several points of view, as the unforeshortened pilaster flanking the door shows. In 1629, Zurbarán painted another "interview" picture, *Saint Bonaventure's Mediation at the Council of Lyons* (fig. 12), in which many of these faults have been corrected, thus indicating that the Cartuja picture must have been done before this work.

The other paintings in the group, which hung together

Figure 12.
SAINT BONAVENTURE'S MEDIATION AT THE COUNCIL OF LYONS. 1629.
Oil on canvas,
98 1/2 × 88 5/8".
The Louvre, Paris

Figure 13. Hernando Sturm. SAINTS JUSTA AND RUFINA. 1555. Oil on canvas. *Chapel of the Evangelists, Cathedral, Seville*

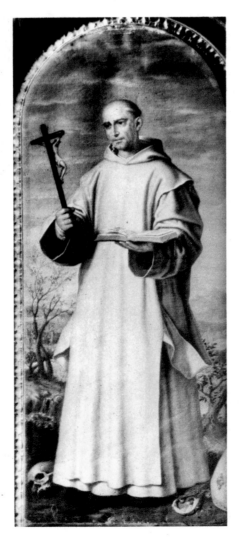

Figure 14. Juan Sánchez Cotán.
SAINT BRUNO. 1615–17.
Oil on canvas, 61 3/8 × 26″.
Museo Provincial de Bellas Artes, Granada

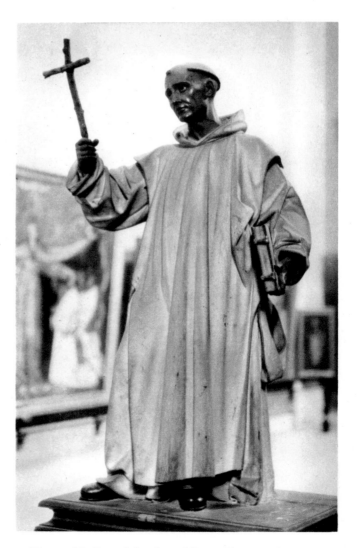

Figure 15. Juan Martínez Montañés. SAINT BRUNO.
1634. Polychromed wood, height c. 5′.
Museo Provincial de Bellas Artes, Seville

in the refectory, are more fluent. *The Virgin of the Carthusians* is the beneficiary of a borrowed composition; but its almost medieval majesty and the stunning contrast between the metallic red dress of the Virgin and the stark white robes of the monks are Zurbarán's original contributions. In *Saint Bruno and the Miracle of the Uneaten Meat* (colorplate 1) a perfect coincidence between style and content occurs. The entranced monks are treated in the same manner as the still-life objects before them, as surfaces bathed in a bright, even light.

These large, laconic paintings, perhaps the first that Zurbarán did on this scale, are puzzling not only in their dates but also in their artistic origins, for they do not obviously respond to the impulses of contemporary Sevillian painting. Francisco de Herrera the Elder (1576–1656), Juan de las Roelas (1558/60–1625), and Francisco Pacheco (1564–1654), who were in the forefront of Sevillian painting then, did nothing that compares with the lean, astringent style of these works. Both Herrera and Roelas were using a lively *facture* unlike Zurbarán's neat, self-effacing brushstrokes. It may even be doubted whether Zurbarán was initially attracted to the slow evolution away from the academic Mannerist style that was occurring then. The highly polished skin tones, the tightly set expressions, the luminescent pastel color of the Virgin's gown reflect the work of Sevillian painters who were active in the sixteenth century. A painting like *Saints Justa and Rufina* of 1555 (fig. 13) by the Flemish expatriate artist, Hernando Sturm (active 1537–57), may have seemed familiar and attractive to a painter who had been isolated from newer developments.

The only living artist whose work offers a possible comparison to these early paintings did not live in Seville. He was Juan Sánchez Cotán (1560–1627), a painter who had joined the Carthusian order and resided in a Granadan monastery when Zurbarán was an apprentice. The resemblance between passages of Zurbarán's paintings and a cycle of Carthusian history done about 1615 by Sánchez Cotán is occasionally striking. Besides the obvious typological similarities, the gallery of portraits in *The Virgin of the Carthusians* is executed with a delicate technique that was employed by Sánchez Cotán (fig. 14). But the visual evidence alone seems too fragile to support the weight of a hypothetical journey to Granada between 1617 and 1625. The points of contact between the two painters are deceptive and are largely the result of common subject matter. In the same way, the influence of the Sevillian sculptor Juan Martínez Montañés (1568–1649) on the young Zurbarán, which has been suggested on the basis of works like his *Saint Bruno* of 1634 (fig. 15), should not be overstressed. Zurbarán knew his work, but the sculpturesque qualities of his figures are not the result of imitating the effects of sculpture, but rather of his personal style of chiaroscuro painting.

Zurbarán's penchant toward conservative styles continued well into his maturity and comes to the fore in his manner of composition. A typical example is encountered

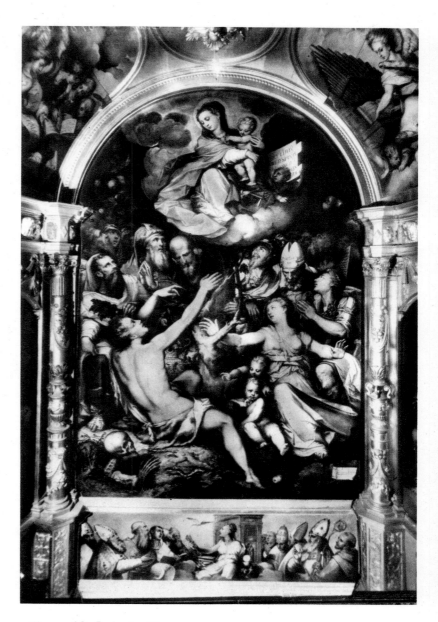

Figure 16. Luis de Vargas.
TRIUMPH OF THE NEW TESTAMENT. 1561.
Oil on canvas. *Chapel of the Conception, Cathedral, Seville*

in *The Vision of Saint Alonso Rodríguez* (colorplate 9), painted in 1630. The picture surface is organized vertically into two tiers, an earthly zone below and a heavenly zone above. The upright format is emphasized because the figures are crowded against the front plane of the picture, thus reducing the importance of the background, which takes the form of a limited architectural vista. This method of composition was in common use throughout Europe during the late sixteenth and early seventeenth centuries, but gradually disappeared as time went on. Examples of it abound in the works of artists living in Seville between 1550 and 1620. Luis de Vargas's *Triumph of the New Testament* (fig. 16), painted in 1561 for an altar in the Cathedral of Seville, clearly shows the Mannerist

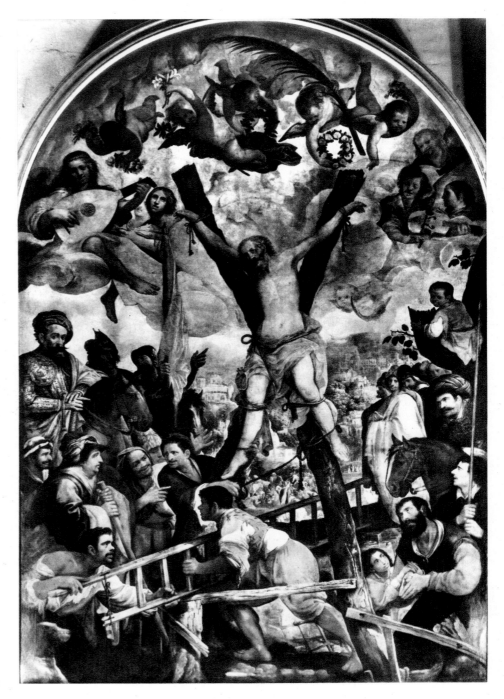

Figure 17. Juan de las Roelas.
THE MARTYRDOM OF SAINT ANDREW.
1609–13. Oil on canvas, 17' 3/4" × 4' 4".
Museo Provincial de Bellas Artes, Seville

Figure 18. THE SURRENDER OF SEVILLE.
1634. Oil on canvas, 63 × 81 1/2".
Duke of Westminster, Saighton Grange,
Chester, England

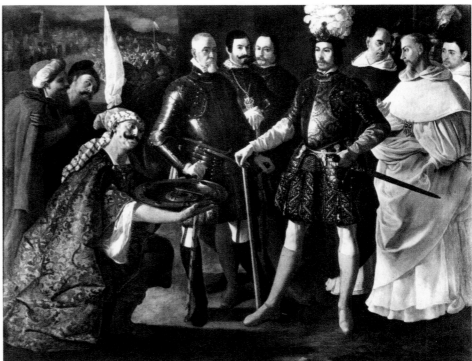

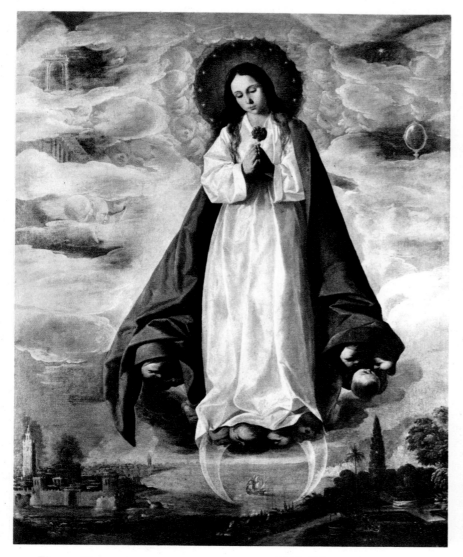

Figure 19. THE IMMACULATE CONCEPTION. 1630. Oil on canvas,
68 1/2 × 54 3/8". *Nuestra Señora del Carmen,
Jadraque (Guadalupe)*

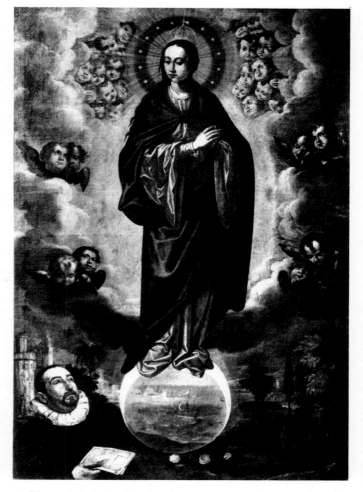

Figure 20. Francisco Pacheco.
THE IMMACULATE CONCEPTION WITH MIGUEL CID.
1621. Oil on canvas, 59 × 43".
Sacristy of the Chalices, Cathedral, Seville

penchant for the scheme. At the turn of the century, the composition was still in use, but the style of its new practitioners had evolved to a point that was closer to Zurbarán's. In *The Martyrdom of Saint Andrew* of 1609–13 (fig. 17), Juan de las Roelas employed a more naturalistic manner of drawing figures and constructing space. His work in general seems to have been a principal agent in transmitting to Seville the wave of naturalism that was brought from Central Italy by Italian artists who worked for the royal court. The two-tiered compositional format, by placing emphasis on the foreground, gave Zurbarán the opportunity to paint monumental figures whose massive proportions filled the surface and all but obscured the background. Hence the problem of rendering space and adjusting the scale and perspective of objects within it was solved through strength, not weakness. The visual

effect of towering human forms, immobile but charged with spiritual energy, was so great that it overpowered any minor flaws.

Over this scaffolding of Mannerist structure Zurbarán laid elements of another and seemingly contradictory style—Baroque naturalism, which answered the need for vitality and verisimilitude. In order to animate his almost static compositions, Zurbarán adopted the convention of strong contrasts of light and dark. A beam of light that is cast across sharply creased robes creates an illusion of relief that heightens the sense of corporeality and enlivens the surface of a stationary figure. This artistic device had of course been made famous by Caravaggio, but by Zurbarán's time it had become a standard practice of Baroque painting. Thus it is impossible to know whether he learned it from seeing paintings or copies of

paintings by Caravaggio, or from studying the works of an advanced Sevillian artist such as Velázquez (or both).

The earliest works that show this technique belong to the large commission by the Dominicans of San Pablo in Seville. On January 17, 1626, Zurbarán agreed to paint twenty-one pictures for the order, comprising fourteen episodes from the life of Saint Dominick, plus seven single figures including the four Latin Church fathers and Saints Dominick, Thomas Aquinas, and Bonaventure. Eventually the commission was augmented by another subject, a *Crucifixion* (colorplate 4), done in 1627, that constituted Zurbarán's first major public success and contains the earliest trace of his dramatic light effects. Eighteenth-century writers paid it the highest compliment known to the representational tradition: it appeared to be real. This impression was achieved primarily by the unrealistic use of strong light, which illuminates the figure but, contrary to natural law, does not reach the darkened background. Zurbarán has grasped the paradox at the core of Caravaggio's art—the conception of religious scenes as if they were contemporary events enacted by common people, but illuminated by arbitrary and unnatural effects of light.

The combination of Mannerist and Baroque tendencies, as they come together in *The Vision of Saint Alonso Rodríguez,* seems to explain the genesis of Zurbarán's mature style. However, like all simple formulas, it fails to reveal the essence of his greatest paintings. Between 1628 and 1634, Zurbarán and his workshop executed a large commission for the Merced Calzada in Seville, including twenty-two scenes from the life of Saint Peter Nolasco and a number of individual Mercedarian saints. In the multifigured paintings, the simplified, historical explanation works with reasonable efficiency, as, for example, in *The Surrender of Seville* of 1634 (fig. 18). But it will not serve to account for a moving visionary painting like *Saint Peter Nolasco's Vision of the Crucified Saint Peter* (colorplate 6). The strength of this work lies in the artist's genius for communicating deep emotion by means of an unusual composition realized with cryptic understatement.

On the basis of these works, Zurbarán consolidated the further development of his style and his position as Seville's leading painter. In recognition of his achievement, he was accorded the unprecedented honor of an invitation from the city council to transfer his residence from Llerena to Seville. The motion that was introduced at the meeting of June 27, 1629, indicates the esteem in which the painter was held. It read in part, "the Order of Mercy has brought Francisco de Zurbarán from Llerena to paint the pictures that are to be placed in the new cloister that is now being built. And judging by those that have been finished, and by the painting of *Christ* in the sacristy of the church of San Pablo [colorplate 4], it can be judged that he is a consummate artist of painting."

Only one obstacle to his future success appeared and it was quickly overcome. On May 23, 1630, the regents of the painters' guild, with Alonso Cano as their spokesman,

visited Zurbarán and demanded that, within three days' time, he submit himself to the guild's qualifying examination. The reasons for this unfriendly act are nowhere spelled out, but professional jealousy was surely at the root of it. Zurbarán had been exceptionally honored by official recognition that made him, an outsider, pre-eminent among Seville's painters. He responded to the demand by writing a letter to the city council, asking its support of his refusal to take the examination. In the letter, he cleverly set the council against the guild. He had been invited to Seville by the council, which deemed him to be a worthy painter—would the guild be permitted to question this judgment? The documents that report the outcome of the case are lost, but Zurbarán was clearly the victor. And to emphasize its confidence in him, on June 8, the council commissioned Zurbarán to paint an *Immaculate Conception* for the city hall (fig. 19). Compositionally, this lovely painting follows Francisco Pacheco's conservative model as seen in *The Immaculate Conception* of 1621 (fig. 20), but its rich colors and solid, carefully rendered forms again indicate Zurbarán's unique amalgamation of the old and the new.

This style formed the basis of Zurbarán's achievements in the 1630s, his most productive and successful decade. Important commissions from churches and monastic orders kept his workshop fully employed producing paintings that cover the range of religious art. *The Apotheosis of Saint Thomas Aquinas* of 1631 (colorplate 14) is an imposing didactic painting. Within the Mannerist compositional framework (fig. 21), Zurbarán keenly portrayed a gallery of men clad in cloth stuffs of almost palpable reality. The four Latin Church fathers are especially effective, with their opulent gold and red cloaks drawn about them like stiff canvas tents.

As a counterweight to this formal religious painting, Zurbarán did more intimate works that emphasized the human aspect of the divinities, an approach that Zurbarán was responsible for popularizing in Andalusia. In *The Virgin and Christ in the House at Nazareth* (colorplate 11), Zurbarán captured the Virgin's melancholy as she witnessed the prefiguration of her Son's death. Subsequently, Zurbarán excerpted the motif of Christ pricking his finger on the crown of thorns and made it an independent composition (fig. 22) that was often imitated by his followers. In both versions, still-life elements were meant to assist the illusion of commonplace reality, but the strong emphasis given them elevated the simple objects to almost equal stature with the figures, so that even nonsymbolic accessories seem charged with meaning. Perhaps this is why Zurbarán's spare still lifes (colorplates 20 and 26) have sometimes been read in a symbolic sense. They are, in fact, examples of his intense artistic concentration, which focused on objects one at a time until each was highly finished. Although this practice entailed a sacrifice of compositional unity, it was offset by the creation of an arhythmic effect of unexpected groupings and intervals.

Figure 22. CHRIST CHILD WOUNDING HIMSELF ON A CROWN OF THORNS.
c. 1630. Oil on canvas, 50 3/8 × 33 1/2″.
Collection Sánchez Ramos, Seville

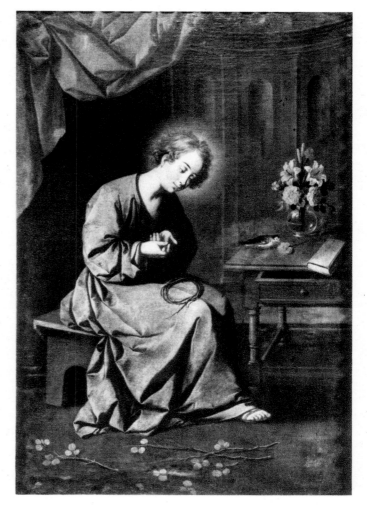

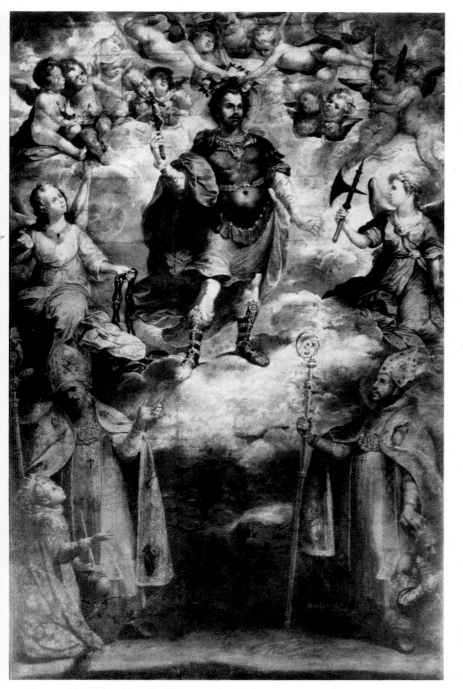

Figure 21. Francisco de Herrera the Elder.
THE TRIUMPH OF SAINT HERMENEGILD. c. 1624. Oil on canvas,
17′ 4 1/2″ × 10′ 5 5/8″. *San Hermenegildo, Seville*

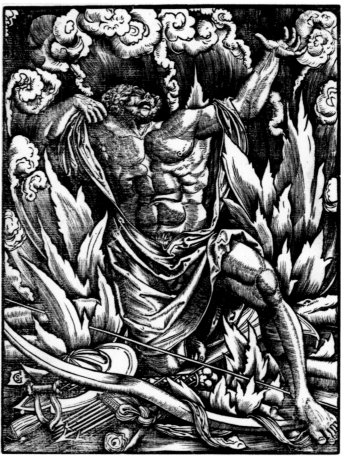

Figure 23. Gabriel Salmon. THE DEATH OF HERCULES.
1525. Woodcut, 7 5/8 × 5 3/4″

Figure 24.
HERCULES SLAYING KING ERYX.
1634. Oil on canvas,
53 1/2 × 65 3/4″.
The Prado, Madrid

Figure 25.
HERCULES DIVERTING
THE RIVER ALPHEUS. 1634.
Oil on canvas, 52 3/8 × 60 1/4″.
The Prado, Madrid

TRVNCATVM HESPERIDES ETIAM FLEVERE DRACONEM RAPTA QVOD EX HORTIS AVREA POMA EOREN'T

Figure 26. Cornelis Cort after Frans Floris.
HERCULES OBTAINING THE APPLES OF THE
HESPERIDES.
1563. Engraving, 8 1/2 × 11″

In 1634, Zurbarán was summoned to Madrid to participate in the decoration of the Hall of Realms in the newly constructed Buen Retiro Palace. He was the only painter outside Madrid who was invited to participate in the project, a fact which measures how his reputation had grown. The assignment consisted primarily of a series of the "Labors of Hercules," which were to complement twelve scenes depicting the military triumphs of Philip IV. In addition, Zurbarán was also given two of the battle scenes to paint, thus making his the largest share of the commission (although two of the original twelve "Labors of Hercules" were ultimately omitted). Though it cannot be proven, it has been suspected that this opportunity to succeed at court was arranged by Diego Velázquez (1599–1660), who had known Zurbarán in Seville. If so, his goodwill must have obscured his artistic judgment because he assigned Zurbarán a task for which neither experience nor temperament had prepared him. Perhaps Velázquez believed that a successful series of nudes would bring Zurbarán a resounding triumph in the sophisticated milieu of the court where, unlike the rest of Spain, the prejudice against this motif was not held.

Faced with this unprecedented assignment, the artist leaned heavily on compositions that he found in earlier prints. *The Death of Hercules* (colorplate 22), for instance, was modeled on Gabriel Salmon's 1525 woodcut (fig. 23), while *Hercules Slaying King Eryx* (fig. 24) relied on Frans Floris's composition of *Hercules Obtaining the Apples of the Hesperides,* done in 1563 (fig. 26). That Zurbarán would seek his models in Northern Mannerist prints is at once natural and illogical—natural, given his sympathy toward the style; illogical, because it could only furnish him with

exaggerated and distorted poses that did not conform to the contemporary style of drawing nudes. Coupled with his own uncertainty about how to paint this subject, the result was bound to be uneven. However, the best pictures capture the impression of raw energy and brute force more vividly than a polished anatomical study could do. And all of the paintings have superb landscape backgrounds that subtly complement the foreground action. The harmonic grays of *Hercules Diverting the River Alpheus* (fig. 25), for instance, lend a dank atmosphere to the watery scene.

Although Zurbarán painted no independent landscapes, he became the master of a type of landscape background almost from the start of his maturity. The earliest landscapes occur in pictures-within-pictures, but they contain some of the basic conventions of the style (fig. 27). The recurrent element is a tree with soft, rounded clumps of rust-colored or silvery and dark green foliage, which are frequently reflected in a body of water. Small houses or towers and sloping land define the middle ground, while distant mountains close the view. The tonal range stays within greens, yellows, and oranges. It is a tidy, spare landscape that is miraculously limpid and unclouded by atmospheric effects.

On only one occasion before the mid-1630s did Zurbarán enlarge its ancillary role, and that was in *The Vision of Saint John the Baptist* (fig. 28), painted in the early 1630s. This blue green landscape ultimately originated in Flemish sixteenth-century landscape paintings by artists such as Joachim Patinir, but it had been absorbed and transformed by Zurbarán's Sevillian predecessors, from whom he may have learned it. In the background of *The Double*

27

Figure 27. SAINT BRUNO AND THE MIRACLE OF THE UNEATEN MEAT (detail of colorplate 1)

Figure 28. THE VISION OF SAINT JOHN THE BAPTIST. Early 1630s. Oil on canvas, 46 7/8 × 77 1/8″. *Collection Molas Rifa, Barcelona*

Figure 29.
Juan de Uceda Castroverde.
THE DOUBLE TRINITY. 1623. Oil on canvas,
10′ 1/8″ × 7′ 6 1/2″.
Museo Provincial de Bellas Artes, Seville

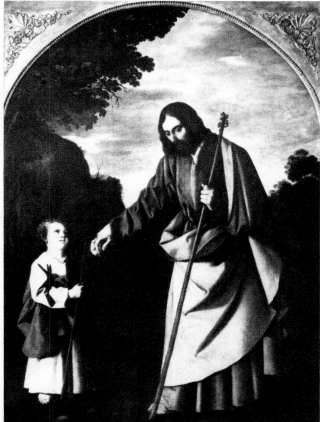

Figure 30.
SAINT JOSEPH AND THE CHRIST CHILD
WALKING IN A LANDSCAPE.
c. 1636. Oil on canvas, 93 3/4 × 67 3/4″.
Saint-Médard, Paris

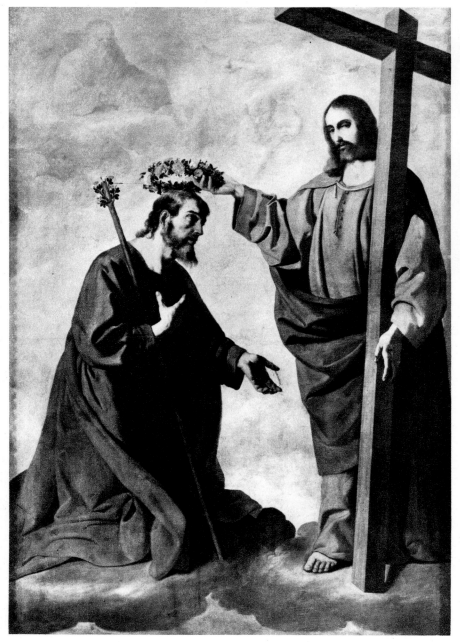

Figure 31.
CHRIST CROWNING SAINT JOSEPH.
c. 1636. Oil on canvas, 98 1/2 × 65 3/8″.
Museo Provincial de Bellas Artes, Seville

Figure 32. SAINT LAWRENCE. 1636. Oil on canvas, 9' 7" × 7' 5". *The Hermitage, Leningrad*

Trinity (fig. 29), painted in 1623 by Juan de Uceda Castroverde (d. 1631), the shape and color of the trees and their spatial relationship to the foreground figures anticipate Zurbarán's landscapes. The importance of landscape to Zurbarán increased after his return from Madrid, perhaps because he had observed how Velázquez was using it as a setting for his royal portraits. But Zurbarán was not tempted to emulate Velázquez's gray green, atmospheric views of nature; instead he continued to develop the style he had been using previously.

In terms of his career, the trip to Madrid was only a qualified success. On the one hand, he was nominated honorary painter to the king, a title that he occasionally used when signing his pictures. But no further offer of prestigious royal commissions was forthcoming. Even if an offer to remain had been made, it is easy to understand why he would have wished to resume his secure and profitable career in Seville. As far as his style was concerned, the influences of Madrid, of Velázquez, and of the royal collections of Flemish and Italian painting were minimal. The apparent lack of artistic consequence of his six-months stay in the capital is indeed its most noteworthy aspect. No revolutionary change is observable after 1634; only a growing suavity of manner and greater emotional candor, which could have resulted from purely internal developments. Between 1635 and 1640, these elements increasingly complement his unruffled monumentality and were ultimately to dominate it. Several of the paintings commissioned in 1636 by the Merced Descalza (Unshod Mercedarians) for their church of San José show this new direction.

In *Saint Joseph and the Christ Child Walking in a Landscape* (fig. 30), which occupied the center of the main altarpiece, Zurbarán maintains his reserve as he depicts the dignified passage of father and Son through a muted, melancholy landscape. But the representation of *Christ Crowning Saint Joseph* (fig. 31) is freer in technique and expression. Without yielding the monumentality of the figures, he infuses them with greater spiritual animation. This is accomplished by reducing the level of abstraction, above all in facial expression. Saint Joseph's reaction to the event is less theatrical than what we see in earlier representations of divinely inspired ecstasy. A greater fluency of surface movement is also achieved, particularly in the drapery of Saint Joseph, which flows into soft curves that emphasize the body underneath. The *Saint Lawrence* of 1636 (fig. 32), formerly in a transept altarpiece, indicates Zurbarán's increasing mastery of pictorial space, which leads to more extensive landscapes during this period. Here the background is constructed by means of alternating light and dark bands that help the eye make the transition from near to far distance. The artistic growth observable in these paintings is not revolutionary, but evolutionary, for Zurbarán developed at a measured pace. The full, deep colors, imaginative in hue and in contrast, remain as before, and monumental figures stand at the core of his means of expression. However, the de-

Figure 33. KING HENRY III OFFERS THE ARCHBISHOPRIC OF TOLEDO TO BROTHER FERNANDO YAÑEZ. 1639. Oil on canvas, 9′ 6 1/2″ × 7′ 3 3/8″. *Sacristy, Monastery of Guadalupe*

velopment of a style more technically proficient and more emotionally varied and flexible continued to unfold.

The last years of the 1630s were principally occupied by two of Zurbarán's most important commissions, which challenged the full range of his talents. From Jerez de la Frontera he received a request to paint the altarpiece of the Carthusian church and a series of saints of the order. At the same time, the remote monastery at Guadalupe in Extremadura commissioned him to paint eight large portraits of Jeronymite saints for the sacristy of the church and a number of paintings for the small adjoining chapel, including an altarpiece and two scenes from the life of Saint Jerome. The sheer magnitude of these tasks is astonishing, for within a two-year span Zurbarán painted fourteen large pictures, each measuring about ten feet high and six feet wide. Two others were approximately eight feet high and ten feet wide. Besides these large canvases there were over a dozen smaller works, some of which were done by the atelier. This accounting omits paintings for other patrons, which were numerous. The balance sheet is significant because it helps us to grasp the creative energy of the period. Even for a painter accustomed to producing multiwork commissions, it was an extraordinary effort.

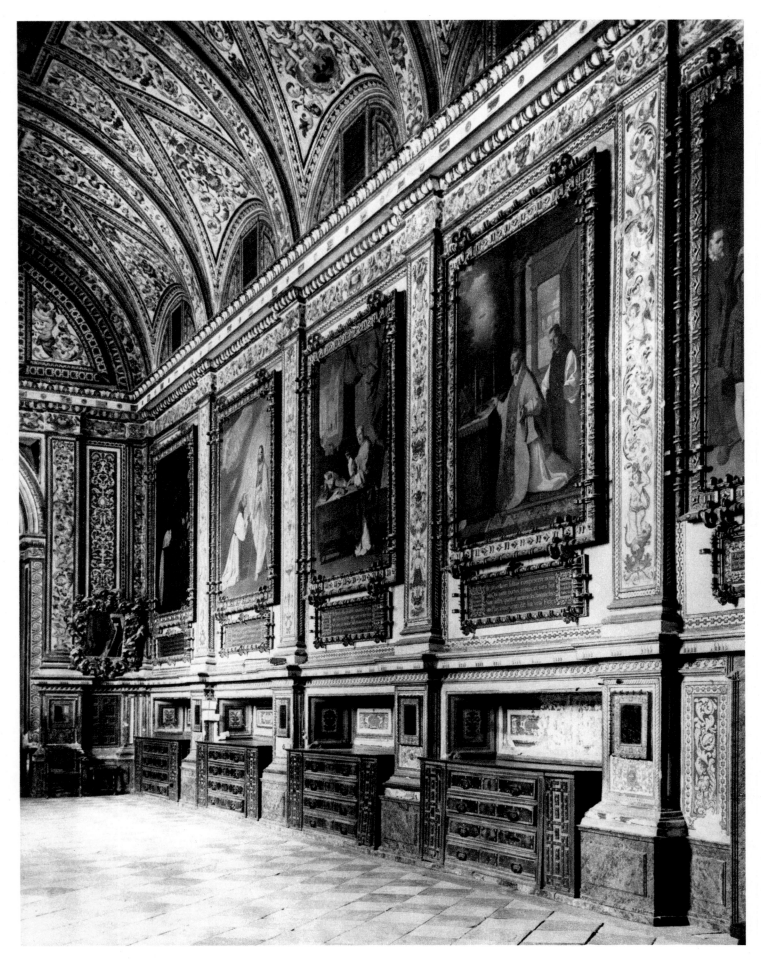

Figure 34. View of sacristy, Monastery of Guadalupe

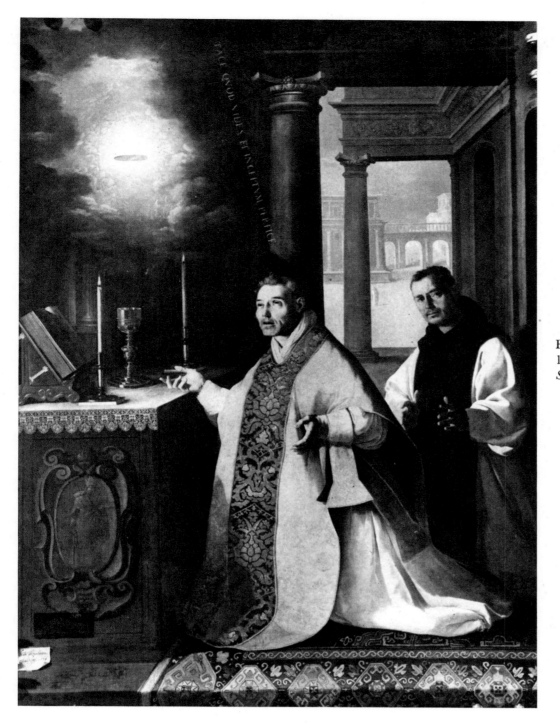

Figure 35. THE MASS OF PADRE CABAÑUELAS.
1638. Oil on canvas, 9' 6 1/2" × 7' 3 3/8".
Sacristy, Monastery of Guadalupe

On a qualitative level, the paintings for Jerez and Guadalupe contain some of Zurbarán's greatest work, especially the ones that portray the experience of profound spiritual emotions. Indeed, the paintings are surely among the most brilliant representations of the monastic spirit ever conceived. This spirit, as perceived by Zurbarán, was varied in expression and encompasses a range of human emotions aroused by contact with divinity.

Guadalupe, alone among Zurbarán's monastic commissions, is still in its original setting. In 1638, the architectural renovation of the Gothic sacristy was begun, and Zurbarán was commissioned to paint eight scenes drawn from Jeronymite history. Thematically, six of the paintings

were to express the intellectual and spiritual attainments of the order, as illustrated by representative episodes from the lives of famous brothers of the monastery. In the two remaining paintings, the honors that were bestowed on the order by man and God were shown by reversing the same composition (figs. 33 and 37). Viewed in their highly ornate setting, the paintings form an impressive record of the special virtues of the monks and their recognition by spiritual and temporal authorities (fig. 34). Although the ensemble has been preserved intact, it appears that some of the paintings subsequently were shifted around. The original disposition is suggested by the salient architectural feature of the sacristy; on the south

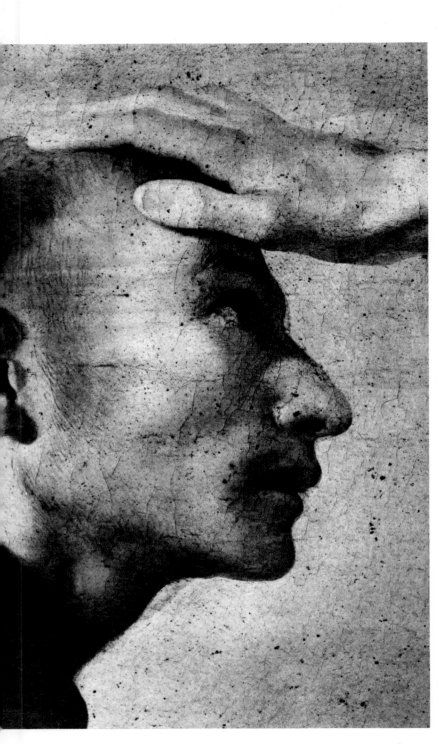

Figure 36. CHRIST APPEARING TO BROTHER ANDREW SALMERÓN
(detail of figure 37)

side are two highly placed windows that divide the wall into three bays, in which three paintings are hung. Opposite them, on a long, unbroken wall, are the five remaining pictures. They would be seen in full natural illumination, whereas the ones on the window wall would appear in indirect light. Zurbarán seems to have taken account of these varying conditions of light, because three of the paintings were done in luminous tones while five were painted with dark colors and backgrounds that are fully visible only under direct light. As they are now placed, however, the three lighter paintings are opposite the windows and receive the full light of day, while three of the darker paintings are nearly lost in the shadows of the southern wall. The only logical reason for the change is that the three lighter paintings were judged to be superior to the other five and thus deserved to be fully visible; indeed, they are among the greatest works to come from Zurbarán's brush.

In them, Zurbarán perfectly combined his powers of color, form, and light to evoke powerful feelings through understatement. The massive, monolithic figures created by Zurbarán evoke a subtle tension between the containment and expression of feeling. These monumental forms experience strong emotions but manage to confine them within their unruffled surfaces. In each painting, figures loom large in the foreground and hold poses of frozen movement. A slice has been cut from time and preserved under strong light with supernatural clarity. *Bishop Gonzalo de Illescas* (colorplate 33), a scholar, is captured as he formulates a thought just before writing it down. In *The Mass of Padre Cabañuelas,* (fig. 35) a miraculous vision penetrates the small chapel and elevates the spirit of the kneeling priest while his body remains unmoved beneath his weighty vestment. Zurbarán studies the mundane objects with painstaking care; the pattern of the oriental rug, the lacy border of the altar cloth, the richly colored embroidery of the priestly garment are rendered in detail although they are secondary elements. By a paradox, the superreal becomes surreal and lends compelling power to these pictures. The tension between reality and abstraction reaches its climax in *Christ Appearing to Brother Andrew Salmerón* (fig. 37). The heavens have invaded earth, dematerializing the mundane in haze and twisting clouds. From this insubstantial background emerges the figure of Christ, who is painted as a man of flesh and blood, thus transforming a spiritual vision into a physical reality. In this controlled, concentrated world the slightest expression or movement communicates deeply felt emotions (fig. 36).

The two scenes from the life of Saint Jerome in the small chapel explore further the interpenetration of the natural and the supernatural. Both paintings depict visions experienced by Saint Jerome, and in both Zurbarán seeks the moment when apparitions are undeniably tangible. Yet by placing some of the figures in stiff, contrived poses, he manages to create the impression that, despite the superficial realism, what we see is partially unreal. In *The*

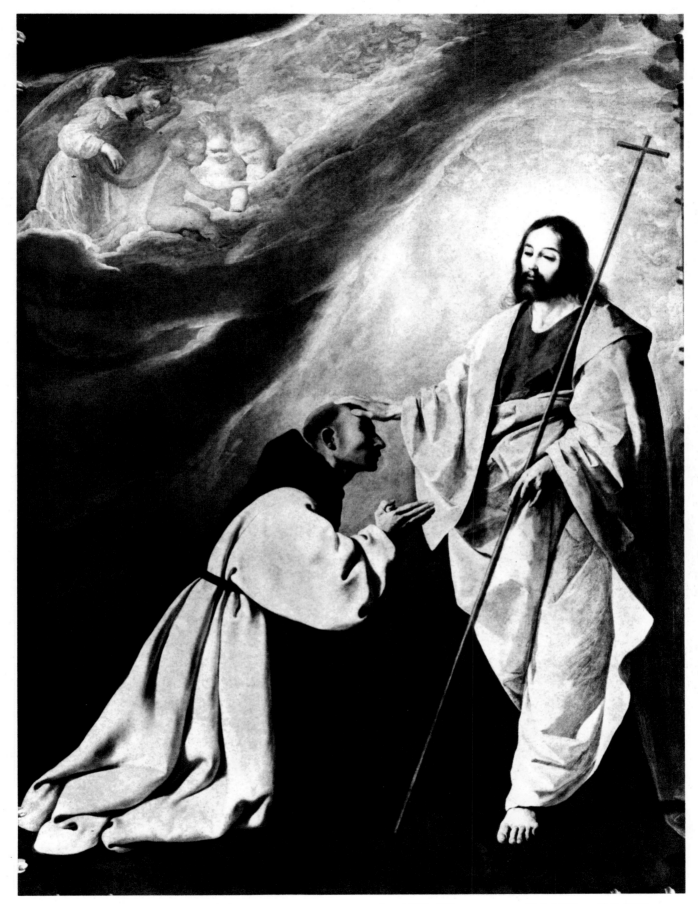

Figure 37. CHRIST APPEARING TO BROTHER ANDREW SALMERÓN. 1639. Oil on canvas, 9′ 6 1/2″ × 7′ 3 3/8″.
Sacristy, Monastery of Guadalupe

LIBRARY
ART CENTER COLLEGE OF DESIGN
PASADENA, CALIF.

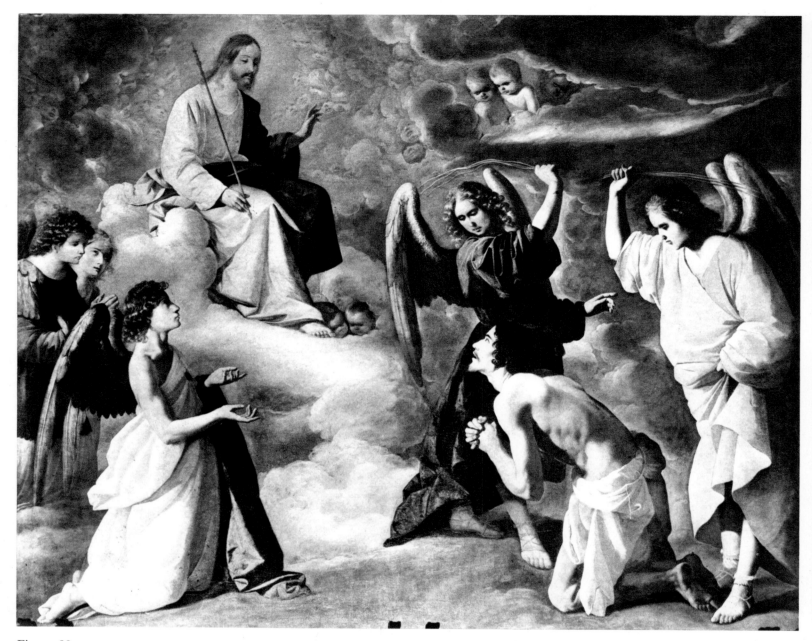

Figure 38. THE FLAGELLATION OF SAINT JEROME. C. 1639. Oil on canvas, 7′ 8 1/2″ × 9′ 6 1/2″. *Chapel of Saint Jerome, Monastery of Guadalupe*

Flagellation of Saint Jerome (fig. 38), the two angels with whips are stopped in mid-motion and held in dancelike positions that convert the drama into a ritual. *The Temptation of Saint Jerome* (colorplate 35) is one of Zurbarán's most powerful paintings, filled with astonishing surprises and deliberate inconsistencies. The chorus of temptresses is not superficially tempting; they are chastely dressed and only moderately attractive. But Saint Jerome rejects their seduction with an extravagant gesture of refusal, abstracted to the point where it becomes hieroglyphic.

The effect of Zurbarán's paintings for the Cartuja of Jerez de la Frontera has been dulled because the paintings were dispersed after the Secularization Act of 1835. Originally they were divided into two groups, with twelve pictures set in an ornate gilded altarpiece while the other ten were installed on the walls of a curved passageway that led from the altar to a room behind it, the *sagrario*.

The altarpiece was about fifty feet high by thirty feet wide and divided into three stories (fig. 39). In the center compartments were *Saint Bruno*, the founder of the order, and below him, the scene of *The Battle of Christians and Moors at El Sotillo* (colorplate 28), in which the Virgin's miraculous intervention had allowed the Christians to defeat the Moorish enemy. The monastery was built on the site of the battle and named Nuestra Señora de la Defensión in her honor. Four large paintings flanked the center panels and showed *The Annunciation* and *The Adoration of the Shepherds* on the first story, and *The Adoration of the Magi* and *The Circumcision* on the second. Above each one was an evangelist portrait and at the top of the altarpiece, on the third story, were pictures of *Saint John the Baptist* (Museo Provincial de Bellas Artes, Cadiz) and *Saint Lawrence* (colorplate 32).

The paintings for the altarpiece are remarkable for

their quality and coloristic brilliance. *Saint Bruno in Ecstasy* (fig. 40) has never received its due praise. It is now installed in a small, low museum gallery, where the exaggerations of pose and expression that were perfectly suited to its high position on the altarpiece seem forced. But *in situ,* it must have had imposing clarity and carrying power.

The four New Testament scenes, now in the museum at Grenoble, are among Zurbarán's most ambitious paintings. Their greatest strength is their color. For range, richness, and subtlety they are unsurpassed in his oeuvre. Zurbarán had an unconventional sense of color, which is revealed in both his selection and his combination of tones. Often his colors were derived from nature and are remarkable only for their strength. At the same time, he developed a spectrum of shimmering, pastel shades that seem to have been drawn from a Mannerist palette. The flaming orange yellow robe of Gabriel in *The Annuncia-*

tion (colorplate 29) is an example of this fondness for artificial colors. Often he exposed these colors to strong light, which they reflect more than they absorb, making them appear as if they had been bleached. The robe of the Moorish king in *The Adoration of the Magi* (colorplate 30) is pink, washed by light until it becomes thin in tone. When this color is placed beside the deep golden robe with maroon embroidery worn by the kneeling magus, the effect is startling. Colors that would seem to clash become bizarre but effective combinations.

Zurbarán also used color and light as a means to create depth. In the four Nativity scenes the figures are placed into a foreground space that is relatively shallow and narrow, so that overcrowding occurs in the three large group scenes. In order to clarify the placement of individual figures in the tightly compacted masses, Zurbarán employed bold and sudden contrasts of color, pattern, and light. *The Adoration of the Magi* is exceedingly daring in

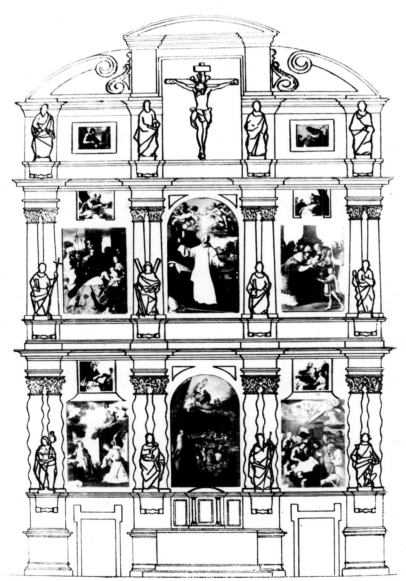

Figure 39. Photographic reconstruction of altarpiece,
Nuestra Señora de la Defensión, Jerez de la Frontera.
1638–39. Height c. 50′
Photo by Leonard Kane

Figure 40. SAINT BRUNO IN ECSTASY. 1638–39. Oil on canvas, 11′ 2 1/4″ × 6′ 4 3/4″.
Museo Provincial de Bellas Artes, Seville

this respect; the brightly patterned golden robe of the kneeling king establishes the foreground plane against which the eye measures the positions of the other figures. The retreat into the deeper space is then suggested solely by darkening the middle ground. Color, not line, thus becomes a principal means of constructing space. Zurbarán had used this manner of composition before, but in these paintings he applied it with increased authority. To take another example, depth is also suggested by use of a powerful vertical accent in the middle ground; but the motif, usually a column, is always shown in darkness, which contrasts with brightly lit passages in front of it and behind it. This vertical accent stiffens the spine of the composition by emphasizing its height and monumentality. By means of a brilliant and original conception of color, Zurbarán achieved narrative clarity and great visual power.

Next to these symphonic paintings, the series of eight standing Carthusians and two angels with censers is seemingly straightforward. The figure placed in a landscape or townscape is one of Zurbarán's leitmotivs. Here, however, he takes the familiar theme and runs it through a fascinating set of variations. The paintings, now in the museum in Cadiz, depict martyrs, theologians, bishops, and abbots who are united by deep faith that has, however, different facets. *Cardinal Albergati* (fig. 41), *Saint Hugh of Lincoln*, and *The Blessed John Houghton* (fig. 42) express a fervent faith by swaying poses, gestures of the hands, and animated faces. *Saint Bruno* and *Saint Hugh of Grenoble* (fig. 43) are calm, upright, and obedient. *Saint Ainald* (fig. 44) and *Saint Anthelm*, who read books, supplement feeling with intellect. In their original setting, the ensemble was still more impressive because of the way it conformed to the architecture. The corridor where the pictures were hung curved behind the altarpiece and led to a room, the *sagrario,* on the central axis of the church. Each half of the U-shaped passageway was divided into four bays on one side by pilasters. Zurbarán adjusted the profile of each figure according to its location in the passageway. A monk entering the corridor first saw a saint in full face. As he continued, the next one was turned one-quarter toward the entrance of the *sagrario.* The last two had revolved one-quarter turn more and so appeared in profile. In this way, the progression of movement in the pictures mirrored the changing position of the viewer as he entered and then walked through the hallway, and a bridge was created across the fictive and real world that unified time and space. Carthusians past and present joined in a procession to the *sagrario,* where the Host, a central article of their faith, was kept.

In the cycles for Guadalupe and the Cartuja at Jerez, Zurbarán achieved not only visual magnificence but also his utmost penetration of the monastic spirit. It is ironic that they mark the virtual end of his career as a monastic painter. During a fourteen-year period, he had executed about a dozen important commissions for Seville's religious orders; after 1639, he received only one and that

Figure 41.
CARDINAL NICHOLAS ALBERGATI.
1638–39. Oil on canvas, 47 5/8 × 24 3/4".
Museo Provincial de Bellas Artes, Cadiz

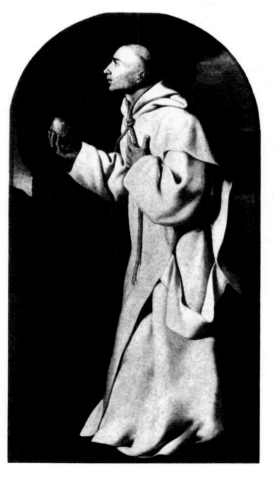

Figure 42.
THE BLESSED JOHN HOUGHTON.
1638–39. Oil on canvas, 47 5/8 × 24 3/4".
Museo Provincial de Bellas Artes, Cadiz

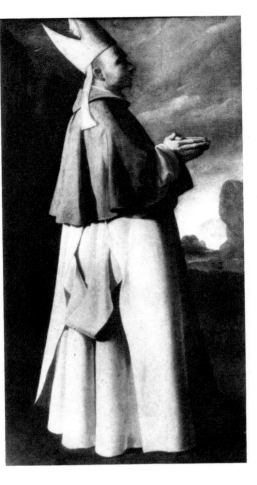

Figure 43.
SAINT HUGO OF GRENOBLE.
1638–39. Oil on canvas,
47 5/8 × 24 3/4".
*Museo Provincial
de Bellas Artes, Cadiz*

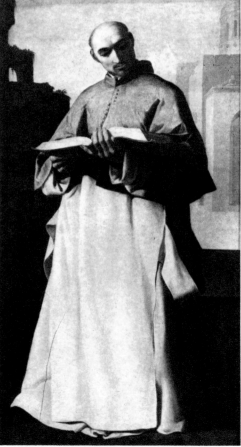

Figure 44.
SAINT AINALD. 1638–39.
Oil on canvas,
47 5/8 × 24 3/4".
*Museo Provincial
de Bellas Artes, Cadiz*

occurred in 1640–41. This strange turn of events can perhaps be explained by reference to the historical conditions that prevailed generally in Spain and particularly in Seville at the time.

Beginning about 1640, the weakening Spanish empire underwent one of its severest political and economic crises. In that year, Catalonia and Portugal rebelled against the king's authority, and the Catalonians invited the intervention of French troops, who occupied their territory. The consequences of the rebellion of Portugal, which ended when it was granted independence in 1668, were especially dire for Seville, which supported a major part of the war effort. It placed a severe drain on the local economy already severely weakened by the reckless military and financial policies of the central government. In 1641–42 and again in 1651–52, the money went through a drastic cycle of revaluation-devaluation, which effectively made currency almost worthless. In 1647, the king declared bankruptcy, and when it proved ineffective to save his financial condition, he was forced to do it again in 1653. The disruption of the economy inevitably was felt by the monasteries, though they were somewhat protected because they received income in goods from their estates. However, only one sizable commission of paintings was given in the 1640s, this in 1645 by the Franciscans to the young Murillo. Their choice of artist may well have been made on economic grounds, because Murillo's style at this time was largely modeled on Zurbarán's example. But as a still unproven painter, he would have been cheaper to employ than the renowned Zurbarán.

The artist's response to the loss of the home market was to turn to the American colonies with their rapidly maturing economies. The export market had been a reliable source of income for Sevillian artists since the early seventeenth century, but until 1640 Zurbarán had been kept busy with local commissions. Thereafter, he progressively industrialized his workshop to produce masses of pictures for export. The principal markets were Mexico and Peru, where the construction of new churches had created a great demand for paintings. Their preference was for large picture cycles of a given theme—Christ and the Apostles, the founders of religious orders, processions of virgin martyrs, the twelve sons of Jacob. Zurbarán was content to leave the execution mostly to his assistants, thus capitalizing on another advantage of the colonial market—its lower standards of quality. However, Zurbarán may have felt justified in delegating the labor because it was paid for at a much lower rate. In the long run, Zurbarán was not able to replace his lost income, and from 1650 onward there is increasing evidence of financial problems in his life.

The reorganization of Zurbarán's artistic life was accompanied by equally drastic changes in his personal life. In May, 1639, his beloved second wife died, ending fourteen years of happy marriage. The loss seems to have disoriented the painter, if indirect evidence provides any indication of his state of mind. For one thing, he

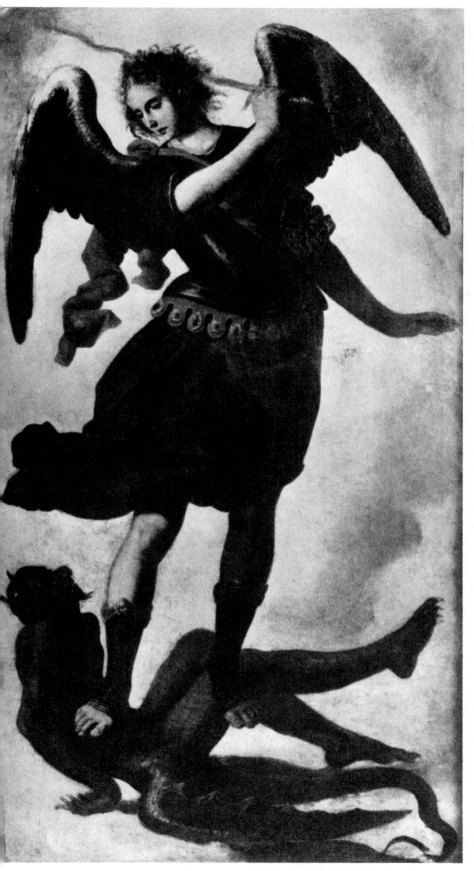

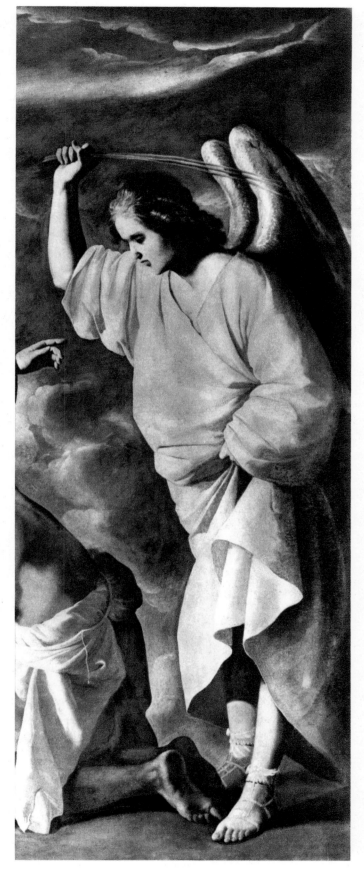

Figure 45. THE ARCHANGEL MICHAEL. 1643–44. Oil on canvas, 78 3/4 × 39 3/8″. *Colegiata de Santa María, Zafra (Badajoz)*

Figure 46. THE FLAGELLATION OF SAINT JEROME (detail of figure 38)

seemed unable to find a suitable domicile. In June, 1642, he sublet his house in Seville and rented another outside the city walls for a two-year term. One year later, he abruptly terminated both agreements and returned to his own house. In February, 1644, he married for a third time, to Leonor de Tordera, a younger widow. Shortly after, they moved into another house and then moved again in 1645 to a place that Zurbarán extensively remodeled. This itinerant pattern may, of course, have had additional causes. On the one hand, his financial condition was deteriorating. And he was also starting a new family. In 1645, his wife gave birth to the first of their six children, who necessitated greater living space. But these mitigating factors still leave room for speculation that his wanderings had a psychological as well as pragmatic basis and reflect a search for stability and peace of mind. This decade of reorientation closed with an event as tragic as the loss of his wife—the death of his son and pupil, Juan, in the great plague of 1649.

The relationship of these events to the evolution of Zurbarán's art is difficult to establish, perhaps because we tend to overestimate the speed at which personal events are translated into artistic statements and the degree to which a painter can alter his fundamental means of expression. Zurbarán's great success up to 1640 was a strong reason to continue as before. And his own conservative nature was another barrier to radical change.

Nevertheless, the 1640s were years of transition during which Zurbarán came to terms with the new facts of his life and art. They are elusive years, when the paucity of concrete knowledge further complicates the difficult task of reconstructing his evolution as man and artist. Dated or documented works are rare; between 1644 and 1650 none at all exist, and the gap must be filled by conjecture. Two paintings, one from the early 1640s, the other from the early 1650s, indicate the general trend of development—*The Blessed Henry Suso* of c. 1640–41 (colorplate 39) and *Christ Carrying the Cross*, signed and dated 1653 (colorplate 43). *Henry Suso* belongs to the genre of saints in a landscape which began in 1636 with *Saint Lawrence* (fig. 32) and basically adheres to Zurbarán's formula for representing this subject. One important difference is the taller, thinner proportions of the body, which became a stable element in the later works. But in technique and sentiment, *The Blessed Henry Suso* has more in common with the earlier paintings, whereas the Christ has a gentleness, even a sense of muted pathos, that is more subtly portrayed than the stock poses and expressions of the standing saints. This sensation is communicated by a softening of line and color. The marked contrast between light and shadow persists; indeed it was part of Zurbarán's art to the end. But the transitions are gentler, the shadows more transparent at the same time that colors have become thinner and softer. The forms remain simple and large, but they are less overbearing because they are calmer and gentler.

The first works in the softer, more refined style begin to appear about 1645. *The Archangel Michael* (fig. 45) is part of the only surviving documented commission of the 1640s, the altarpiece painted in 1643–44 for a small chapel in the Colegiata de Santa María in Zafra (Badajoz). The graceful movement and the more feminine body of Michael contrast with the stocky, immobile angel in *The Flagellation of Saint Jerome* at Guadalupe (fig. 46), which was painted five years earlier.

It is also in the middle of this decade that we find the first examples of a characteristic theme of the later years, the Virgin and Child. It is surprising that no earlier version of this popular subject has been discovered, because Zurbarán was certainly capable of communicating its warm intimacy, even in his firmer style. The simplest explanation for its absence may be the lack of demand. After 1640, a perceptible change occurred in the themes that Zurbarán was asked to paint, with a greater call for subjects that encouraged involvement with the divinities instead of distant respect. Perhaps the significant stylistic changes that we observe in Zurbarán are responses to a new religious conception, a kind of humanization of the divine that received its fullest expression in Murillo's art of the 1660s and 1670s. *The Virgin and Child* painted about 1645 (fig. 47) can be considered Murillo *avant la lettre,* and confirms the important changes that occurred during this period. The Virgin and Child huddle together and play with an apple. They gaze out of the picture toward the viewer as a means of engaging him in their world. Both figures are painted with sharp, delicate features, especially the Virgin, whose youthful face is openly attractive in contrast to the severe Virgins of the 1630s.

An *Annunciation* (colorplate 41) that Zurbarán signed and dated in 1650 ends a six-year period of undated paintings. The composition and the poses of the Virgin and Gabriel are based on *The Annunciation* of 1638–39 (colorplate 29). But the softer modeling, as seen for instance in the Virgin's head (colorplate 42), and the gentle movement of the bodies are evidence of Zurbarán's more relaxed style. The light, though still strong, is more diffused through the painting, so that the abrupt contrasts between planes of depth are virtually eliminated. Zurbarán retains his taste for large figures and his sharp eye for detail, but he subordinates secondary objects so that they do not interfere with the composition—the vase of lilies, for instance, is set in a corner instead of intruding between the figures.

Between 1645 and 1650 then, Zurbarán fundamentally altered the intent and style of his painting. Unfortunately, just at this moment a younger master with a similar approach began to emerge as a serious rival—Bartolomé Esteban Murillo (1617–1682). The relationship between the two artists has often been oversimplified, much to Zurbarán's disadvantage. The conception of the late work of Zurbarán as a partial imitation of the early work of Murillo minimizes the complexities of artistic developments still too little known. If Murillo ultimately achieved a greater mastery of the new style, it is questionable wheth-

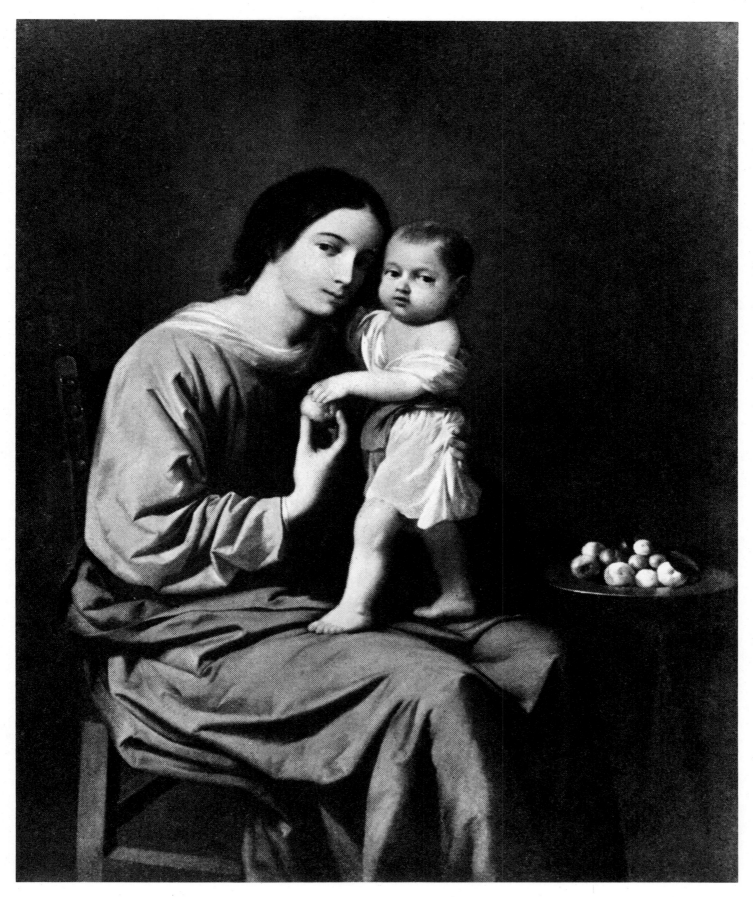

Figure 47. THE VIRGIN AND CHILD. c. 1645. Oil on canvas, 55 7/8 × 42 7/8″. Whereabouts unknown

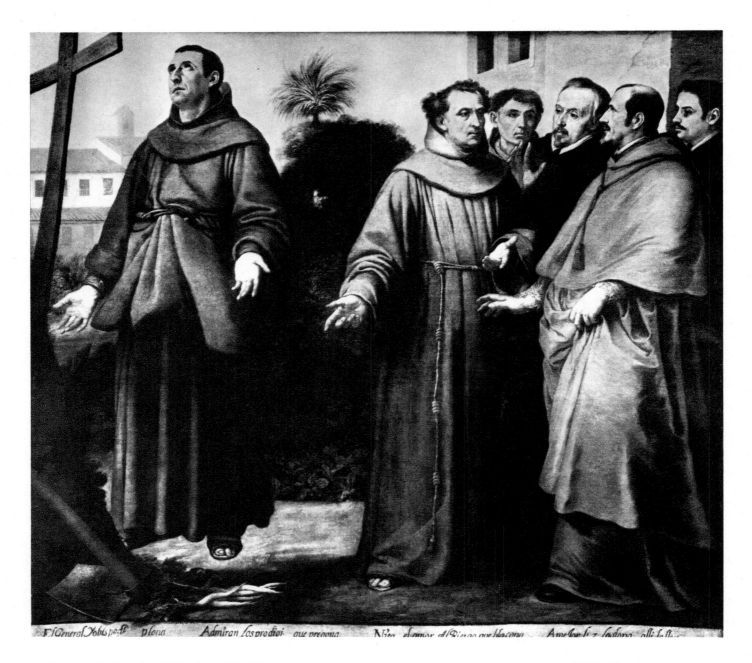

Figure 48. Bartolomé Esteban Murillo. SAN DIEGO DE ALCALA IN ECSTASY BEFORE THE CROSS. 1645–46.
Oil on canvas, 67 3/4 × 72 1/2″. *Musée des Augustins, Toulouse*

er he, rather than Zurbarán, introduced it to Seville. A careful evaluation of the incomplete evidence would appear initially to indicate the reverse. Murillo's earliest datable works, the paintings for the monastery of San Francisco el Grande in Seville in 1645–46, are not more advanced than Zurbarán's painting of the period. Rather, they bear unmistakable traces of Zurbarán's monastic cycles of the 1630s. *San Diego de Alcalá in Ecstasy Before the Cross* (fig. 48), with its monumental figures, its language of gesture, its firm, hard modeling, is a descendant of Zurbarán's *Saint Bonaventure Refers Saint Thomas Aquinas to Christ as the Source of his Knowledge* of 1629 (fig. 49). Only in the later paintings of the series does Murillo offer clues to

a style that did not mature until the late 1650s. On the other hand, Zurbarán's *Virgin and Child* could be taken as a prediction of Murillo's later works. Yet it is no more accurate to offer the conception of Murillo as Zurbarán's follower. Both artists appear to have grasped the need for a more emotionally engaging art at approximately the same time. But whereas Zurbarán was deeply rooted in an older way of expression, which both stabilized and limited his art, Murillo was open to all that was new. Without the encumbrance of thirty years of experience, he was free to employ the exaggerations of movement and emotion that the more conservative painter instinctively shunned. Looking back upon his later works, we see clear-

44

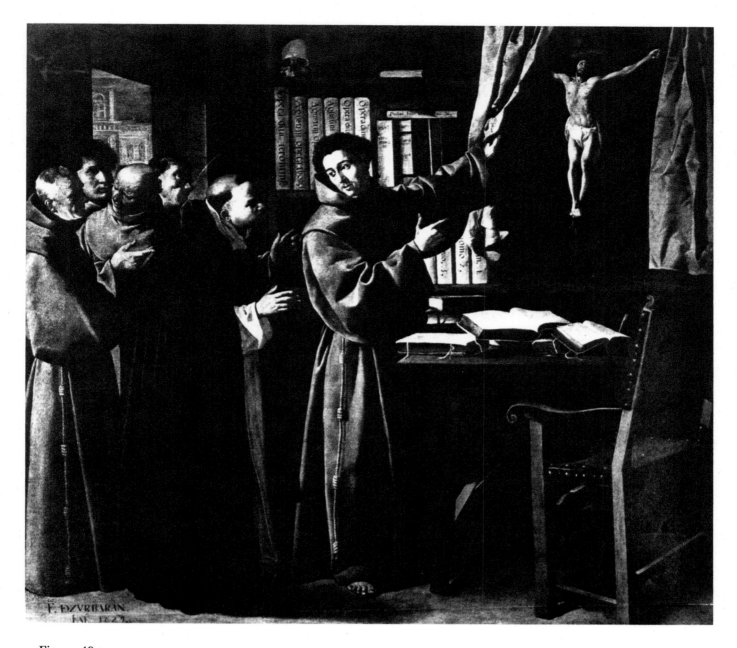

Figure 49. SAINT BONAVENTURE REFERS SAINT THOMAS AQUINAS TO CHRIST AS THE SOURCE OF HIS KNOWLEDGE. 1629. Oil on canvas, 8′ 4 3/4″ × 9′ 4 5/8″. *Formerly Kaiser Friedrich Museum, Berlin* (destroyed)

ly that Zurbarán made a greater concession to the new content than to the new form. And paintings that seem to us to have preserved measureless dignity must have appeared to his contemporaries as merely old-fashioned. Thus Zurbarán eventually yielded his artistic hegemony in Seville to the younger man.

Zurbarán's decline in favor can be measured by the fact that after 1650 no documented commissions have been discovered either from Andalusian or South American clients. Murillo, however, was thriving, despite poor economic conditions. During the 1650s, he was regularly employed by the Cathedral of Seville, as prestigious a patron as the city could offer. The loss of favor worsened

Zurbarán's economic position and finally pushed him into debt. In 1652, he moved from his house to an apartment in order to reduce his expenses. But by 1656 he had fallen a year behind in his payment of rent, and in December of that year a lien was attached to his goods to cover the debt. Ultimately, he decided to leave the city that no longer seemed to require his services and in May, 1658, he went to Madrid, where he spent the rest of his life.

Initially he may not have planned a long stay because he went without his wife. But at the end of the year he was still in the capital, as is proved by the testimony he offered in support of Velázquez's application to join the noble

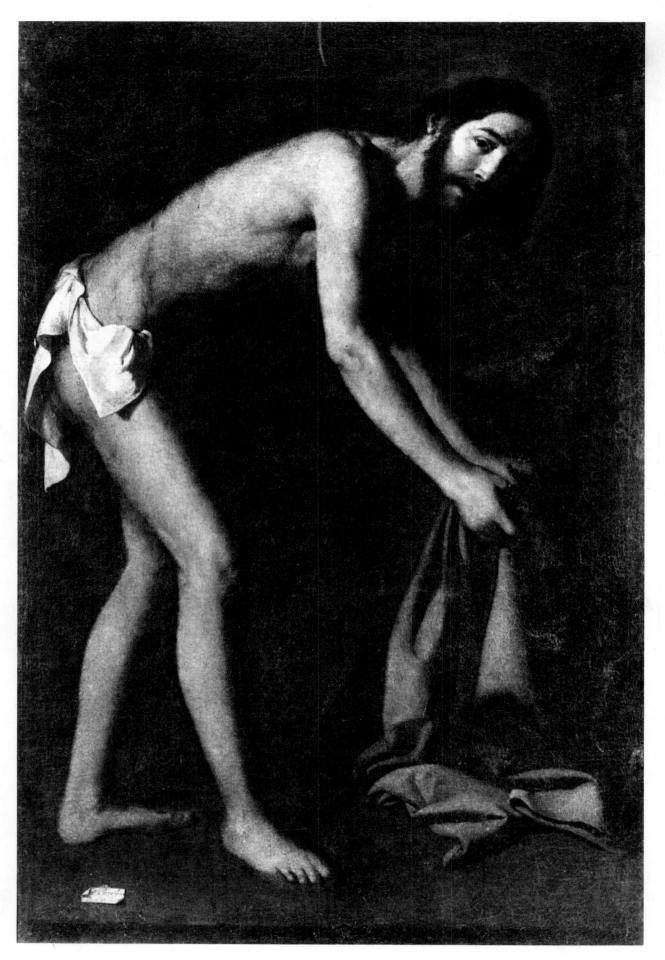

Figure 50. CHRIST GATHERING HIS GARMENTS AFTER THE FLAGELLATION. 1661.
Oil on canvas, 65 3/4 × 42 1/8″. *Nuestra Señora del Carmen, Jadraque (Guadalupe)*

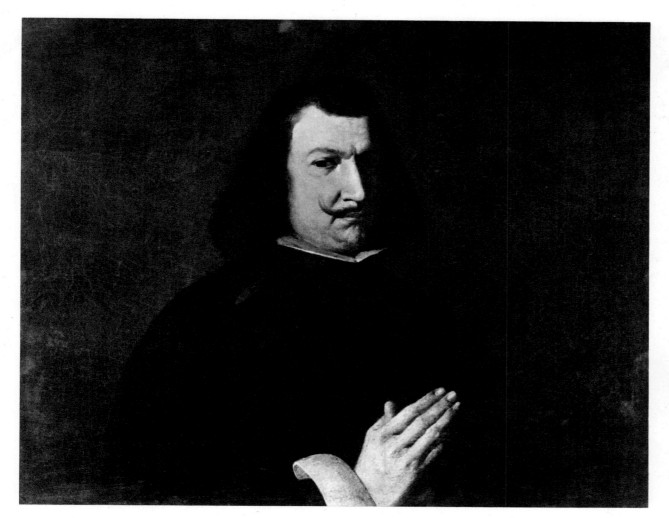

Figure 51.
ALONSO DE SALAS PARRA.
1643–44. Oil on canvas,
21 5/8 × 29 1/2".
Colegiata de Santa Maria,
Zafra (Badajoz)

Order of Santiago. On December 23, Zurbarán became the eighty-sixth witness to testify to the nobility of Velázquez's blood and profession. In his statement, Zurbarán told the investigating panel that he had known Velázquez for forty years, thus confirming their earlier acquaintance in Seville. Nevertheless, Zurbarán was able to find employment in Madrid during his first months there. Perhaps Velázquez, who was always generous to fellow artists, helped to arrange Zurbarán's participation in the decoration of the chapel of San Diego in the Franciscan church at Alcalá de Henares, for which he produced the superb *Saint James of the Marches* (colorplate 44). This encouraging development may have convinced Zurbarán to remain in Madrid in the hope of improving his fortune. The decision was to some extent justified, because after a gap of five years in his work—1653–58—he produced another group of paintings, which were his last.

Just over twenty works can be dated in the last seven years of Zurbarán's life, and they are unusual in two respects. First, there is the preponderance of devotional pictures, that is, representations of nonnarrative subjects such as the Immaculate Conception, the young Virgin reading, and the Holy Family. In addition, over half of the pictures are signed and dated, an unusually high percentage which, taken with the repetition of popular

themes, suggests that they may have been painted on speculation rather than on commission.

His final works are increasingly expressive of gentle emotions. In *Christ Gathering His Garments After the Flagellation* (fig. 50), painted in 1661 for the parish church in Jadraque (Guadalupe), Zurbarán revived the pose that he had used in *Christ Carrying the Cross* of 1653 (colorplate 43), but the implicit pathos of the earlier work has been brought to the surface by a further muting of style. The strong outline that Zurbarán almost always used to define form now fuses with the background, and the modeling of the face is less sharp. These changes may be the result of renewed contact with Velázquez. Certainly a portrait of this period acknowledges this source of influence.

A Doctor of Laws (colorplate 45) is one of Zurbarán's rare portraits. Although he often used live models for his religious subjects, he seldom painted formal portraits and when he did the results were uneven. *Alonso de Salas Parra* (fig. 51), donor of the Zafra altarpiece, is painted with implacable and somewhat dull objectivity, whereas the young *Alonso Verdugo de Albornoz* of c. 1635 (colorplate 25) convincingly imparts an air of authority to a twelve-year-old boy who was made a military commander. It is curious that the two best portraits, *Alonso Verdugo*

47

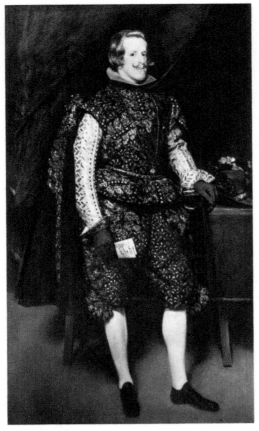

Figure 52. Diego Velázquez.
PHILIP IV (THE SILVER PHILIP). 1631–35.
Oil on canvas, 78 1/2 × 44 1/2".
The National Gallery, London

and *A Doctor of Laws*, strongly resemble certain portraits by Velázquez (fig. 52). But whereas the 1635 portrait borrows only a typical pose from Velázquez, *A Doctor of Laws* appropriates his technique as well. The loose brushwork that blurs the edges, the hand that seems to melt into the air, these are mannerisms that surely came from a study of Velázquez's later paintings.

With a more supple style at his command, Zurbarán was able to create devotional paintings that answered the need for a more familiar religious art. In 1658, he painted the first of three pictures of *The Virgin and Child with Saint John the Baptist* (fig. 53). Although it is a variation of *The Virgin and Child* of c. 1645 (fig. 47), where the two figures are seated near a table with a plate of fruit on it, the 1658 version is livelier because it is planned around an incident that triggers movement. The young Saint John holds up a small bird to the Christ Child, who looks at it with surprise and fear. His twisting pose is faultlessly rendered and effectively contrasted with the calm, maternal figure of the Virgin. Within the context of his later works, this painting achieves a new level of mastery by forging psychological and artistic unity without mitigating the powers of factual observation (fig. 54).

About 1660 and again in 1662, Zurbarán returned to

Figure 53.
THE VIRGIN AND CHILD
WITH SAINT JOHN THE BAPTIST. 1658.
Oil on canvas, 54 1/2 × 42".
The Fine Arts Gallery, San Diego

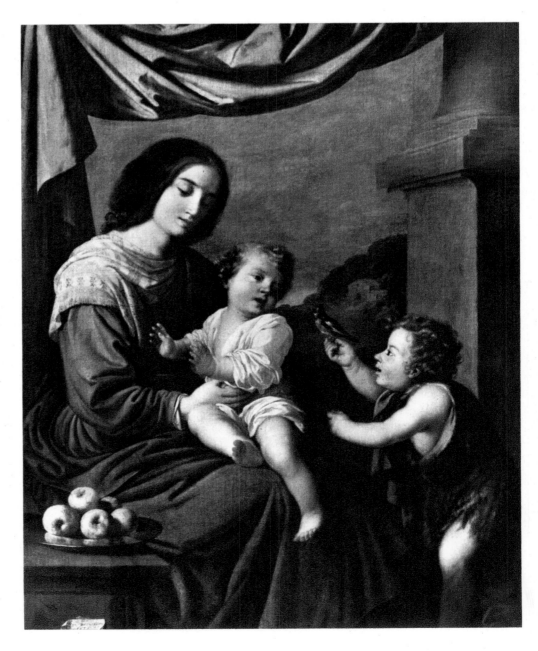

Figure 54. THE VIRGIN AND CHILD WITH SAINT JOHN THE BAPTIST (detail of figure 53)

Figure 55. THE VIRGIN AND CHILD WITH SAINT JOHN THE BAPTIST. c. 1660. Oil on canvas, 51 1/8 × 39 3/8″.
Private collection, Bubenberg, Erlenbach, Zurich

Figure 56. Albrecht Dürer. THE VIRGIN OF THE MONKEY. 1498–99. Engraving, 7 1/2 × 4 7/8″

the subject in two closely related paintings (fig. 55 and colorplate 48). The pose of the Virgin is almost identical; she is seated, her head is turned and slightly inclined, and she holds the infant Christ in one hand, a book in the other. The coincidence is explained not because Zurbarán was repeating a motif of his own invention; rather he once again had copied a print, this time Albrecht Dürer's *Virgin of the Monkey* (fig. 56). The transformation is complete, but it is fascinating to observe how, even at this late stage of his career, Zurbarán retained the habit of using prints as a source for his compositions.

These two paintings epitomize the problem of evaluating Zurbarán's late style. The contrast to earlier works is inevitable, if misleading. His severe style challenges modern taste; it is formally complex and at the same time emotionally understated. The later works, though no less accomplished, seek to arouse emotions of tenderness and devotion to their subjects, and these feelings can intrude upon our perception of the work. In *The Virgin and Child with*

Saint John the Baptist of 1662 (colorplate 48), Zurbarán evokes a melancholy reverence and demonstrates how he came to dominate the expression of this somber side of life. But those who seek the controlled power of his earlier style may not respond to this softer, darker religious mood that, despite its superb quality, falls outside the range of modern sensibility.

The subdued *Virgin and Child with Saint John* is Zurbarán's last known painting. Its air of sadness is an appropriate, if unintentional, reminder of the poverty and neglect that the artist suffered in his last years. On August 26, 1664, the day before he died, he drafted his last will and testament, which movingly testifies to those unhappy days. The text is short because the painter had little to leave his heirs except three small debts still owed him. He bequeathed the money from them to his wife, together with the "few possessions that we have," which were to be auctioned for his widow's benefit. On September 3, 1664, an inventory was made of Zurbarán's effects.

Figure 57. Attributed to Pedro de Camprobín. STILL LIFE WITH A BASKET OF FLOWERS. c. 1660. Oil on canvas.
Collection Conde de Ibarra, Seville

Figure 58. Gustave Courbet. BURIAL AT ORNANS. 1849–50. Oil on canvas, 10′ 3 5/8″ × 21′ 9″. *The Louvre, Paris*

The list is not impressive; the only items of value seem to have been a few pieces of furniture and some tapestries. There were also a number of paintings and, not surprisingly, a small collection of prints. His clothes and other household furnishings were described as "worn." And the silver had already been pawned to pay the expenses of his funeral.

From obscurity Zurbarán slid into oblivion in Spain, though he was often imitated by Spanish-American painters. A few followers and former workshop collaborators kept the memory of his style alive for a few years, then it faded completely. His most lasting influence occurred in still-life painting, a genre that played a very minor role in his oeuvre. Until later in the century, when his spartan ideal was displaced by the opulent style of Flanders, it was practiced by a few Sevillian painters. *Still Life with a Basket of Flowers* (fig. 57), attributed to Pedro de Camprobín (1605–c. 1674), is a typical Zurbaránesque imitation, even to the point of borrowing the cup and flower on a pewter plate from Zurbarán's *Still Life* of 1633 (colorplate 20).

Until the early nineteenth century, Zurbarán lay beneath the horizon of European artistic consciousness. As his paintings began to appear in France after the Peninsular War, interest in his art slowly reawakened. In May, 1824, Eugène Delacroix recorded in his *Journal* a visit to the collection of Field Marshal Soult, former commander of the French army in Andalusia, where he admired Zurbarán's *Saint Agatha* (Musée Fabre, Montpellier). But Zurbarán had no place in his aesthetic, and he never appeared again in Delacroix's writings. The painters who saw the Zurbaráns at the Galerie Espagnole between 1838 and 1848 were considerably more impressed, particularly those who sought to escape from the confining standards of the Academy. To Millet, Courbet, Ribot, and others, Zurbarán furnished a model of nonacademic art. His willingness to ignore the conventional rules of painting—perspective, correct anatomy, smooth finish—and his refusal to follow a classical conception of man and nature encouraged painters who themselves wanted to approach their art with a fresh eye. For example, the inspiration for the stark colors and contrasts and the isolated grief of the mourners in Courbet's *Burial at Ornans* (1849–50; fig. 58) was derived from Zurbarán's *Saint Bonaventure on His Bier* (colorplate 7), then to be seen in the collection of Field Marshal Soult.

Figure 59. Edouard Manet. KNEELING MONK. 1865.
Oil on canvas, 56 1/2 × 43″. *Museum of Fine Arts, Boston.*
Purchased, Anna Mitchell Richards Fund

Figure 60. Paul Cézanne. UNCLE DOMINICK AS A MONK.
c. 1866. Oil on canvas, 25 1/2 × 21 1/2″.
Collection Enid A. Haupt, New York City

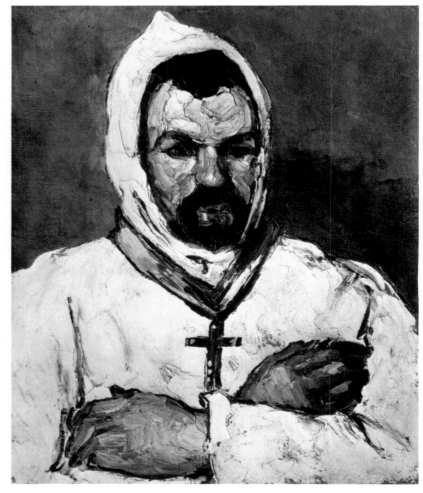

Again, in the 1860s, Zurbarán was studied carefully by painters who disdained the rules of the Academy. Édouard Manet, in particular, a great lover of Spanish art, was attracted to Zurbarán. His anachronistic *Kneeling Monk* of 1865 (fig. 59) is a virtual paraphrase of Zurbarán's *Saint Francis Meditating* (fig. 5), the star painting of the Galerie Espagnole. Even the most radical aspect of Manet's painting, its flattened, undefined space, only emphasizes Zurbarán's suppression of illusionistic depth. Zurbarán's continuing relevance to modern art is witnessed in Cézanne's *Uncle Dominick as a Monk* of c. 1866 (fig. 60), which seems to synthesize the portraits of white-robed monks. It is fitting that Cézanne, whose painting is prerequisite to our appreciation of Zurbarán, should himself have acknowledged a community of artistic spirit with this great Spanish artist.

In the twentieth century, the intuitive admiration of the French painters has been supplemented by an enormous amount of primary research, which continues to bring Zurbarán's life and art into ever sharper focus. This scholarly activity has confirmed the basic discovery of nineteenth-century artists and critics about the painter: namely, his uncompromising individuality and sincerity. Although Zurbarán came into contact with the main currents of seventeenth-century painting, he was never swept away by any of them. Like Georges de la Tour in France, Zurbarán bent new artistic ideas to fit a personal set of values, and thus kept his style amazingly pure and direct. Freed from the pressures of fashion by his ecclesiastical and monastic patrons, he was able to seek the quintessence of their faith. More than any other Spanish painter, Zurbarán captured the ideal of a virile, ascetic Christianity that questioned neither devotion to heavenly powers nor its miraculous rewards. In his paintings, the abstractions of faith became incredibly real by an artistic process that remains continually fascinating.

BIOGRAPHICAL OUTLINE

1598 Francisco de Zurbarán born in Fuente de Cantos, in western Spain.
NOVEMBER 7: Baptized in the church of Nuestra Señora de la Granada.

1614 JANUARY 15: Begins three-year apprenticeship in Seville with Pedro Díaz de Villanueva.

1616 Paints *The Immaculate Conception* (Collection Valdés, Bilbao), his earliest known work.

1617 Leaves Seville and moves to Llerena; marries María Páez Jiménez, first of three wives.

1620 JULY 19: Baptism of Juan de Zurbarán, second of three children of first marriage, and later his pupil and follower.

1623 or
1624 Death of first wife.

1625 Marries Beatriz de Morales.

1625–26 Paintings for Carthusian monastery of Santa María de las Cuevas, Seville.

1626 JANUARY 17: Contract with Dominican monastery of San Pablo el Real, Seville, for twenty-one paintings, including scenes from the life of Saint Dominick and seven single saints.

1628 AUGUST 29: Contract with monastery of the Merced Calzada, Seville, for twenty-two paintings of the life of Saint Peter Nolasco and a number of individual saints.

1629 JUNE 27: City council resolves to invite Zurbarán to move to Seville.
Recorded as resident of Seville, together with his wife, three children of first marriage, and eight servants. Four paintings for Franciscan church of San Buenaventura.

1630 MAY 23: Painters' guild demands that Zurbarán submit himself to statutory examination.
JUNE 8: Commissioned to paint *The Immaculate Conception* for city hall (now in Nuestra Señora del Carmen, Jadraque), probably as a token of council's support against guild's petition.
Painted *The Vision of Saint Alonso Rodríguez* (Academia de San Fernando, Madrid) for Jesuit church at Seville.

1631 JANUARY 21: Contract with Dominican College of Santo Tomás de Aquino for large painting of *The Apotheosis of Saint Thomas Aquinas* (Museo Provincial de Bellas Artes, Seville).

1633–35 Paintings for the altar of Saint Peter, Cathedral, Seville.

1634 JUNE–NOVEMBER: In Madrid to paint ten "Labors of Hercules" and two battle scenes for Hall of Realms, Buen Retiro Palace.
Named honorary painter to the king.

1636 Paintings for Merced Descalza, church of San José.

1638–39 Paintings for Carthusian church of Nuestra Señora de la Defensión, Jerez de la Frontera and for Jeronymite order in sacristy and chapel of Nuestra Señora de Guadalupe.

1639 MAY: Death of Beatriz de Morales, his second wife.

1640–41 Paints transept altarpieces for Dominican church of Santo Domingo de Portaceli, Seville.

1643–44 Altarpiece for Colegiata de Santa María, Zafra.

1644 FEBRUARY 7: Marries third wife, Leonor de Tordera. They have six children, of whom at least five die while very young.

1647 MAY 22: Contract to paint thirty-four pictures for nuns of Our Lady of the Incarnation, Lima, Peru.

1649 FEBRUARY 28: Receipt signed by two agents in Buenos Aires for fifteen virgin martyrs, fifteen kings and famous men, and twenty-four saints and patriarchs, shipped by Zurbarán for sale in Spanish America.
JUNE: Juan de Zurbarán dies, victim of plague.

1650 Signs and dates *The Annunciation* (Philadelphia Museum of Art).

1651 Possibly makes short visit to Madrid.

1653 Signs and dates *Christ Carrying the Cross* (Cathedral, Orléans).

1658 MAY: Goes to Madrid, where he spends the rest of his life.
DECEMBER 23: Testifies on behalf of Velázquez before tribunal investigating his claims to nobility. Paints *Saint James of the Marches* (now in the Prado, Madrid) for Franciscan church at Alcalá de Henares.

1658–62 Signs and dates about a dozen paintings (except for 1660, for which none has been discovered).

1662 Last known painting, *The Virgin and Child with Saint John the Baptist* (Museo de Bellas Artes, Bilbao).

1664 AUGUST 27: Dies in Madrid, at sixty-six years of age.

COLORPLATES

SAINT BRUNO AND
THE MIRACLE OF THE UNEATEN MEAT

c. 1625–26

Oil on canvas, 8' 7 1/8" × 10' 7/8"

Museo Provincial de Bellas Artes, Seville

This large canvas, one of three painted for the Cartuja of Santa María de las Cuevas in Seville, illustrates and confirms a rule of the Carthusian order, the abstinence from eating meat. The order was founded in 1084 by Saint Bruno and six companions on a plot of rugged land in the Alps near Grenoble that was donated by Saint Hugh, bishop of Grenoble. Its way of life was modeled on the ascetic example of the Early Christian hermits; manual labor and prayer were to occur in an atmosphere of silence, for speech was restricted. The Carthusians ate the simplest fare, and meat was rigorously excluded from their diet. The painting illustrates the origin of this proscription.

During its early days, food for the original seven monks was provided by Hugh of Grenoble. On Quinquagesima Sunday, fifty days before Easter, he sent them a small ration of meat, because the rule against eating it had not yet been officially adopted. After noontime prayer, the monks went to the refectory and, seeing the meat on the table, began to debate whether they should eat it. While they were discussing the matter, they fell asleep. On the Wednesday before Easter, forty-five days later, Saint Hugh decided to visit the monastery. He sent a messenger ahead to announce his arrival, and he returned with news that the monks were sitting at table with meat set before them, although it was Holy Week when meat was strictly forbidden. Saint Hugh hastened to the monastery to verify the scandalous event and, as soon as he arrived, the seven monks awakened. When Hugh asked Saint Bruno if he knew what day it was, he replied, "Quinquagesima Sunday," not realizing how long he had been unconscious. The miracle was verified immediately afterward, when the meat was turned to ashes before the bishop's eyes. This was taken as a further sign that God looked with favor upon the prohibition of eating meat, and thus it became part of the Carthusian rule.

The painting depicts the arrival of Saint Hugh and his page in the refectory and the subsequent arousal of the seven monks from their long sleep. Zurbarán has brilliantly captured the torpor of the just-awakened monks. It is almost as if the painting were a still life, for the monks are as inanimate as the food and tableware before them. They seem unable to focus their eyes, as though still drugged with sleep. There is a purity and severity to the painting that comes from the simple composition and the gray and white tonalities. A strong, even light illuminates men and objects alike, though only objects cast shadows consistently. The picture has immense sincerity and concentration that is the result of its lack of sophistication. But the clarity and legibility of the picture and the very lack of artifice were an ideal way to imagine an historic moment of Carthusian renunciation.

On the wall behind the figures is a painting set in a gold and black frame that shows the Virgin and Child with Saint John the Baptist seated in an open, pastel-colored landscape. The purpose of the picture is not simply decorative because the Christ Child is asleep and not suckling at His mother's breast, as may appear at first glance. As a result, the scene provides both a parallel and a precedent for the miracle taking place below, where the monks, like Christ, slumber rather than partake of food.

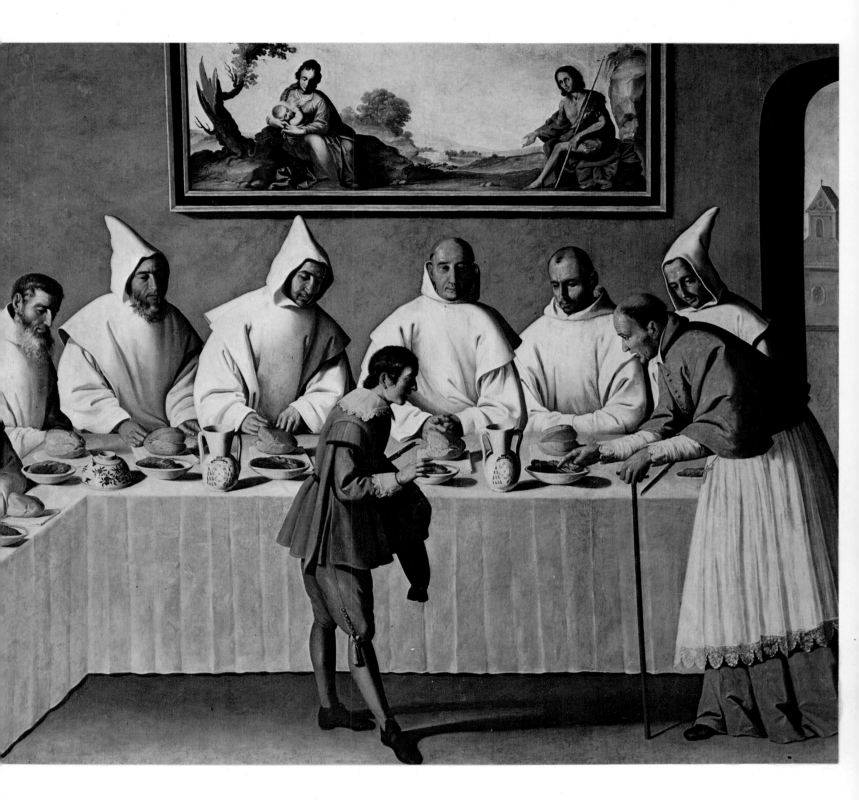

COLORPLATE 2

SAINT BRUNO AND

THE MIRACLE OF THE UNEATEN

MEAT (*detail*)

In this painting Zurbarán first displayed his great talent for still life. Although the number of his independent still lifes is very small, there are countless paintings that contain commonplace objects which were elevated above their humble station by his keen eye. Zurbarán must have been fascinated with small things, because he painted them with no less care than he did the central figures in his stories. Indeed, long before he had mastered the intricacies of figure painting he was a superb still-life artist.

The objects on the table before the Carthusians are, in their way, more intriguing than the monks. Whereas the monks are treated in an almost abstract way, there is a sense of reality and palpability about the loaves of bread, the dishes of meat, and the ceramic jars, even though they are arranged with formal precision. The pottery, in fact, can be identified as a contemporary make from Talavera that was popular in the early seventeenth century throughout Spain. The overturned bowl, with its deftly placed white highlight, is a free copy of Chinese porcelain that was made after 1600. Near it is one of two double-handled jars with a blue coat of arms painted on the brilliant white glaze for which Talavera was famous. The coat of arms belonged to Gonzalo de Mena, a bishop of Seville, who founded the monastery of Santa María de las Cuevas in 1400. The inclusion of this realistic anachronism enlarges the meaning of the picture. On a general level, the painting reminded the Carthusians of Seville that their dietary rule was sanctioned by a divine miracle. And the presence of their founder's crest at the miracle emphasized their role as spiritual heirs of Saint Bruno. Hanging, as it surely did, in the refectory of the monastery, it was both an explanation of the rule and an inspiration to follow it faithfully.

THE VIRGIN SHOWS A DOMINICAN

THE TRUE PORTRAIT OF

SAINT DOMINICK

c. 1626–27

Oil on canvas, 74 3/4 × 90 1/2"

Church of the Magdalena, Seville (formerly San Pablo)

This painting illustrates one of the typically obscure episodes of monastic history that Zurbarán was often called upon to supply for a religious order. It originally belonged to a series of fourteen scenes from the life of Saint Dominick, commissioned from the artist by the Dominican monastery of San Pablo, Seville, in January, 1626. Only two of the pictures have survived, and they are still in the church that formerly belonged to the monastery.

The scene is a miracle that occurred in the Italian monastery of Soriano in 1530, when the Virgin appeared to one of the brothers and showed the founder's true image in order to guide future representations of him. Saint Catherine displays the painting before the kneeling Dominican, as the Virgin, who wears a crown and holds a scepter and rosary, tells him that Saint Dominick should thereafter be painted holding lilies in one hand and a book in the other. At the far right stands Mary Magdalene. In the upper left corner are two *putti* with attributes of the order, including its insignia; they were added later when the corners of the arched picture were filled in to make it square.

This arcane subject emphasizes the essentially private nature of Zurbarán's audience when he painted for monastic patrons. Often these paintings were hung in a common room within the monastery and were seen only by members of the order, who obviously understood their meaning. Zurbarán's early successes were based largely on his ability to satisfy the special needs of this small and select clientele. In his paintings, the monks of Seville must have found a reflection of the strict faith and severe life to which they were in principle committed.

After the stony monumentality of the Cartuja of Seville series, the charm and elegance of this painting are unexpected. These qualities stem from the three attractive and self-confident women, who are the first of the standing female saints that are Zurbarán's most appealing creations. Although they do not wear the opulent gowns of their successors, they are attractively clad in colorful costumes. Their long oval faces, brushed with shadow on one side, were inherited by later members of the saintly family.

The figures, arranged in a shallow curve against a black background, are seemingly lit by spotlights. This artificial presentation is offset by the realistic painting of details. For instance, the rosary, which appears three times in the painting as a reminder of the Dominican devotion to its cult, is painted bead by bead each time it occurs. The combination of the real and the unreal is an effective way to present the mystery of miraculous contact between heaven and earth, and Zurbarán was to use it repeatedly during his career.

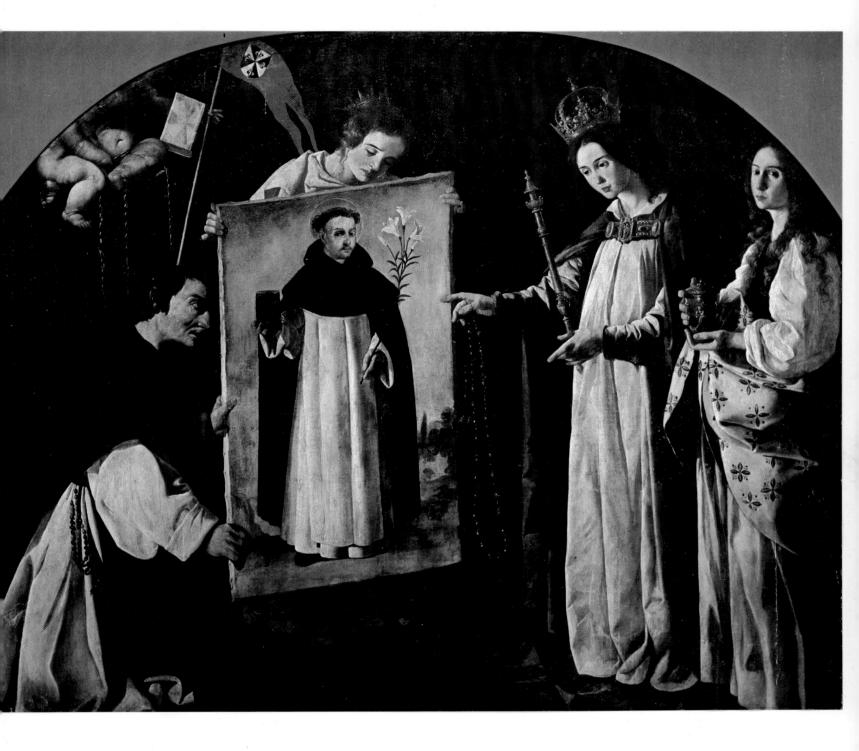

CRUCIFIXION

Signed and dated 1627

Oil on canvas, 9' 6 1/2" × 5' 6 1/8"

The Art Institute, Chicago. Robert Alexander Waller Fund.

The Crucifixion was often painted by Zurbaran, but this version of 1627 is his most moving realization of the subject. The picture was painted for the Dominican monastery of San Pablo and originally hung in a chapel in the sacristy of its church. It was immediately recognized as a masterpiece and its fame continued throughout the eighteenth century, when it was considered to be Zurbarán's greatest work. The writers who praised it were impressed above all by the illusion of reality it produced. As one admirer described it while it was still in place, "it is viewed behind the closed grill of the poorly lit chapel and all those who see it, and do not know that it is a painting, believe it to be a piece of sculpture."

The sculpturesque quality of the painting, while undoubtedly its most arresting feature, is only partially responsible for its powerful effect. No less important was the decision to paint the subject as an icon rather than as a narrative episode. The figure of Christ, nailed to the roughhewn Cross, is completely isolated; all references to time, place, or other persons have been suppressed and this isolation enforces total concentration on the image. In adopting this format, Zurbarán was following the example of his older contemporary, Francisco Pacheco, who popularized the composition in Seville. It was also Pacheco who instructed painters to show Christ crucified with four nails rather than three. But his treatment of the theme pales beside Zurbarán's vigorous image. It is not merely that Zurbarán has a better eye for appearances; he is also aware of the silent conflict between reality and unreality, between humanity and divinity, that is essential to the subject.

This tension, and not simply the clever imitation of reality, energizes the picture. The brilliant light that enters at the right allows us to see the muscles and bones of Christ, but only on the right side. The left is in shadow, a shadow that arbitrarily cuts the legs with a razor-sharp edge. The sensation of dead weight is obtained by extending Christ's left arm in a straight line to the end of the crosspiece, while on the other side a continuous, gently curving line runs from the waist to the wrist. A leftward sag is thus established, with a long arc played against a sharp angle. The position of Christ's head and the fall of white drapery further accentuate the gentle movement. Hence the initial impact of reality slowly yields to an understanding of the subtle artifice used to dramatize the supernatural essence of Christ.

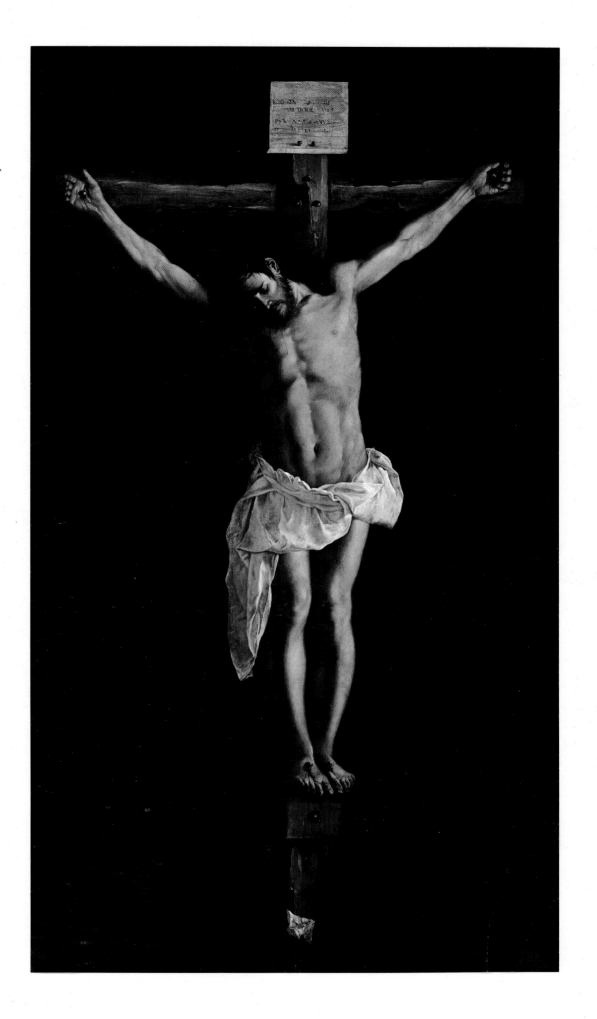

SAINT SERAPION

Signed and dated 1628

Oil on canvas, 47 1/2 × 41″

Wadsworth Atheneum, Hartford

Ella Gallup Sumner and Mary Catlin Sumner Collection

Saint Serapion was painted for the monastery of the Merced Calzada (Shod Mercedarians) in Seville and hung originally in the Sala de Profundis, the room where deceased members of the order lay in state before burial. In this setting, *Saint Serapion* was more a symbol of death than an illustration of his own martyrdom. The symbolic function explains the most impressive aspect of the painting—its rigorous suppression of morbid details. Zurbarán has painted a bloodless martyrdom in direct contradiction to the atrocious death suffered by the young English monk in 1240. Peter Serapion had gone to North Africa to pledge himself to the Mohammedan enemy in return for the release of Christian prisoners. While he waited for his monastic order to ransom his freedom, he sought to preach Christianity to the Moors, for which he was put to death. According to one account, his stomach was cut open so that his entrails hung out, causing him to suffer a long and excruciating death. With this gruesome story in mind, Zurbarán's drastic abstraction of detail can be fully appreciated.

The artist has constructed his metaphor of Christian martyrdom with deliberate care. The initial force of the image is assured by the dramatic use of light. A brilliant beam strikes the golden white robe and, where it fails to penetrate, dark shadows create an illusion of depth and palpability. At the same time, the background is dark, somehow resisting illumination, and thus the figure is thrust forward. Only enough light penetrates to show the tree to which he is tied by his wrists.

Not until after the shock of the initial confrontation has passed does the subtlety of the pose become apparent. Saint Serapion has lost the strength to sustain his body, which hangs like an unused puppet, held up only by strings. The powerful illusion of the inanimate suspended is reinforced by careful attention to realistic detail. A slight leftward pull of the unresisting body is achieved by placing the head on the right shoulder. As a result, an unnaturally long arc stretches from the neck to the left hand and exaggerates the limpness of the body. The hands are also important clues to the appearance of lifelessness. They can no longer move and gently bend at the wrists against the restraining ropes. These details are carefully subordinated to the overall idea—a virtually symbolic representation of Christian martyrdom.

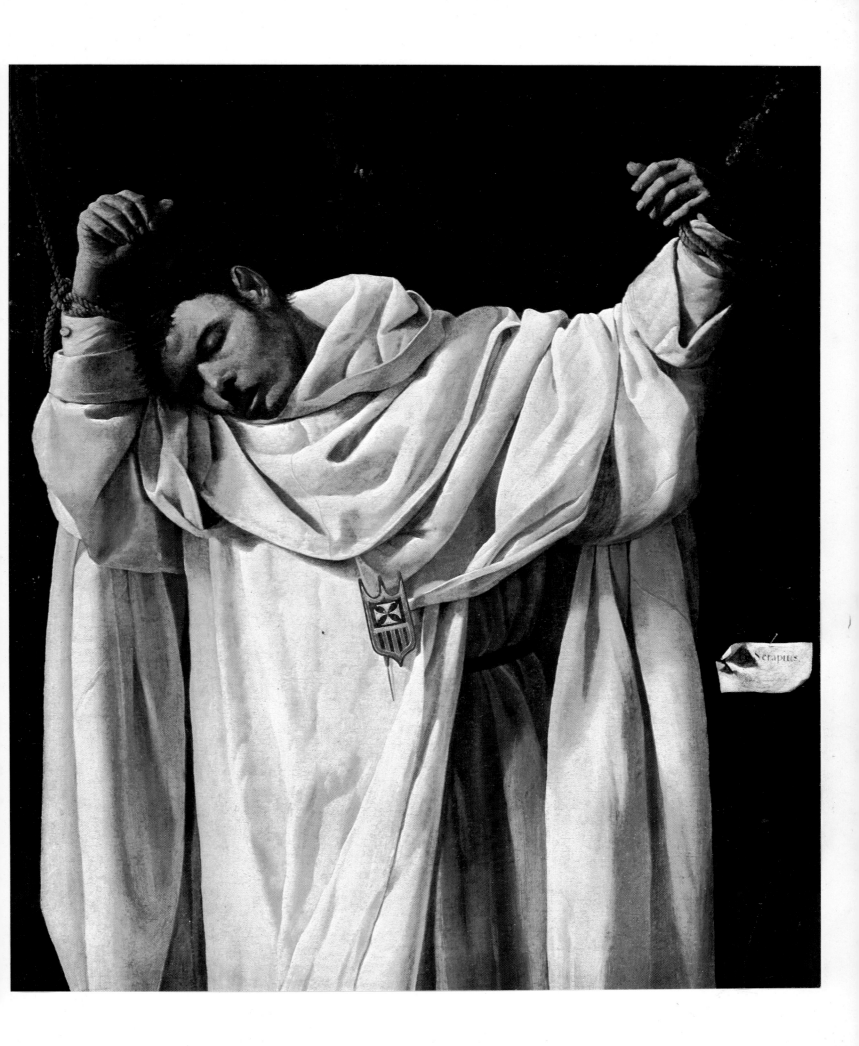

SAINT PETER NOLASCO'S VISION OF

THE CRUCIFIED SAINT PETER

Signed and dated 1629

Oil on canvas, 70 1/2 × 87 3/4″

The Prado, Madrid

In this visionary painting, Zurbarán once more displays his power to give form and substance to the supernatural and to exploit the resultant tension and ambiguity. The picture, like *Saint Serapion,* belonged to the large commission that was given by the Merced Calzada on August 29, 1628, and was one of the twenty-two scenes illustrating the life of Saint Peter Nolasco, who founded the order in Spain during the thirteenth century. Whether Zurbarán completed the full series is unknown; in the eighteenth century only fifteen pictures were still in place and not all of them were attributed to Zurbarán. Today nine of these have been identified, of which five are certainly by the master. The remaining four are the work of either an assistant or an independent collaborator who has been tentatively identified as Francisco Reyna. These pictures were installed on the walls of the small cloister in the monastery and fall into two categories—visions of Saint Peter Nolasco and episodes from his life. *Saint Peter Nolasco's Vision* is one of the two surviving visionary paintings; it is also the masterpiece of the cycle.

As its subject, the painting takes the moment when Peter Nolasco was kneeling before the altar, silently wishing that he could go to Rome in order to pray at the sepulcher of the saint for whom he was named. At that instant, the Apostle Peter appeared to the saint crucified upside down, as he had died. This bizarre motif lends a surrealistic air to the painting, which Zurbarán emphasizes by eliminating everything but the two figures. The Apostle Peter materializes from a dark orange hue that fills the room and erases the sharp lines that define illusionistic space. The floor imperceptibly melts into the wall, the wall into the ceiling. Within this nonrational zone, the vision occurs with sharply defined realism. To take one detail, the apostle's eyes are opened wide and seem to bulge out under the pressure of the blood that rushes to his head. Saint Peter Nolasco's reaction is surprisingly calm. He spreads his hands apart, but otherwise his body remains stationary under the creamy white Mercedarian habit. The picture derives its strength from this restrained reaction; it seems to capture the momentary paralysis of human response when confronted by corporeal manifestations of the divine.

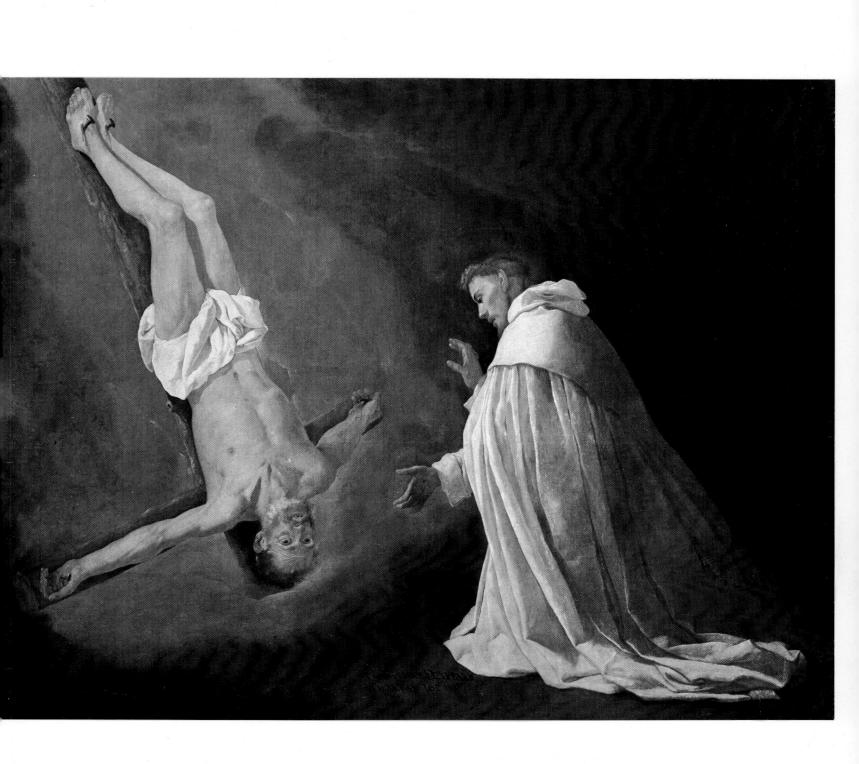

SAINT BONAVENTURE ON HIS BIER

c. 1629

Oil on canvas, 98 1/2 × 87 3/8"

The Louvre, Paris

It was probably late in the year 1628 that Zurbarán was invited to participate in another major commission—the decoration of the Franciscan collegiate church of San Buenaventura. The work had originally been given to an older contemporary, Francisco de Herrera the Elder, who, on December 30, 1627, signed a contract to paint six scenes from the life of Saint Bonaventure. Herrera agreed to finish the paintings within nine months and accepted the order's right to employ another artist to complete the work if he failed to meet the deadline. Zurbarán's subsequent intervention would, at first glance, seem to indicate that Herrera had not finished in time. However, at some point it was decided to increase the number of paintings from six to eight. Perhaps to satisfy the obvious desire for haste, Zurbarán was assigned four of the paintings, which were placed on the nave wall facing the paintings by Herrera. Thanks to his well-organized workshop, Zurbarán was able to execute the work despite the heavy demands of his contract with the Mercedarians, signed just a few months before.

Saint Bonaventure on His Bier is the final episode of the cycle. On July 15, 1274, while participating in the Ecumenical Council of Lyons, Saint Bonaventure suddenly died. Zurbarán's painting depicts not the funeral, but rather the lying-in-state of the deceased saint, when members of the council and the Franciscan order and secular dignitaries gathered to mourn his passing. It is, then, a depiction of grief and sorrow. Furthermore, it is one of the rare group portraits in Spanish art and challenges the excellence of the two masterpieces of that genre—El Greco's *Burial of the Count of Orgaz* (1586; Santo Tomé, Toledo, Spain) and Velázquez's *The Surrender of Breda* (1634; The Prado, Madrid).

There are, in fact, certain striking similarities to El Greco's painting. Both are shallow in depth, almost friezelike in arrangement, and organized around a diagonal figure. In addition, both artists amalgamate time by including personages from the past and present. And, finally, there is a contrast between ornate, highly colored patterns and black or neutral tonal areas that creates planes of depth within the narrow space. The resemblance to El Greco, which is purely a coincidence, focuses attention on important aspects of this complex painting, especially on Zurbarán's preference for late-sixteenth-century principles of composition.

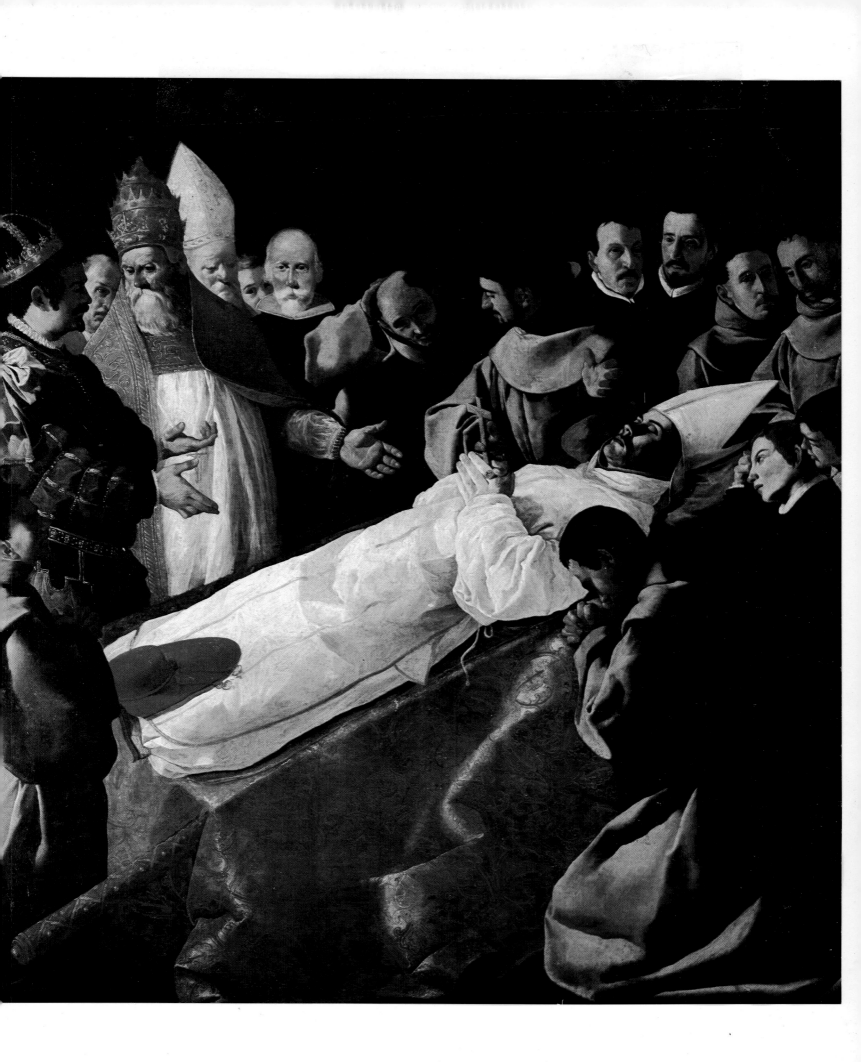

SAINT BONAVENTURE ON HIS BIER (*detail*)

The formal portrait played a minor role in Zurbarán's art; fewer than ten authentic examples have survived. And of this number, only two or three are exceptional in quality. The artist's lack of success in this genre comes as a surprise, because his religious paintings abound in incisive human characterizations. On the basis of their strong individuality, it is evident that Zurbarán used live models for his inspiration, occasionally putting the same face in different paintings. The discrepancy between Zurbarán the portraitist and Zurbarán the portrayer of human physiognomy is difficult to explain. Perhaps, as has been suggested by José López-Rey, the obligation to produce an exact likeness inhibited his imagination and prevented him from painting with the freedom that makes the imaginary portraits seem so alive. Whatever the reasons, Zurbarán's great ability to express character and emotion appears only in the fictitious portraits.

The gallery of men who appear in *Saint Bonaventure on His Bier* proves the point. Although each face conforms to Zurbarán's preference for a long oval form, the features and expressions of the men are individualized so that they seem to be portraits of actual models, whether they were or not. None is more individualized than this bald man with white beard and moustache, who has been rendered by Zurbarán with the clarity and emphasis of a major character, despite his secondary place in the composition. We see a man who is aged but vigorous. What is left of his hair has turned snow-white, and there is a noticeable sagging of the skin under the eyes. But his ruddy complexion gives him an aura of good health and sets off the well-trimmed beard and full moustache. The high forehead, which reflects the light, adds to his presence. And he is given further emphasis by the stiff, white, fan-shaped collar that acts almost like a base for a sculptured bust. If this close attention to a minor character interrupts the flow of the composition, it also increases the richness of the painting by introducing us to a wider range of humanity.

THE VISION OF SAINT ALONSO RODRÍGUEZ

Signed and dated 1630

Oil on canvas, 8' 8 3/4" × 5' 5 3/4"

Academia de San Fernando, Madrid

This painting is one of the richest creations of Zurbarán's early maturity and allows us to see clearly the special qualities of his art. Alonso Rodríguez was almost forty years old when he decided to join the Society of Jesus. He was assigned to the College of Montesión in Palma de Mallorca, where he humbly served as gatekeeper; hence the key that hangs from his waist. As a reward for his devotion, Alonso Rodríguez frequently experienced heavenly visions and was encouraged by his superior to write them down. After he died in 1617, parts of his text were incorporated in an anonymous biography, which was written to advance a claim for sainthood, ultimately granted in 1888. From this book comes his account of a vision that we see in Zurbarán's painting. "One day this person [as he calls himself] was reciting the rosary of Our Lady when suddenly she and her Blessed Son appeared to him. The Son was on His mother's right . . . and the Virgin was holding her heart in her hand and was on this person's right. Suddenly the heart of this person was filled with a feeling so great that it has lasted to this day."

Zurbarán's picture expands Alonso Rodríguez's spare narrative in several ways. Although the enrichments were surely specified by his Jesuit patrons, who commissioned the work for their church in Seville, Zurbarán made the subject come alive by a curious mixture of conservative and contemporary practices. The composition with two tiers of figures pressed close to the frontal plane is a standard format of sixteenth-century painters; it has even been suggested that Zurbarán was specifically inspired by Federico Barocci's print of *The Vision of Saint Francis* (c. 1575). But the scheme is so common to earlier painters in Seville that it is needless to postulate a single source. Similarly, the transference of the hearts of the Virgin and Christ to Alonso Rodríguez is rendered as a medieval artist might have done it. Light rays visibly etch hearts on his breast and each one has an identifying monogram, MV for the Virgin Mary, IHS for *Iesus Hominum Salvator*. The difference in scale between man and the gods and the greater abstraction of the Virgin and Christ are also common medieval conventions. Finally, some of the colors, notably the apricot robe of the guardian angel, reflect a Mannerist penchant for exotic, unreal tones.

These surprisingly old-fashioned procedures are balanced by the sophisticated treatment of light to create the illusion of reality. The light strikes the drapery and creates sharp ridges that make the cloth seem almost palpable. Zurbarán also brings small details to life by carefully reproducing their appearance. The angel's wings are startlingly naturalistic and Alonso Rodríguez's aged face is individualized by small, observant touches. The resultant style is a hybrid that combines the real and the abstract.

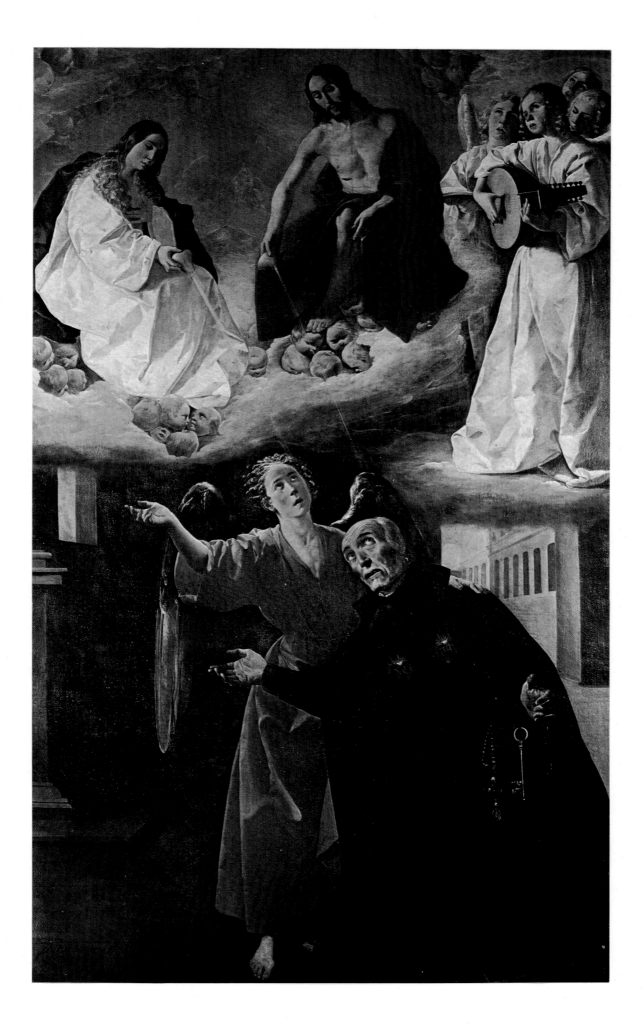

THE VISION OF SAINT ALONSO
RODRÍGUEZ (*detail*)

The group of musical angels is a charming complement to this painting. Their presence was motivated by a passage in another of Alonso Rodríguez's visions. On Assumption Day (August 15) in 1591, he beheld a vision of the Virgin being received into heaven by Christ. The act was accompanied by angels playing music that had a magical effect on the listener. As it is described by the saint, "a single angel can play a melody so great that it raises men's spirits to the point where, even after years have passed, they are still transported [by the sound]."

Zurbarán's angelic ensemble consists of a lute-playing angel and three singers. The angel with the instrument in the foreground is a pictorial tour de force. The brilliant white robe with its steely blue shadows catches the eye with its illusion of reality. The firmly modeled face is framed by curls of golden hair. But even more remarkable is the pose, which is unusually relaxed and natural despite its complexity. The lute is perfectly foreshortened and played with convincing expertise. The angel supports the instrument by pressing it against the chest and arches the wrist to free the fingers for plucking the strings. The other hand is held in the classic position for playing stringed instruments, with a wide space between the fingers and the thumb.

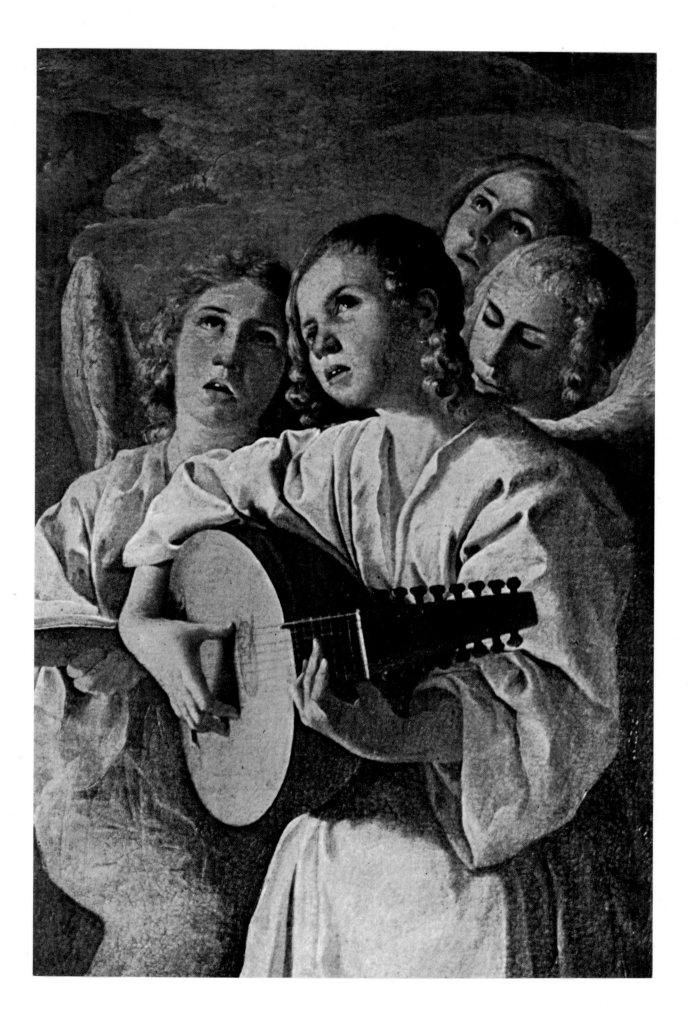

THE VIRGIN AND CHRIST IN THE

HOUSE AT NAZARETH

c. 1630

Oil on canvas, 64 7/8 × 90 1/2"

The Cleveland Museum of Art

Purchase, Leonard C. Hanna, Jr. Bequest

This homey scene of Christ and the Virgin is one of the most spectacular pictures painted by Zurbarán during his earlier years, and displays, as few works do, the special quality of his art as he moved to the forefront of Sevillian painting. The color is overpowering; the rich ruby red of the Virgin's dress, the iridescent blue gray of Christ's robe, the bleached whites, the golden browns achieve unprecedented clarity and depth. But its compelling attraction is equally indebted to the unusual tension between conception and execution.

The episode comes from one of the countless apocryphal legends that were rejuvenated in the seventeenth century as part of a campaign to popularize the Catholic faith. Religious writers revived old legends and invented new ones that re-created the untold story of Christ's childhood, usually in anecdotal terms. This scene takes place in the house of Joseph and Mary at Nazareth and shows the prefigurement of Christ's martyrdom. Christ is weaving a crown of thorns and has just pricked His finger on one of the points. Mary, who is sewing nearby, observes the incident in which she sorrowfully foresees the agony of the Passion. In his painting, Zurbarán has sought to secularize the scene without becoming irreverent or undignified. He strikes the balance in an altogether personal way.

Great attention has been paid to detail. The Virgin, for example, wears a loose scarf around her neck and a thimble on her middle finger. A variety of commonplace objects have been scattered throughout the room—a clay bowl, a sewing basket, a table with books and fruit on it. Some of the things have been put in place for symbolic purposes, such as the vase with lilies and roses (conventional attributes of the Virgin) and the two turtledoves, which may signify the poverty of the Holy Family. (Turtledoves were customarily offered to God by the poor during the feast of Presentation or Purification.) And Zurbarán has tried to make the reactions of his characters true-to-life. Christ examines His injured finger with self-conscious involvement, while the Virgin's anguish is expressed by tears that run down her cheeks from red and swollen eyes. Yet despite this attention to detail, it is difficult to describe the painting as a transcription of reality, and not merely because we can identify the characters as divinities. There are inherently artistic causes for this perception.

These are mainly involved with certain idiosyncrasies of composition and execution. The composition is not entirely harmonious. The Virgin and Christ seem to be lost in their own worlds, although they occupy the same room. Inanimate objects have become exceptionally clear. These devices subtly abstract the episode from reality and establish a moving tension between the everyday and the extraordinary.

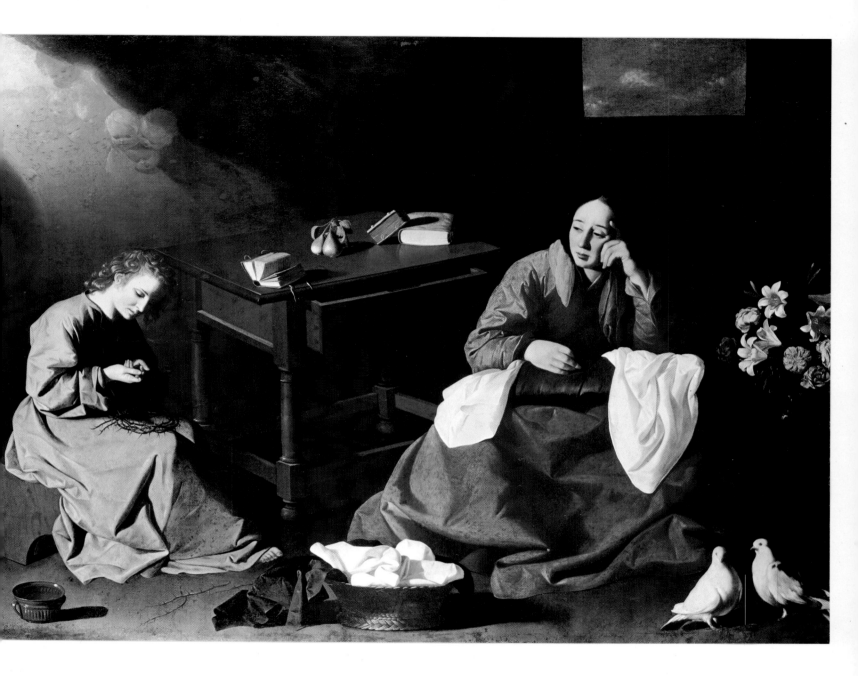

THE VIRGIN AND CHRIST IN THE

HOUSE AT NAZARETH (*detail*)

The table with books and pears epitomizes Zurbarán's method of composition. Great care has been taken to obtain the appearance of random objects casually arranged. The table drawer is partially open, as if someone had neglected to give it a final push. One book lies on its spine with the pages open and the leather straps carelessly hanging over the edge of the table. On the far side of the table, a small leather-bound book leans against a larger volume. And in the center is a cluster of three pears, one of them almost obscured by the other two. Yet there is nothing offhanded about the arrangement. Each object has been painted as if it were the centerpiece of the painting. The three pears, for instance, are firmly outlined and strongly lit so that they become unnaturally clear. Their color is a careful combination of golden green and orange. Light is strongly reflected off the surface, which makes the fruit look hard and smooth. We are thus fully informed about their shape, color, and texture. But the result is almost too attractive. It is hard to link such a definite image to other elements in the picture. Each object declares its independence from the others, making it seem as if Zurbarán were analyzing and contrasting curved and rectilinear forms.

This distinctive approach to composition is reminiscent of early genre scenes by Velázquez, which were being painted when he and Zurbarán were in Seville. In paintings such as *The Old Woman Cooking Eggs* (National Gallery of Scotland, Edinburgh), Velázquez placed a collection of kitchen objects on a ledge and carefully, almost obtrusively, realized each one. Perhaps Zurbarán was influenced by these pictures, which at the time of their creation were stunningly bold and revolutionary in their unvarnished realism. Or perhaps the lucid still lifes in the paintings of both artists were symptoms of pride in their ability to duplicate the appearance of commonplace things.

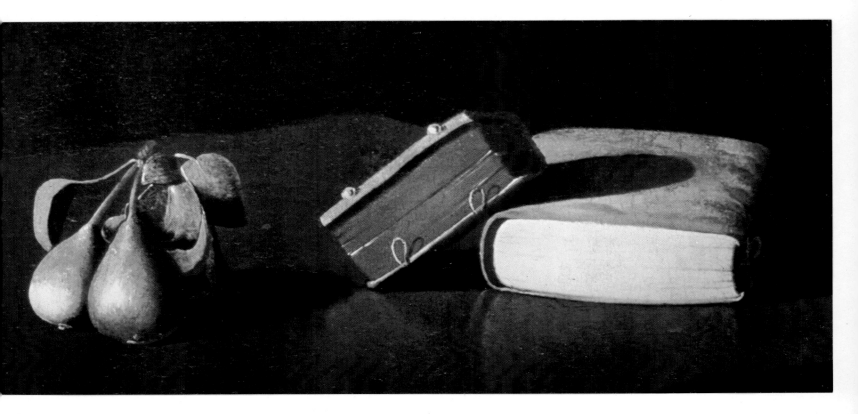

THE VISION OF SAINT ANTHONY

OF PADUA

c. 1630–33

Oil on canvas, 71 × 44 1/2"

Kresge Art Center, Michigan State University, East Lansing

Gift of Friends of the Gallery

The cult of Saint Anthony of Padua enjoyed great popularity during the seventeenth century, especially in Spain. For, despite his association with an Italian city, Saint Anthony had been born in Portugal in 1195 and had lived there until 1221. His status as a native of the Iberian peninsula encouraged a chauvinistic interest in his life and miracles, and artistic representations of him abounded, particularly after 1600. The most popular image of Saint Anthony was his vision of the Christ Child, an event which is supposed to have occurred when he was in France. This scene was chosen among many because it provided the opportunity to show a divine visitation to a man of faith, and thus illustrated a point—the rewards to the faithful—that the Counter-Reformation Church was always eager to make. Hence, although Saint Anthony had originally won fame as a preacher and worker of miracles, he ultimately became known as a visionary.

Zurbarán painted the subject at least four times, but this version is clearly the best. In fact, it offers a lucid insight into his special manner of painting celestial visions. The main part of the painting is a crisp, clear study of the saint at prayer. He is depicted as a young man with strong, plain features kneeling before a simple prie-dieu on top of which lie a lily and a book, his attributes. The forthright naturalism of this scene is interrupted by the apparition of a rather manly Christ Child amidst swirling brownish orange clouds. His presence is the source of the mellow light that floods the composition, a light that illuminates the saint's face and makes deep shadows between the ridges of his heavy Franciscan habit. Though the light is miraculous, its effects promote the realism of the saint and the still-life objects on the table before him. As a result of this light, the interpenetration of the celestial and terrestrial zones becomes complete, even though Zurbarán has refused to dramatize the encounter by means of exaggerated expressions or gestures. Indeed, the very lack of theatricality and the deliberate emotional restraint make the vision more lifelike and thus more accessible to the viewer.

In the distance is a small but extraordinary landscape, which echoes the somber mood of the main scene. The trees with dark green foliage are silhouetted against a faded pink and twilight sky. A large rock formation fills the otherwise empty scene. The soft, melancholy effect subtly reinforces the quiet but profound meeting between man and God.

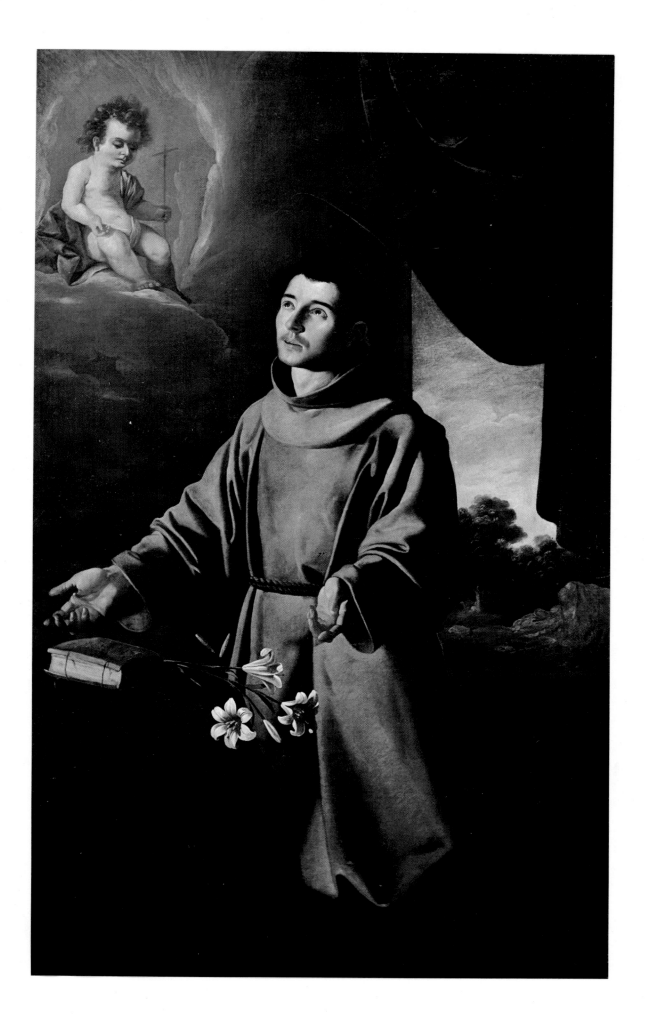

THE APOTHEOSIS OF SAINT

THOMAS AQUINAS

Signed and dated 1631

Oil on canvas, 15' 7" × 12' 3 5/8"

Museo Provincial de Bellas Artes, Seville

On January 21, 1631, Zurbarán signed a contract with the Dominican College of Santo Tomás de Aquino to execute a painting for the altarpiece of its small chapel. Under the terms, the iconography of the picture was to be prescribed by the rector of the college, and Zurbarán agreed to follow it faithfully. The result was a complicated subject that is only partially defined by its title. The picture serves two purposes: first, it glorifies the learned Dominican saint, Thomas Aquinas, by placing him among the four fathers of the Latin Church and under the protection of the Holy Spirit. Secondly, it commemorates the founding of the College of Santo Tomás in 1517 by the Dominican cardinal, Diego de Deza. He is shown kneeling to the left of a table on which the college charter is displayed, while opposite him is Charles I, friend of the cardinal and patron of the school. By implication, the painting emphasizes the intellectual attainments of the Dominican order as embodied by Thomas Aquinas and his successors.

The didactic intention of the painting imposed, above all, a need for clarity, despite the many figures it had to contain. Fortunately the dimensions of the canvas were enormous—it is Zurbarán's largest work—and the painter took the opportunity to produce one of his most powerful creations. The legibility of the composition was assured by reviving once more the vertical format used in the sixteenth and early seventeenth centuries in Seville. Here the surface is divided into two zones; below there is a terrestrial zone with an architectural background. Above it there is a heavenly region filled with clouds that is subdivided into larger and smaller bands. The resultant clarity is heightened by the symmetrical arrangement of the figures. On this lucid substructure Zurbarán imposed two rows of monumental human forms (and a third row of smaller forms) whose sheer size and rigorous simplicity lend immeasurable gravity and dignity to the painting.

But the real achievement of the picture is that it escapes being dull. Given its size and purpose, it could easily have gone the way of countless didactic works and become overbearing or boring. Zurbarán avoided this possible result by virtue of his sharp human characterizations and the brilliant use of color. On the lower level, we see men who worship and are respectful of the saints above them. These saints are the four fathers of the Latin Church (left to right, they are Saints Ambrose, Gregory, Jerome, and Augustine), among whom Saint Thomas takes his place as an equal. They are also personifications of learned authority, with their serious faces and slow, deliberate gestures. The weight of their learning is suggested by the massive robes. In their midst stands Saint Thomas Aquinas, holding his pen aloft and looking toward the Holy Dove as if receiving divine inspiration from above, where Christ and the Virgin Mary sit on the left, and Saint Paul and Saint Dominick on the right.

The solemnity of the event is emphasized by the magnificent costumes. Zurbarán had a remarkable talent for painting richly embroidered vestments and here he displays it without restraint. Saint Ambrose, seated on the left, wears a deep red and gold cope embroidered with standing figures along the inner edge. At the far right, Saint Augustine is dressed in a glittering gold cope which contrasts with the solid red of Saint Jerome's garment. Here and elsewhere the painting displays a chromatic richness that Zurbarán seldom equaled and never surpassed.

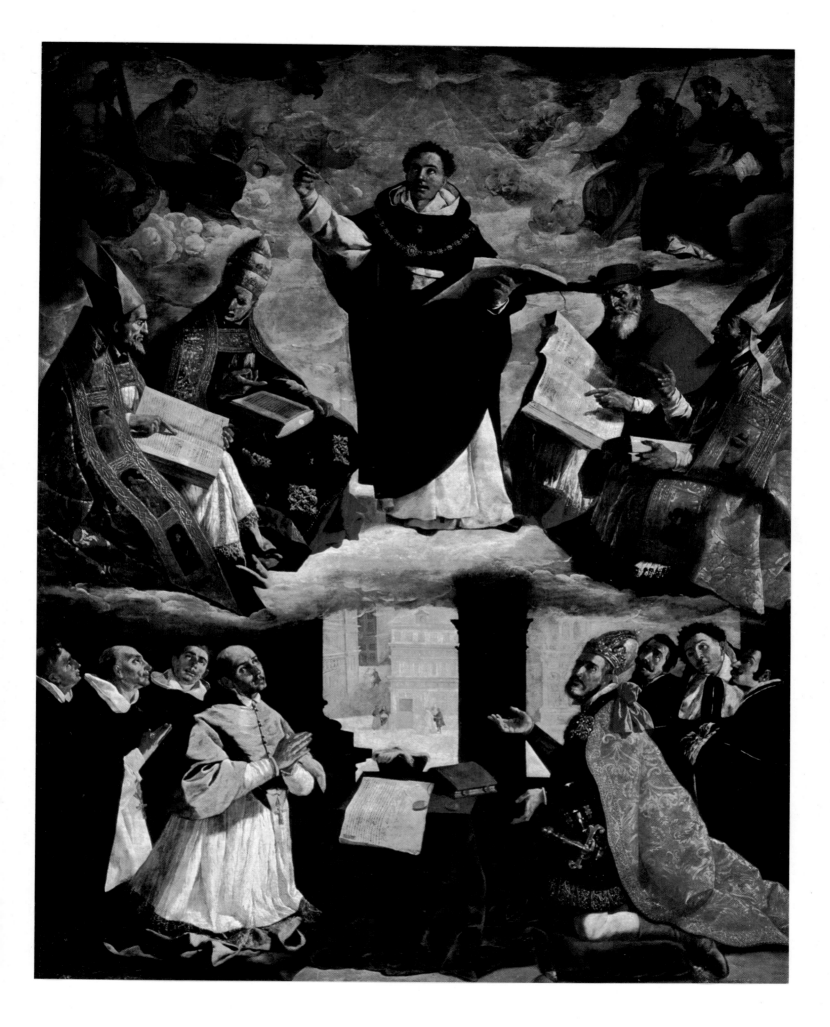

THE ARCHANGEL GABRIEL

c. 1631–32

Oil on canvas, 57 1/2 × 24"

Musée Fabre, Montpellier

The rugged monumentality of Zurbarán's monastic commissions has sometimes overshadowed his ability to paint with delicacy and charm. But from time to time there was an opportunity to depart from the stern and masculine themes of monastic history and to paint subjects that required elegant refinement. *The Archangel Gabriel* is such a picture and the first of a small number of superbly painted angels that he did in the course of his career. Originally the painting was in the Carmelite monastery of San Alberto in Seville, where it may have formed part of a small altarpiece in the church. Between 1629 and 1632, several painters of Seville, among them Francisco Pacheco and Alonso Cano, executed a number of altarpieces for the monastery's church. Zurbarán's work was mentioned briefly by eighteenth-century writers, but never described in detail. However, a group of homogeneous paintings, including this one, was appropriated in 1810 by the French General, Field Marshal Soult, during his systematic looting of Sevillian churches, and these paintings, about ten in number, must have been placed together in one or possibly two altarpieces in the church.

The Archangel Gabriel is akin to the lute player in *The Vision of Saint Alonso Rodríguez*, with its round, firmly modeled face that reflects light like a polished stone, except for a crescent shadow that falls on the right. But the impact of *Gabriel,* who is free from the distractions of a wider context, is greater. The painting is a coloristic tour de force. The imaginative colors of the robes vibrate against a blue gray sky. Gabriel wears a faded pink gown partially covered by a resplendent white tunic, which is gathered at the waist and held by a golden clasp. Behind the angel are gray wings heightened at the top by touches of white and ocher. Through their very unreality the phosphorescent colors convey the extraordinary quality of the angel who carried the Lord's message to the Virgin Mary. The strong effect of the colors is balanced by the pose and expression, which combine to impart an air of gentle piety. Gabriel walks forward at a slow pace and turns one palm upward, while in the other he holds a baton surmounted by the Virgin's monogram. The porcelainlike face is set in a serious expression and the eyes seem to search the heavens.

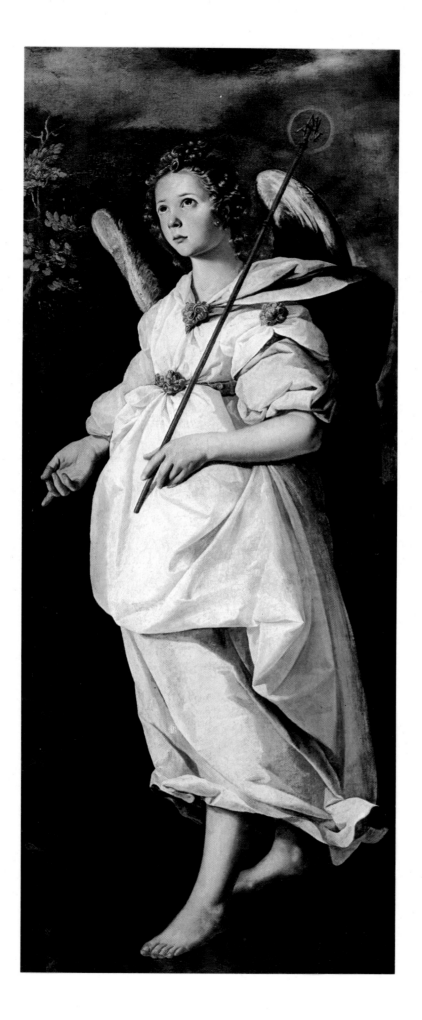

THE IMMACULATE CONCEPTION
WITH TWO YOUNG NOBLEMEN

Signed and dated 1632

Oil on canvas, 99 1/4 × 66 1/8"

Museo de Arte de Cataluña, Barcelona

For all its magnificence, *The Immaculate Conception with Two Young Noblemen* is a curiously anachronistic work. During the fifteenth and sixteenth centuries, paintings of the Virgin Immaculate were overloaded with hieroglyphic symbols that explained by analogy the belief that the Virgin had not been carnally conceived. The symbols were drawn from the Marian litanies, prayers that used Biblical metaphors to praise the Virgin's excellence and purity. At the beginning of the seventeenth century, however, painters began to seek ways to accommodate the symbolic apparatus within a more lifelike setting. In Seville both Velázquez and Pacheco, following Italian models, depicted a panoramic landscape beneath the Virgin's feet and covered it with the symbols that lent themselves to the natural setting. Zurbarán has adopted a compromise solution wherein some symbols are set artificially within compartments formed by clouds and others are used naturalistically in the landscape below.

On either side of the Virgin are *putti* who hold tablets engraved with fragmentary quotations from the litany that establish the Virgin's symbolic identity. "Who is she [*Quae est ista*] that looketh forth as the morning [*Aurora consurgens*], fair as the moon, clear as the sun, and terrible as an army with banners?" (Song of Solomon 6: 10) The reply is taken from Revelation 12: 1 and describes the central figure: "And there appeared a great wonder in heaven; a woman clothed with the sun, and the moon under her feet, and upon her head a crown of twelve stars." The *putti* hold additional symbols, the "lily among thorns" and the "rose of Sharon" described in the Song of Solomon 2: 1–2. Beneath them are a stepladder and a portico, which liken the Virgin to a stairway and gateway to heaven. In the bottom compartments are the "spotless mirror" and the "star of the seas." The arrangement of these objects in the sky defeats the naturalistic treatment of the symbols in the landscape—the "enclosed garden," the "fountain of gardens," a "well of living waters," all derived from chapter four of the Song of Solomon.

Two young boys kneel on the ground before the Virgin and look up at her with reverence. Although their identity is not known, it has been reasonably suggested that they were the first- and second-born sons of a noble family. They are distinguished by the hats that rest on the ground before them. The priest's hat on the right signals the secondborn, the sons who often joined the clergy, while the firstborn, indicated by his secular hat, inherited the family title. Words from the hymn *Ave Maris Stella* come from their mouths, almost as if this were a medieval painting. Indeed, this practice rarely occurred in the seventeenth century because it negated an illusion of nature. This glaring anachronism may have been dictated by the patron, but Zurbarán was responsible for the rest of the composition because he had used it in two other contemporary versions of the subject (The Prado, Madrid; and Jadraque, fig. 19). As a result, the painting emphasizes the central paradox of Zurbarán's art of this time—a conservative manner of composition with an advanced technique of naturalistic painting.

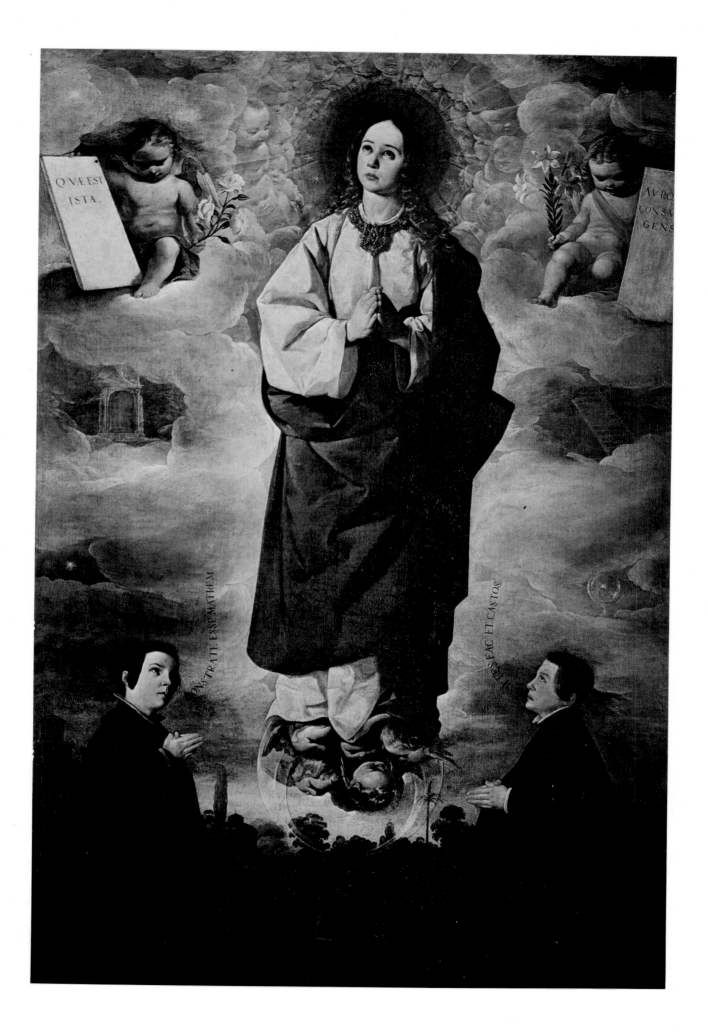

THE IMMACULATE CONCEPTION

WITH TWO YOUNG NOBLEMEN (*detail*)

As Zurbarán's art developed, he became increasingly bold in his use of landscape. His willingness to expand its function must, in some measure, be related to the mastery that he gained in rendering the illusion of space. But he also needed time to develop a conception of landscape, and in his paintings in the early 1630s he evolved the formula that he repeated in later years. As an experiment, Zurbarán sometimes used paintings of the Immaculate Conception, where the symbols could be fitted into a landscape background. Before painting this picture, Zurbarán had completed two versions of the theme that contain significant landscape passages. In the first, now in the Prado, the landscape area is only timidly painted. But *The Immaculate Conception* painted for Seville's city hall (fig. 19) contains a sweeping panorama of Seville on one side and a detailed view of an enclosed garden on the other, separated by a body of water. In addition to these partial landscapes, Zurbarán also attempted a full-scale landscape in the background of *The Vision of Saint John the Baptist,* painted in the early 1630s (fig. 28). By the time Zurbarán painted *The Immaculate Conception with Two Young Noblemen,* he had arrived at his definitive formula.

Zurbarán's landscapes are not pictures of places. There is little to connect them with either Extremadura or Andalusia. Rather, he sought inspiration in works by other painters, especially Flemish painters who worked in Seville during the sixteenth century. In Pieter Kempeneer's *Descent from the Cross* (Musée Fabre, Montpellier), painted in the 1540s, we find a point of departure. The predominantly blue green tonality, the limpid atmosphere, and the buildings randomly scattered throughout the landscape, all these elements were absorbed by Zurbarán and remained with him throughout his life. He subsequently expanded this repertory by adding trees and rocks to form a stock of landscape components that were combined as the necessity arose. The notion of the *paysage composé* was widely held during this period, when little landscape painting was derived directly from nature and when each master evolved a series of conventions to answer his needs.

In this painting, Zurbarán has produced a sophisticated landscape that marks his initial conquest of the genre. The symbolic function of the landscape dictated the presence of many objects in it—the well, the fountain, the temple, the cypress, and the palm were all inspired by the Marian litanies. This disparate collection of motifs is unified by color and light. The landscape is bathed in a melancholy twilight that turns the earth dark brown and the foliage deep green, except for a burst of orange autumn leaves far in the background. The wan yellow sky lights the tallest trees from behind and makes them translucent. The landscape, like the superb cluster of *putti* heads, mirrors the calm and serious tone of the painting.

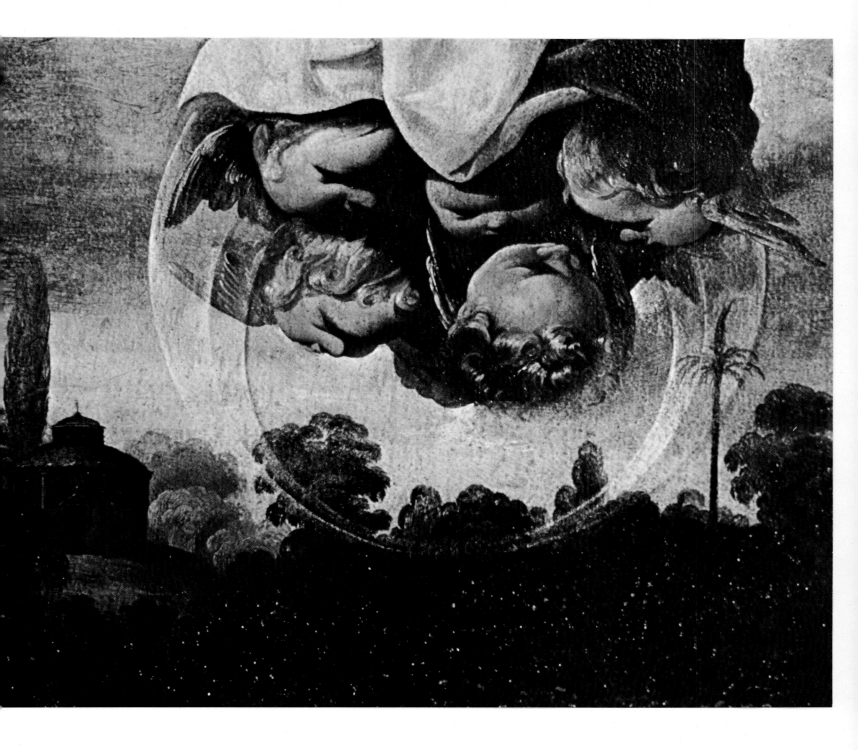

THE YOUNG VIRGIN PRAYING

c. 1632–33

Oil on canvas, 46 1/8 × 37″

The Metropolitan Museum of Art, New York City

Fletcher Fund, 1927

The theme of the young Virgin at prayer is based on the apocryphal writings that were elaborated throughout the Middle Ages in order to supplement the evangelical narratives. The four Gospels contained only the briefest references to the Virgin's life before her marriage to Joseph. As the cult of her worship grew, so did the curiosity about the details of her early life, and later authors supplemented the original texts by inventing the story of her childhood. According to these uncanonical but influential legends, the Virgin as a young girl had lived in the Temple in Jerusalem, where she spent the time in prayer and in sewing such things as priestly vestments. This episode from her life, which was occasionally depicted in the Late Middle Ages, was revived in the seventeenth century when Catholic devotion took a popular turn.

In this painting, Zurbarán has taken the apocryphal story only as a point of departure for a considerably more complex idea. The Virgin is seated on the floor with her embroidery on her lap, but she has interrupted her work for a moment of prayer. Up to this point, Zurbarán has obeyed the usual conventions for the scene. However, he then proceeded to abstract the scene from its narrative format and to convert it into a devotional picture with marked theatrical overtones. The pink curtains that hang in the corners are obvious clues to the alteration in intent. Somewhat less conspicuous is the ledge that is formed by the dark area running along the lower edge of the canvas. Although it may at first appear to be a shadow, there is no object in the picture that could produce one of such a width and length. Hence it must be interpreted as a forestage. The introduction of these two elements changes the picture from an illustration into a theatrical tableau, and this helps to explain the studied appearance of the still-life objects that surround the young Virgin. They are like stage props that lend a realistic touch to the episode. In his usual fashion, Zurbarán has brought the minor objects to a high degree of finish, and placed them with a deliberateness that appears to elevate them from the mundane to the divine. But the temptation to interpret them symbolically must be resisted. Only the lilies and the roses, traditional attributes of the Virgin, carry a second meaning.

Zurbarán has theatricalized the scene for a simple reason—to increase its effect on the viewer. It may seem contradictory first to secularize a divinity and then to place her on a stage where she again becomes remote. But the painter was following an accepted Baroque convention that sought to achieve the powerful if illusory reality of the theater in works of painting and sculpture. When the curtain was raised, as it has been here, the audience suspended its disbelief and accepted an illusion as reality.

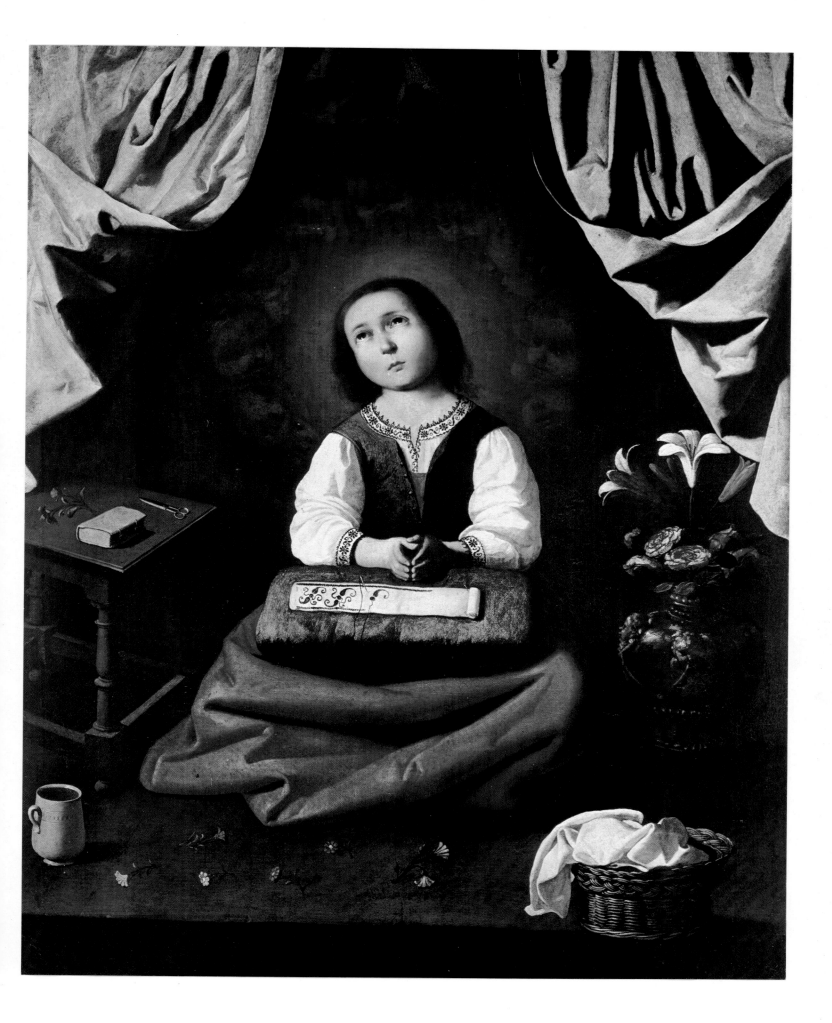

THE YOUNG VIRGIN PRAYING (*detail*)

One of Zurbarán's great, unfailing strengths was his ability to invest small things with an uncanny sense of presence. Instead of subordinating details to the demands of compositional unity, Zurbarán chose to study and analyze them with such close attention that they became conspicuous parts of the painting. Under his microscopic eye, the data of reality were closely recorded so that their inherent grandeur became marvelously apparent.

The Young Virgin Praying contains several superb still-life passages. Zurbarán's insistence upon surrounding each thing with its own space permits him to analyze each of them minutely. The tiny blue and yellow flowers in front of the Virgin have been arranged independently of each other. The scissors, book, and sprig of flowers are laid upon the table without overlapping, as if each had a place prescribed by law. The meticulous attention to detail is especially apparent in the sewing basket, placed in the lower right corner. It is first of all a patient factual study; every plait of straw, every wrinkle and fold of the white cloth have been carefully delineated. Where another artist might have abbreviated the basket and cloth with quick impasto strokes, Zurbarán painstakingly reproduced these objects as they were made. At the same time, he avoided pure and possibly boring literalness by varying the surfaces with the play of light and shadow. A strong beam of light enters the picture from the left and strikes the basket with its full force, making the weave of the straw and the whiteness of the cloth stand out. Halfway around the basket the light starts to fade, finally to disappear, so that the pattern becomes almost invisible and the cloth turns gray in the shadows. In this way, Zurbarán has added the illusion of volume to the reality of surface and produced a small but lasting triumph of the still-life painter's art.

STILL LIFE WITH ORANGES, LEMONS, AND A CUP OF WATER

Signed and dated 1633

Oil on canvas, 23 5/8 × 42 1/8"

The Norton Simon Foundation

The independent still life played a very minor role in Zurbarán's art. No more than a handful have been plausibly attributed to him and, of these, only this painting, which he signed and dated, has been universally accepted. Why this limited production in a genre for which Zurbarán's talents were so manifestly suited? The answer may lie in the fact that still life was then considered to be inferior to figure painting. By contemporary definition, only those artists who lacked the skill and ambition to work in the more demanding genre, and who sought easy success by painting an appealing but insignificant subject, devoted their energies to still life. The painter-theorist Francisco Pacheco expressed this attitude in his treatise, *El arte de la pintura,* published in Seville in 1649. Speaking of flower painters, he says, "These days there is no lack of those who enjoy this kind of painting because it is easy to do and causes delight by its variety." Those who paint pictures of fruit "follow the same road, although it does require more skill . . . if it is to be used in serious history painting" (Book 3, chapter 7).

It is hard for us to accept Zurbarán's magnificent still life as a trivial work of art. Indeed, it is now acknowledged as one of his masterpieces. Even to the casual viewer, it generates a power totally out of proportion to its unpretentious subject matter. Zurbarán has seemingly elevated humble objects to a higher plane of reality, and this impression has led some writers to interpret the fruit and the cup of water as religious symbols or votive offerings. In the absence of any overt symbolic intent, it is perhaps better to see the work through Pacheco's eyes as a showpiece of artistic virtuosity that figure painters occasionally undertook for the sake of amusement. This does not mean that Zurbarán did not take it seriously. Its every aspect has been calculated to produce the effect of nature raised by artifice to a higher power.

The contents of the painting are simple enough: four lemons on a pewter plate, a basket of oranges with a sprig of blossoms, a cup of water and a rose on a pewter saucer. Zurbarán has placed these elements on a narrow ledge with the deliberateness of a chess player making a move. Each has its sovereign space and thus projects its presence without interference from the others. The strict horizontal rhythm partly accounts for the air of gravity and solemnity that pervades the painting. Then a strong light enters from the left and makes the shapes, colors, and textures seem so real that we are almost forced to grasp and contrast them in our minds. However, by an inexplicable suspension of natural law, the light beam fails to penetrate the background and the resultant contrast of the darkness to the brightly lit objects increases their sense of volume. Once again Zurbarán has taken us through his art from the real to the superreal and invested the commonplace with the extraordinary.

BROTHER JERÓNIMO PÉREZ

c. 1633–34

Oil on canvas, 80 1/4 × 48"

Academia de San Fernando, Madrid

Brother Jerónimo Pérez is the most successful variation on the theme of the standing Mercedarian scholar, eleven of which were commissioned by the Merced Calzada for the decoration of their library. Although the history of this commission has yet to be discovered, it must have been the consequence of Zurbarán's success in painting the life of Saint Peter Nolasco for the order, which he began in 1628. The new scheme was meant to commemorate the order's tradition of learning by depicting a group of its distinguished scholars and preachers, most of whom had lived during the sixteenth century. In fact, only one of the monks, Brother Hernando de Santiago, was alive at the time to pose for his portrait. The others were painted from anonymous models, although paradoxically they are more lively than the portrait of Santiago. Undoubtedly Zurbarán felt freer to alter the appearance of the imaginary portraits, whose subjects were no longer alive to verify his accuracy in depicting them.

Although only half of the portraits have survived, they are sufficient to demonstrate the main challenge of the commission—variety. The format was so simple that the paintings could easily have become monotonous. Each figure is clad in the white habit of the order and stands in a shallow space against a dark background. To one side is a small table, usually with a book and an ecclesiastical hat on it. Zurbarán attempted to diversify the group by showing some of the men writing while others hold their pens aloft and look upward for inspiration. The results were somewhat uneven; two or three are superb, the others rather ordinary, though of course the active participation of his workshop was responsible for some of the weaker moments. *Brother Jerónimo Pérez*, a professor of theology at the University of Valencia, is the most interesting and subtle characterization.

The monk is wrapped in voluminous robes which are composed of three different garments—a gown is covered by a long cape and over both a hood has been placed that covers the head and chest. The smooth surface of the hood and gown increase the sculptural effect of the cape, which breaks into a series of uneven folds on the right. From this whiteness emerge the face and hands, through which Zurbarán expresses the scholar's character. His beautifully modeled hands hold pen and book, but from the look on his face he has stopped his writing in order to reflect. His equivocal expression is intensified by the hood that outlines his face in a swelling, symmetrical curve. Whatever thought is in his mind, it has made the monk unconscious of the outside world. His eyes are vague and unfocused, as if their powers of seeing had been directed entirely inward. The expression is ultimately an unquiet one and displays an ambiguity seldom found in Zurbarán's paintings.

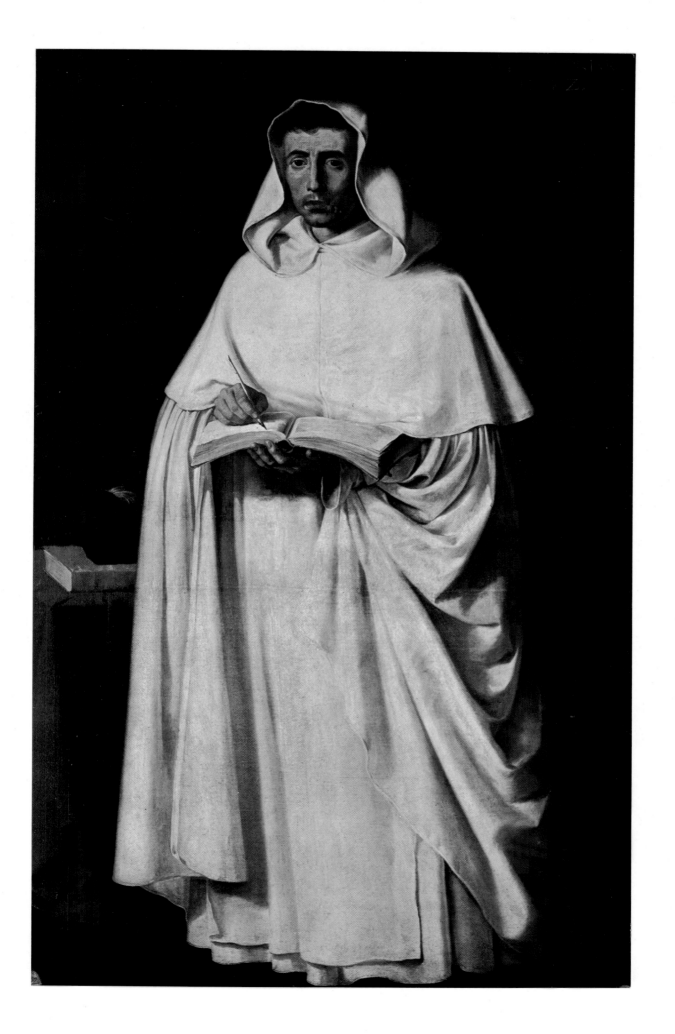

THE DEATH OF HERCULES

1634

Oil on canvas, 53 1/2 × 65 3/4"

The Prado, Madrid

The "Labors of Hercules" are very difficult works to evaluate. By definition, they had to be action pictures in which Hercules engaged in feats of violent combat and impressive strength. And Hercules had to be painted in the nude, as befitted an ancient hero. These requirements posed a problem for Zurbarán, who had become a specialist in religious, and particularly monastic, subjects, where stationary, fully dressed figures were the rule. Without experience to guide him, Zurbarán turned to prints by Northern masters as sources for his compositions. However, these prints provided only a partial solution because they tended to offer exaggerated, overdeveloped examples of the classical ideal nude. Zurbarán sought to temper the distortions by making fresh observations of human figures and expressions, and at times succeeded in producing a markedly personal synthesis of the two.

The Death of Hercules is one of the outstanding episodes in the cycle. As represented here, it amalgamates two episodes of the story. Hercules's death was caused when he put on a robe that his wife, Deianira, had unwittingly poisoned by soaking it in the blood of the centaur Nessus. Earlier, Hercules had slain Nessus with a poisoned arrow when he had attempted to abduct his wife. In the background, the sketchy figure of Nessus is shown just after he has been shot with the arrow, while in the foreground, Hercules destroys himself by fire in order to escape the unbearable pain caused by the poisoned robe.

Zurbarán based his representation of Hercules's death agony on a print of the same subject by Gabriel Salmon, a sixteenth-century French artist (fig. 23). However, he vitalized the rather schematic print in a number of ways. Most important was the use of color. The scene was set against a murky green background that provided a perfect foil for the bright yellow orange flames that leap from the burning robe. Then, by turning Hercules's body to one side, the sweep of the dying, desperate gesture became more emphatic. The revised position also permitted Zurbarán to use the contrast of light and dark, thus increasing the impact. *The Death of Hercules* shows Zurbarán rising to meet a fresh challenge with an unexpected talent for melodrama.

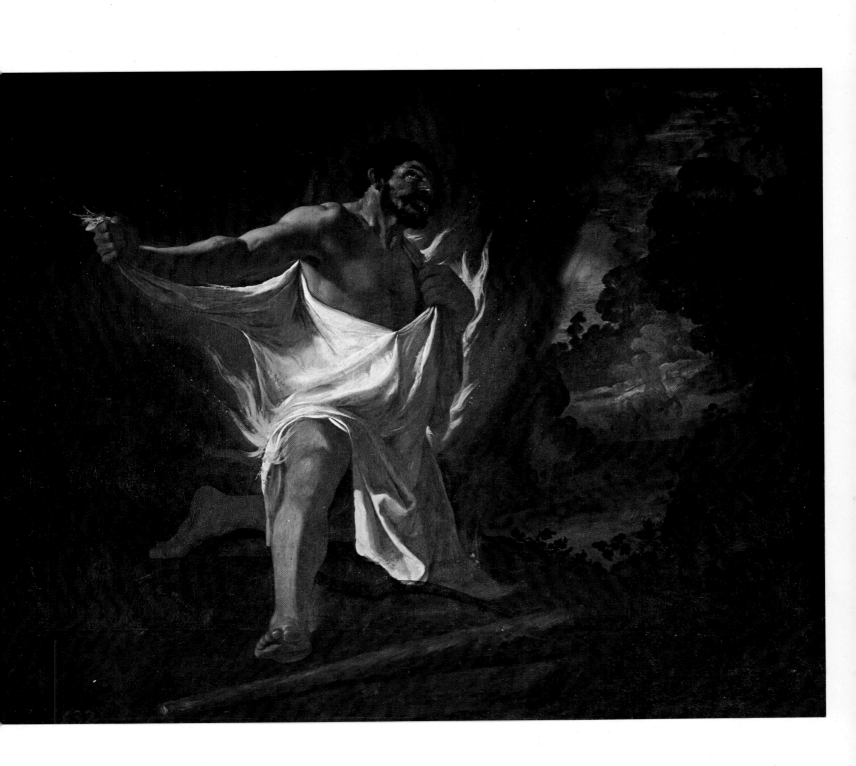

SAINT MARGARET

c. 1634–35

Oil on canvas, 76 3/8 × 44 1/8"

The National Gallery, London

Zurbarán's imaginary portraits of virgin martyrs in contemporary dress occupy a special place in his art. They form one of its most immediately appealing subjects and, together with the still lifes, provide a counterweight to his sober, monumental religious paintings. Their success is based not only on their inherently pleasing theme but also on Zurbarán's talent for creating a graceful, reserved version of a traditional Christian subject.

The origin of the motif has been hypothetically traced to several sources. It has been suggested by Emilio Orozco Díaz, for example, that the virgin martyrs are allegorical portraits of noblewomen, rather in the vein of eighteenth-century portraits in which aristocratic ladies were depicted dressed as pagan goddesses or muses. Because several of them appear to be walking, they have also been interpreted as representations of religious processions that occurred in Seville on holy days. And finally they have been construed as contemporary versions of Flemish and Dutch prints, where the subject enjoyed a certain popularity during the sixteenth century. These hypotheses overlook the fact that the motif was among the most common in Christian art and can be traced in an unbroken line from Early Christian art through the Renaissance.

In Seville, during the sixteenth century, the subject appeared in paintings by Alejo Fernández (1470–1543) and Hernando Sturm. In the early seventeenth century, Francisco Pacheco made a drawing of *Saint Lucy* (Uffizi, Florence), signed and dated November 12, 1612, which indicated that the idea was current in Sevillian art in the years immediately preceding Zurbarán's arrival there. Works like these may have been in Zurbarán's mind when he painted the theme for the first time in the early 1630s, but the very popularity of the subject defeats any attempt to be precise about his sources.

The virgin martyrs were painted for a variety of purposes. Some were installed in altarpieces; others, such as *Saint Margaret*, may have been independent devotional pictures. But the majority appear to have been grouped in series and hung in churches, particularly along the nave walls, where they appeared to be in procession toward the altar. One set of saints painted by a follower of Zurbarán has survived in place (Santa Clara, Carmona), and illustrates how they were originally arranged in a manner that resembles the sixth-century mosaics of Sant'Apollinare Nuovo in Ravenna. The resemblance is a coincidence, but it points to the antiquity of the general idea.

Saint Margaret is one of Zurbarán's best renditions of the virgin martyr. Her face has not only beauty but strength, and her pose conveys understated resolve. Thus she seems to possess the quiet confidence of a martyr of the faith. Her attractiveness is enhanced by a rustic costume with the jaunty straw hat and the shepherd's crook, which are attributes of her occupation. Behind her is a brownish green monster with open jaws, the beast that visited her in captivity and tried to swallow her (according to some accounts he succeeded), but was overcome when Margaret made the sign of the Cross. The serpentine body ends in a capricious double curve which furnishes an appropriate coda to the delightful artifice of the painting.

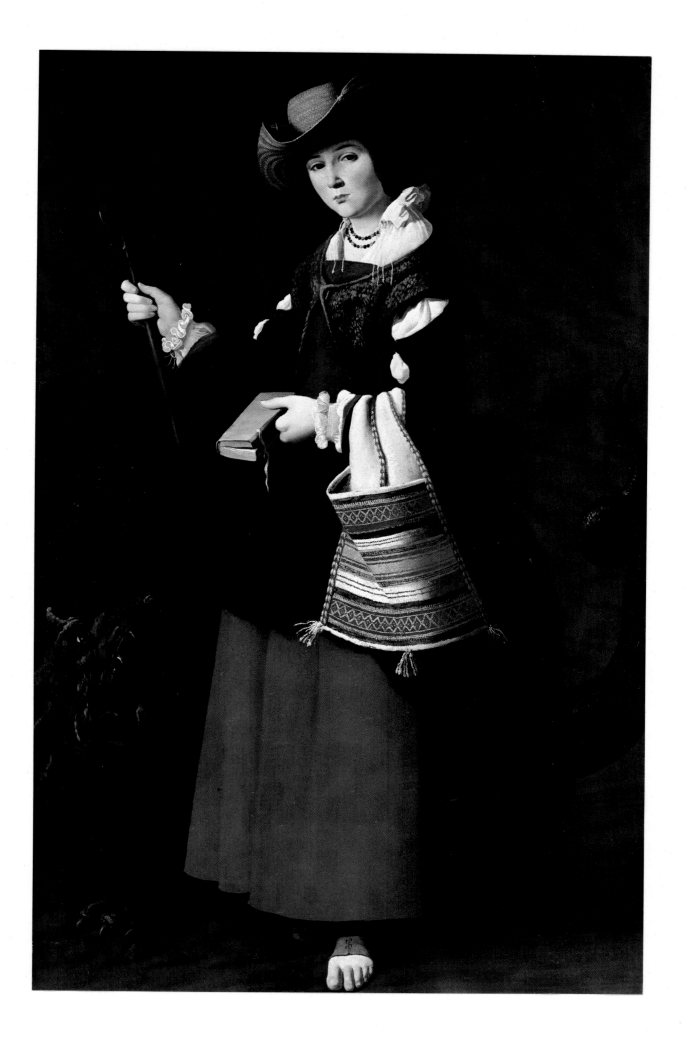

SAINT MARGARET (*detail*)

The ornate, colorful garments worn by Zurbarán's virgin martyrs are largely responsible for their irresistible charm. The idea of a fourth-century saint, like Saint Margaret, wearing a seventeenth-century costume seems to secularize the figure and to make it more immediate. Although the fidelity of their clothing to contemporary fashion has sometimes been doubted, María J. Sáez Piñuela, an historian of Spanish costume, has established that Zurbarán followed the prevailing style of formal dress, with its tightly suppressed bustline contrasting with wide, voluminous skirts.

Saint Margaret is an obvious exception to these fashion plates. Zurbarán has taken account of her occupation as shepherdess and painted her in rustic garb *a la campesina*, although he has prettified a peasant's clothes by omitting or refining their rougher elements. Consequently, *Saint Margaret* looks more like a noblewoman playing at being a shepherdess than a keeper of sheep. The aristocratic style of her clothing is evident in the straw hat with its broad brim bent into a swooping curve. This dashing headpiece is a version in humble material of the hat that seventeenth-century Spanish noblewomen wore on outings to the countryside. In addition, the necklace of coral and jet and the delicately frilled collar and cuffs are more appropriate to a charade than to the hard outdoor life of a shepherdess.

The cloth saddlebags are the final stroke of mock folkloristic grace. They are casually slung over the saint's arm so that the bright bands of yellow, white, and red contrast with the dark blue jacket that appears beneath. Zurbarán has taken great care to re-create the smallest details of pattern and texture. The rough nap of the coarse wool, the heavy stitches, the diamond-shaped pattern with tiny dots within, the varying widths of the bands and their differences of color, the tassels at the bottom—all these impart an astonishing illusion of the peasant-weaver's craft.

ALONSO VERDUGO DE ALBORNOZ

Signed; datable c. 1635

Oil on canvas, 72 7/8 × 40 1/2"

Dahlem Museum, West Berlin

Alonso Verdugo de Albornoz shows Zurbarán at the peak of his power as a portrait painter. It is a sharp, arresting, and commanding image, with the small form highlighted against a black background and a dark brown floor. The young boy—an inscription in the lower right corner gives his age as twelve years—strikes a formal pose, with one hand holding a baton, the other resting on the hilt of his sword. His gaze is intent and serious, and the subdued, somber colors emphasize the sobriety of the portrait. Only the red sash across his breast relieves the dark tones of gray and brown. The reason for the exceptional seriousness is found in the circumstances that precipitated the commission.

The portrait was painted to commemorate the appointment of Alonso Verdugo (1623–1695) as a captain of the Mounted Lancers in his home guard at Carmona, a town near Seville. His military status explains his costume and attributes: the armored breastplate, the sword, the commander's baton, and the red sash, which indicates his rank. The precocious elevation to high military office was arranged by an uncle, Cardinal Gil de Albornoz, who was then a powerful person in the royal court. The cardinal also nominated his nephew to the prestigious military Order of Alcántara, whose insignia is painted on the breastplate and under Alonso Verdugo's coat of arms in the upper right corner. Such appointments were by no means unusual at the time, when aristocratic families, and even wealthy commoners, could purchase military and civil offices offered for sale by a bankrupt government.

Zurbarán perforce has taken the event seriously and presented the captain with the dignity appropriate to his new status. The stance is an adaptation of a pose that was frequently employed in Spanish royal portraiture. Zurbarán, who had recently returned from Madrid, would have had the image fresh in his mind, especially after having seen it in portraits by Velázquez. But the latter's free manner of painting seems to have had no effect on Zurbarán. The portrait has been polished to a high degree of finish and resembles Velázquez's work of the 1620s more than of the 1630s. Zurbarán has made a small but important addition to the traditional format by painting a ledge across the bottom of the picture. This converts the ground into a slightly raised platform and reinforces the impression of authority and power that Zurbarán has conferred upon the juvenile commander.

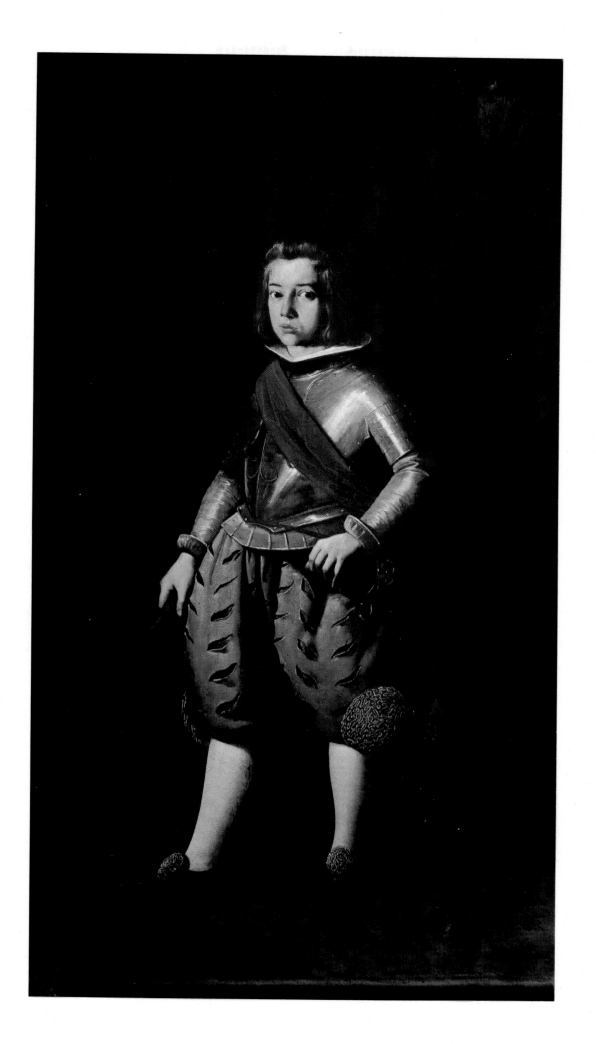

STILL LIFE WITH JARS

c. 1635

Oil on canvas, 18 1/8 × 33 1/8"

The Prado, Madrid

The attribution of still-life paintings to Zurbarán has been one of the most vexing questions of his art. Although his production in this genre was very limited, it inspired a large number of mostly anonymous followers. These artists were both fascinated and deceived by the elegant simplicity of Zurbarán's formula, which required only a narrow ledge on which a few well-lit objects were placed against a dark background. Zurbarán himself arrived at the scheme by refining an idea that was used by Juan Sánchez Cotán, who painted a few brilliant still lifes in the first years of the seventeenth century. Cotán's paintings relied on the strong contrast between illuminated objects and dark backgrounds within a shallow space, but his compositions were usually more complicated than Zurbarán's. By reducing the number of objects in the composition, Zurbarán was able to concentrate on their texture and form, and to relate them to each other with simplicity and directness. The artists who followed Zurbarán's example usually underestimated its difficulties, or were unable to realize its subtleties. With so few elements in the painting, there was little room for error. Usually followers betray themselves by small but significant false steps—cluttered or poorly arranged compositions, unconvincing illusions of volume and texture being most often encountered. Only one painter came close to duplicating the master's style, his son Juan.

In recent years, the artistic personality of Zurbarán's ill-fated son (he died at the age of twenty-nine in the plague of 1649) has become increasingly well defined. There remains, however, a shadowy area where his style is difficult to separate from that of his father. All the paintings that fall into this category are still lifes, in which Juan seems to have specialized, and the *Still Life with Jars* is the most important disputed work. The critics who see the hand of Juan de Zurbarán in this picture detect a sense of form that does not quite reach the level of the *Still Life with Oranges, Lemons, and a Cup of Water* (colorplate 20). In fact, the vases do not seem to have the well-rounded fullness of the fruit in the signed and dated still life, and perhaps they do not appear to rest as securely on the shallow ledge. But the picture also evinces subtleties of composition and texture which surpass any still life surely attributable to Juan. On one level, the painting is a skillful study of the varying effects of light when it strikes different surfaces—in this case metal and pottery, which is both painted and unpainted, glazed and unglazed. The author of this still life has rendered these different values sensitively, deftly capturing the resultant effects of texture. Furthermore, the composition places objects of different height and width in a satisfying pattern. Was the picture, then, done by Zurbarán at a level slightly below his best, or by Juan at a level considerably above his best? If this is a fair way of posing the question, then the attribution to the father is the inevitable answer.

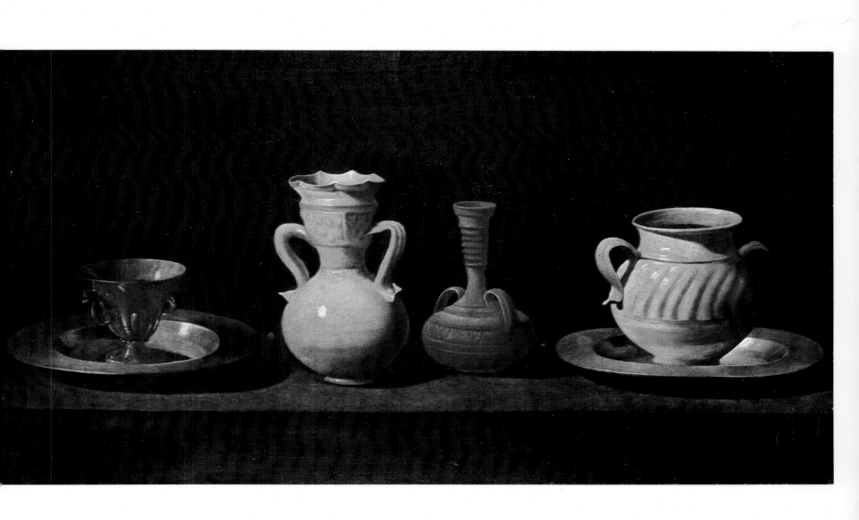

THE VEIL OF SAINT VERONICA

c. 1635

Oil on canvas, 27 1/2 × 20 1/8″

National Museum, Stockholm

The Veil of Saint Veronica is a tour de force of illusionistic painting, a sacred "*trompe l'oeil*," as it has aptly been called. During the 1630s, Zurbarán painted at least a half-dozen versions of it, which in turn inspired numerous imitations by other artists. His frequent repetition of the theme is unusual because it was not often used by seventeenth-century painters. In fact, the motif enjoyed its greatest popularity in the Late Middle Ages. Veronica was one of the minor characters cast in the drama of the Passion in order to satisfy an insatiable appetite for detail about the event. She entered the scene when she offered Christ a cloth to wipe the sweat and blood from His face as He toiled up the hill of Calvary. When He returned the cloth to Veronica, His image had been miraculously imprinted upon it. In the Middle Ages, the supposed cloth became a venerated relic, the *vera icon* or true image, from which Veronica's name was derived. Late medieval artists removed Veronica from the narrative sequence and depicted her alone, holding the holy cloth with Christ's image before her. This format continued to be used during the fifteenth and into the sixteenth centuries, when the image became further simplified. In 1513, Albrecht Dürer made a print in which Veronica was omitted altogether and the veil was held by two angels. Finally, in the late sixteenth century, El Greco reduced the image again and painted the veil by itself, attached to a dark background by nails.

Zurbarán's painting is based on El Greco's composition, in which we see the veil as it might have appeared hanging in a reliquary. Zurbarán wants us to believe, if only for an instant, that the cloth has materialized before our eyes, and he has gone to extraordinary lengths to make the illusion a convincing one. The veil is illuminated by a strong light, which creates shadows in the folds that impart a sense of relief. The nailheads, painted in the upper corners, apparently fasten the cloth to the background. The black border around the sheet forces us to identify the flatness of the canvas with the flatness of a wall, and this makes the illusion of the cloth come alive.

Christ's face is painted faintly with light yellow and brown tones that make it appear to dissolve into the cloth. It has the fugitive quality of a face whose transfer has been miraculously effected with an ink of blood and water, and marks a great advance over earlier versions where it was rendered in sharp, clear detail. Thus Zurbarán has spectacularly realized the divine relic by following accepted Baroque illusionistic conventions. But he has not sacrificed dignity for realism. By giving the cloth a nearly symmetrical form, and by making a gablelike fold over the face of Christ, he has subtly provided a dignified setting for the holy image.

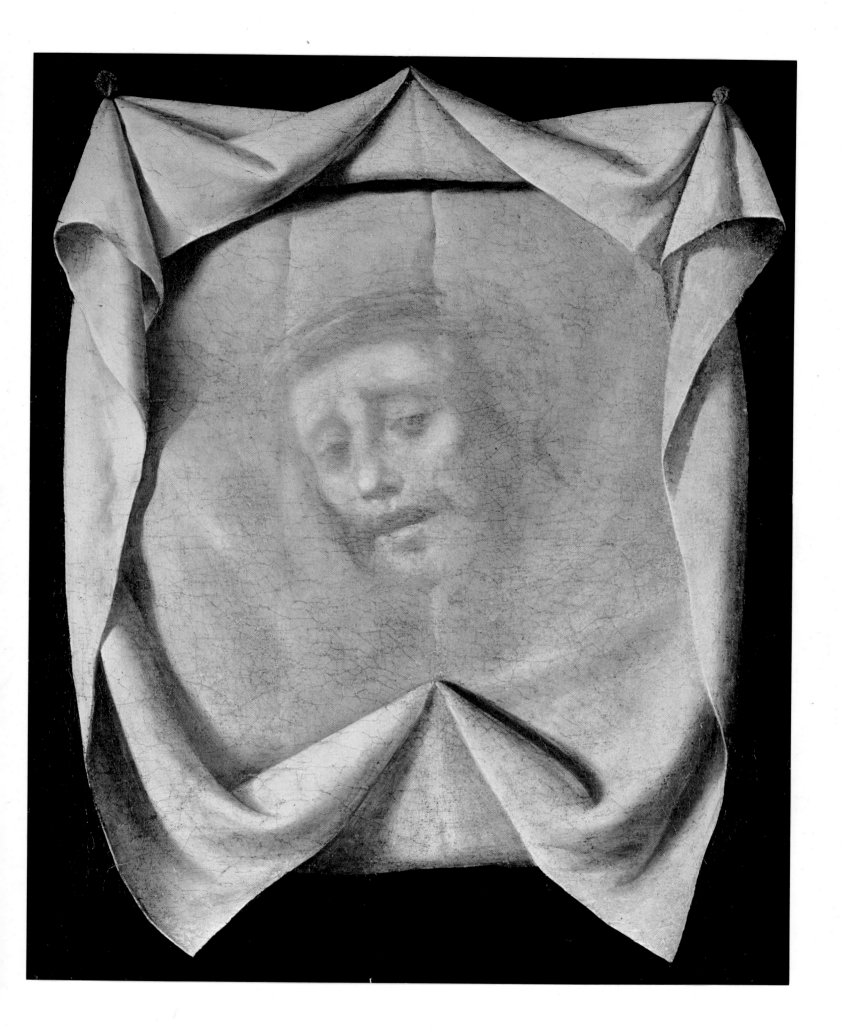

THE BATTLE OF CHRISTIANS AND MOORS AT EL SOTILLO

c. 1638

Oil on canvas, 10' 11 7/8" × 6' 3 1/4"

The Metropolitan Museum of Art, New York City

Kretschmar Fund, 1920

This large, impressive picture originally formed part of the altarpiece in the Carthusian church at Jerez de la Frontera (see fig. 39). The inclusion of a battle scene in the midst of paintings of the Nativity at first seems incongruous. However, it was meant to commemorate the monks' veneration of an important local miracle. In 1370, a battle occurred between the Christians and Moors near the small hermitage church at El Sotillo, a place in the outskirts of Jerez. The Moors had planned a nighttime ambush, using a forest behind the little church as cover. As the Spaniards approached the place, a miraculous light illuminated the landscape, revealing the hidden enemy. In the ensuing battle, the Moors were defeated and afterward the miracle was credited to the intercession of Our Lady of Protection, who appears with the Christ Child in the clouds above. Two centuries later, when the Carthusians decided to build a monastery in Jerez, they selected a spot near the famous battleground and named the monastery Nuestra Señora de la Defensión in honor of the Virgin.

This unique subject posed two difficult problems that were intensified by the fact that the picture was to be set in an altarpiece which could be seen only at a distance. The first problem was how to paint the multifigured battle scene without sacrificing clarity, and second, how to represent a night scene that would still be easily visible. Zurbarán solved the first problem by conceiving the battle as a grand set piece, enacted as a ritual, rather than as a violent, confusing clash of arms. The stage-like presentation is introduced by a large, mustachioed pikeman, who directs our attention to the conflict. Behind him is a cluster of soldiers who also point to the battle with long-handled pikes. Three successive moments of the skirmish unfold on the distant battleground. In the foreground, the Spanish cavalry, having discovered the hidden Moors, charges forward. Then contact is made between the opposing forces, resulting finally in the rout of the Moors, who run for cover in the trees where some still hide. This bold, lucid composition ensured that the significance and progress of the battle could be perceived even from the rear of the church.

The second problem was overcome by a simple but striking color harmony. Night is represented by a dark green tonality that is divided into several shades—lighter on the ground, darker in the trees, and becoming almost black in the distant mountains that close the scene. Against the overall darkness the radiant colors of the Virgin and Child and their angelic consort acquire meaning and visual splendor. She is the light, and from her presence radiate golden beams that illuminate the scene below and make Christian victory possible. Her voluminous aquamarine robe and the pinkish purple dress beneath it are the brightest patches in the picture and thus draw our attention immediately and repeatedly to her presence.

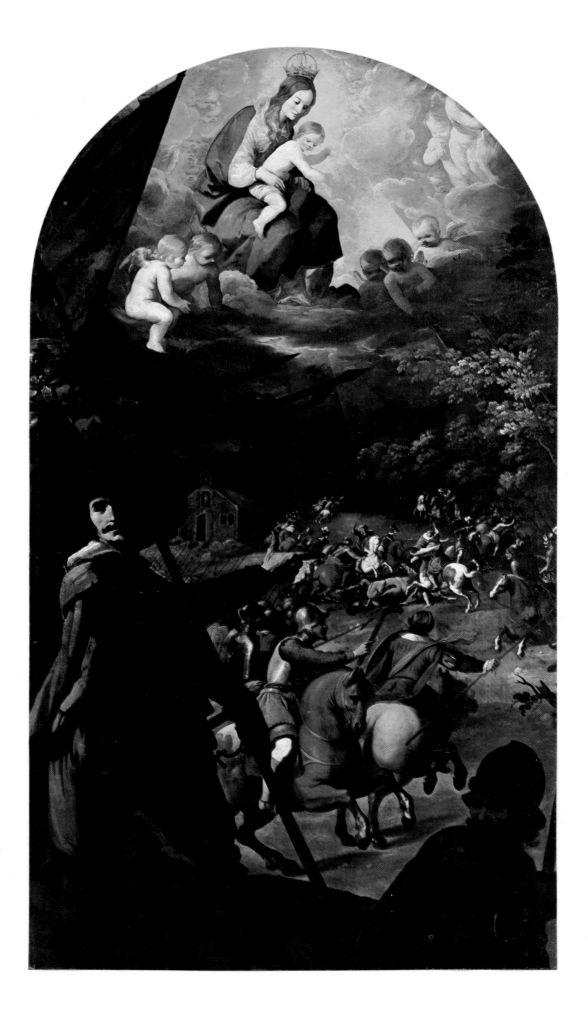

THE ANNUNCIATION

1638–39

Oil on canvas, 8' 6 3/4" × 5' 8 7/8"

Musée de Peinture et de Sculpture, Grenoble

The large commissions that Zurbarán painted in 1638–39 for the Carthusians in Jerez de la Frontera and the Jeronymites in Guadalupe have long been considered the culminating moments in his artistic career. This evaluation is somewhat misleading and imprecise. It misleads because it implies that these pictures represent the conclusion of Zurbarán's active quest for vital artistic expression, and that everything that followed was in some way inferior. And it is imprecise because it suggests that every aspect of his style reached its highest level here, whereas years would pass before he found the answers to many of the questions that interested him. Zurbarán did paint some of his finest pictures for the two monasteries, but their excellence, in terms of his art, is not universal but particular. Above all, they display unrivaled brilliance of color and unparalleled understanding of the monastic spirit. If superlatives are to be used, the paintings may be called the culminating moment in Zurbarán's career as a monastic painter and colorist.

For variety, richness, and imaginative combinations of colors, the four large Nativity scenes from the Jerez altarpiece have few equals in Zurbarán's oeuvre. In *The Annunciation* Zurbarán's chromatic imagination is unusually audacious. The Virgin wears a deep blue cloak over a plum-colored dress. Contrasted to these subdued tones is the dress of the Archangel Gabriel—a flamboyant yellow orange gown of almost dazzling brilliance. The two figures are set against a darkened middle ground which further strengthens the colors. Above the Virgin and Gabriel, the Holy Dove appears amid an eruption of bright yellow light surrounded by brown clouds. Two large angels with blue and rose garments complete the mélange of color.

In contrast to these bold tonalities, the other elements of the painting are cast in a more conservative mold. The composition is arranged by superimposing a heavenly scene above an earthly one. The scale of the figures is enormous, as Zurbarán again uses large proportions to add weight and gravity to the picture. He carefully avoids the usual dramatic Baroque conception of the scene, in which Gabriel plummets from the heavens into the Virgin's chamber and startles her as she reads or prays. Rather, he chooses to ritualize the encounter by painting both the Virgin and the angel in reverent attitudes. Zurbarán accomplishes the transition from the foreground to the architectural background by the use of light rather than line. By darkening the architecture of the transitional area, he helps us to read the space as if it were a stage set, with two bright screens placed parallel to a dark screen between them. In the composition of space and figures, Zurbarán has relied on the habits of his earlier style; but he has enlivened them with a veritable explosion of color.

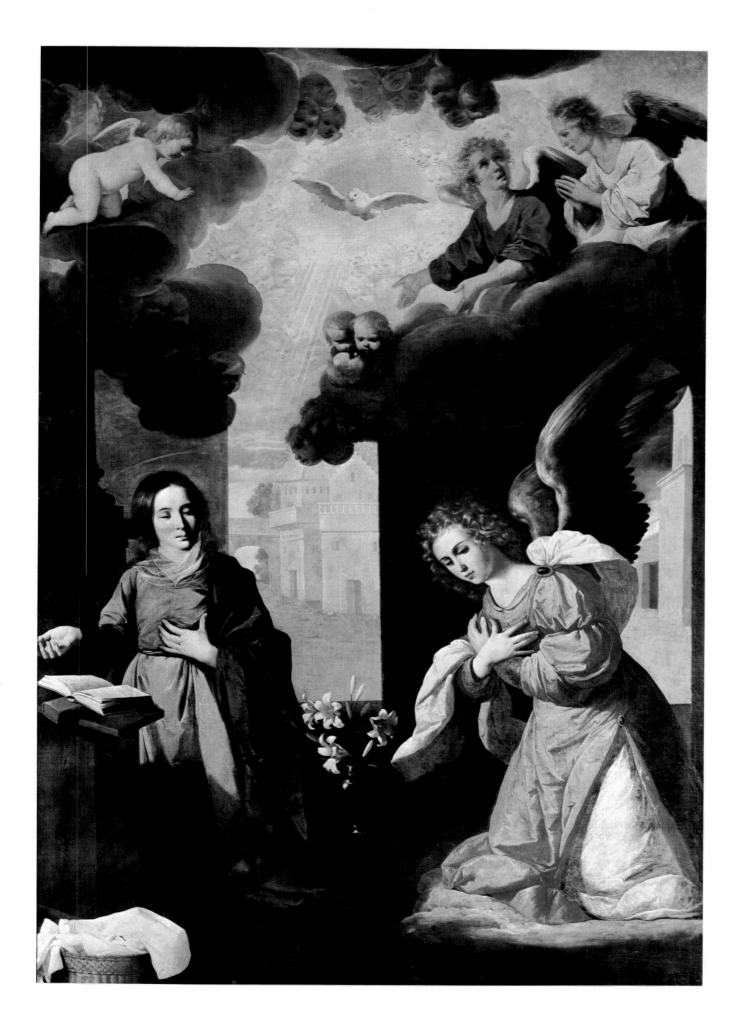

THE ADORATION OF THE MAGI

1638–39

Oil on canvas, 8' 6 3/4" × 5' 8 7/8"

Musée de Peinture et de Sculpture, Grenoble

The Adoration of the Magi is another paradigmatic illustration of the hybrid nature of Zurbarán's art. Like the other Nativity scenes painted for the Cartuja of Jerez, it combines a conservative composition and imaginative color. Zurbarán's conception of pictorial space, and the way he fits the figures into it, correspond to late-sixteenth-century norms.

The illusion of space in *The Adoration of the Magi* is established by constructing three layers of color parallel to the picture plane. The first layer is the widest; it begins with the golden robe of the kneeling magus and terminates at the darkened pilaster in the center of the canvas. Within this relatively shallow area Zurbarán places all the figures. But they are drawn so large that the minor characters must be crammed into the leftover space. Even Joseph has been anatomically abbreviated; he exists only from the chest upward and is uncomfortably wedged against the frame. The two tiers behind the figures are virtually flat and uninhabited. First there is a building form that has been installed primarily for creating the appearance of depth; it makes almost no architectural sense. And then the final plane is implied simply by lightening the color of the sky along the horizon. This type of frontal spatial construction, achieved by alternating bands of light and dark, was used by other Spanish painters well into the seventeenth century. Vincente Carducho's versions of *The Adoration of the Magi* at Guadalupe (1618) and the parish church at Algete (1619) are founded on the same principles used by Zurbarán and resemble his work to a surprising degree.

Zurbarán's conservatism is confined to this aspect of the painting. His figure types, for example, correspond to contemporary ideas; they are unidealized and strongly differentiated. In certain cases, such as the Moorish king Balthasar, it is easy to imagine that Zurbarán used a live model. The rugged faces and the light and shadow that emphasize the features historically belong to the post-Velázquez era of Sevillian painting. Zurbarán's use of color, however, is unique, and in this respect *The Adoration of the Magi* surpasses its companions in chromatic opulence and variety. Caspar's magnificent gold and carmine robe is the center of the exotic color wheel. To its left is the shiny rose color of Balthasar's costume, to its right the royal blue skirt of the Virgin. Behind him, Zurbarán places Melchior, who wears an elaborately brocaded jerkin. The crowding of the figures increases the intensity of these startling juxtapositions, which strike the eye with a richness and variety comparable to a Persian carpet.

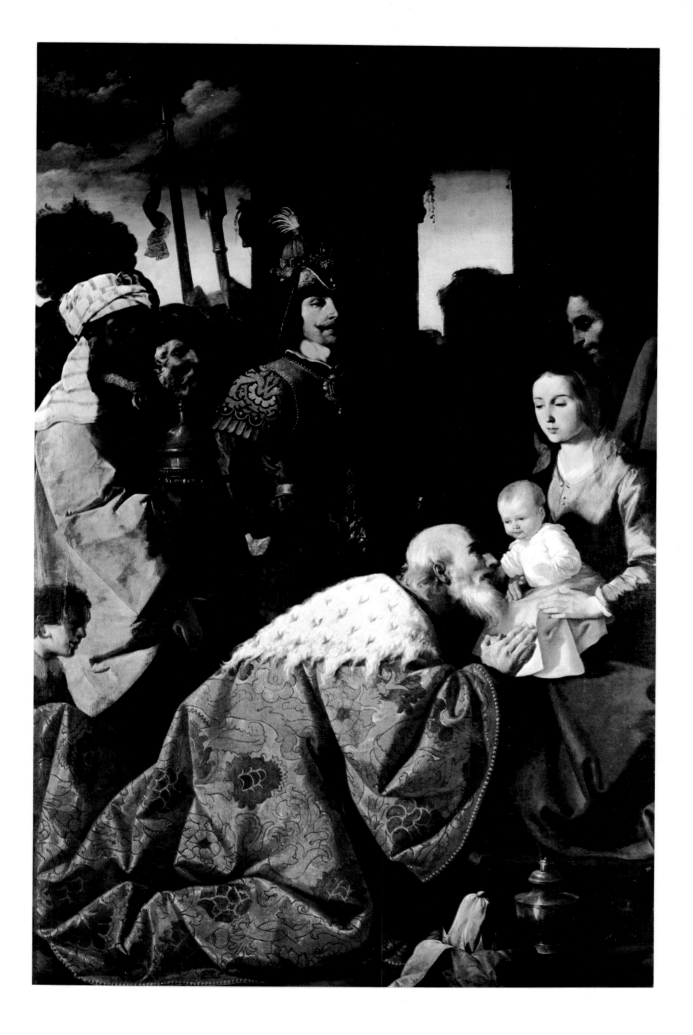

THE ADORATION OF THE MAGI (*detail*)

Zurbarán's meticulous and painstaking technique of painting rich fabrics stands out in this detail of the aged king's robe. The robe is made of golden cloth with an interwoven pattern in carmine. Every line of the design is clearly visible against the luminous golden background. In addition, the cuff of the sleeve is trimmed with pearls, each one of which is carefully depicted. The artist's patience is almost incredible, given the fact that the painting was placed high in an architectural framework behind the main altar and thus could never be seen at close range. But Zurbarán was not tempted to follow Velázquez's example by relying on broadly defined color areas accented with daubs of impasto to produce the illusion of embroidery. A comparison of Velázquez's handling of intricately decorated cloth stuffs to that of Zurbarán defines the differences in their styles. Zurbarán was concerned with re-creating the reality of the robe whereas Velázquez sought to reproduce the reality of its visual effect.

Zurbarán has painted the robe as if it were a piece of polychromed sculpture, imitating a technique called *estofado*, wherein painters of sculpture simulated embroidered fabrics. The analogy to sculpture extends to the "feel" of the material, which is partly the result of the light reflecting off the surface. In addition, the edges of the cloth are sharply drawn to produce a firm, definite outline. Consequently we perceive it as a stiff material, and our perception is reinforced by razor-sharp creases and folds which cast deep shadows in their midst, and by the shaggy ermine collar which, like the damask, has been painted with consummate care. The technique is almost an imitation of late medieval practice, where drapery was rendered with the same reverent concern for reproducing its visual splendor. Zurbarán was a much less stylized painter, to be sure, but he was no less fascinated by luxurious fabrics than his medieval forebears.

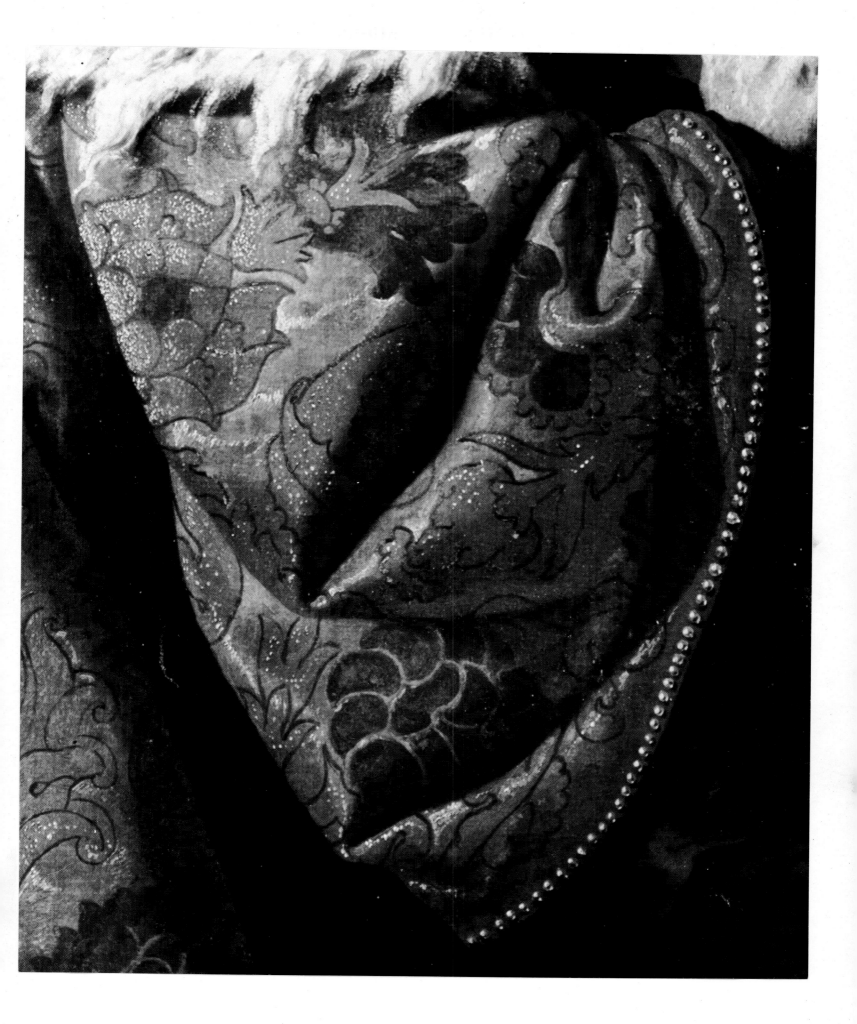

SAINT LAWRENCE

1638–39

Oil on canvas, 23 5/8 × 31 1/8"

Museo Provincial de Bellas Artes, Cadiz

The altarpiece of the Cartuja of Jerez contained six small-scale paintings in addition to its six monumental canvases (fig. 39). Four were evangelist portraits, one of which was placed above each Nativity scene. The remaining two, *Saint John the Baptist* and *Saint Lawrence*, were installed in the upper story flanking a sculptured Calvary group by José de Arce (active 1636–66). All but one of these pictures were painted by the workshop because they were relatively unimportant and hard to see. The one exception was the painting of *Saint Lawrence*, which, on the basis of its superior quality, must have been done by the master himself. It is curious that he would have taken the trouble to paint a picture that was to be put near the top of a fifty-foot-high altarpiece, and even more curious that the picture should be one of such surpassing refinement and sensitivity.

Saint Lawrence is seated on the ground in an attitude of prayer; the attribute of his martyrdom, the grill on which he was burned alive, rests against his body. Behind him there opens a landscape with trees, some of which are reflected in a small pond at the left. The mood is one of quiet meditation, the moment when the world is shut out and the mind seeks refuge in holy thoughts. We see the saint in profile with the sharp outline of his solitary form etched against the empty sky. His long face is perfectly still and expressionless; a shadow covers his eyes and deepens the sense of inner concentration.

The colors are soft and muted and blend into a gentle harmony. Saint Lawrence wears a red dalmatic with gold embroidery that contrasts with the lime yellow sky. The landscape is a subtle mixture of silvery greens and russet browns. In the distance fanlike trees with stippled leaves absorb the even tones of light from the sky and reflect their colors in a placid pond. It is almost as if nature had become an extension of the saint's mood. This small picture is nearly perfect in its expression of the private feelings of a man in prayer. All outward traces of emotion and movement have been carefully suppressed in order to create a moment of absolute concentration.

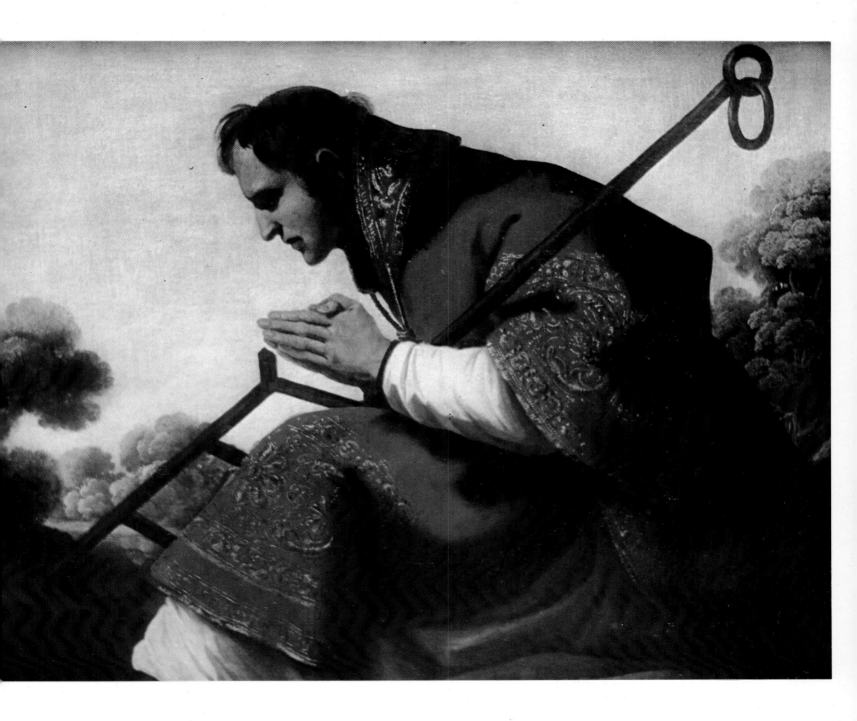

BISHOP GONZALO DE ILLESCAS

Signed and dated 1639

Oil on canvas, 9' 6 1/2" × 7' 2 1/8"

Sacristy, Monastery of Guadalupe

The monastery of Guadalupe was an important seat of the Order of Saint Jerome in Spain. Its construction began in the fourteenth century after a shepherd discovered a statue of the Virgin on the site (1329). By the end of the century, the Virgin of Guadalupe had become renowned, and the care of her sanctuary had been entrusted to the Jeronymites. Almost from the beginning, the order and the monastery enjoyed the protection of the kings of Castile. As a result of the royal patronage, the Jeronymites were to play a significant role in Spanish history for the next two centuries. After Charles I abdicated, he retired in 1557 to the remote Jeronymite monastery at Yuste. And after Philip II had built the Escorial he invited the order to establish itself there. Moreover, Jeronymite brothers were the councillors and confessors of kings, and on occasion were appointed to high government office. The order took pride in its special relationship to the Castilian throne. Thus when the sacristy at Guadalupe was to be redecorated in 1638, it was decided to emphasize this aspect of the order's character in addition to the traditional monastic virtues of piety and charity. Scenes from the lives of eight monks were chosen to illustrate the concept of Guadalupe as a center of Jeronymite history and practice. Two of the paintings represent monks who had been closely associated with Castilian kings, including Gonzalo de Illescas (d. 1464), the confessor of John II and co-regent of Castile. His portrait symbolizes the Jeronymite as statesman.

The scene takes place in Bishop Gonzalo's study, a room that is illogically but effectively set within an open portico. In the foreground, the bishop is seated at a desk with writing implements spread out before him—books, inkwell, a seal, a small box of sand for drying ink, and a quill sharpener. There are also a skull and hourglass, traditional symbols of death and passing time, which serve as reminders of things eternal. The moment is one of frozen action, when Gonzalo de Illescas has paused histrionically in the midst of composing a letter. A strong ray of light enters from the upper left and throws his deliberate pose into high relief. It also sets off the subtle color harmony of his light blue mozzetta and the surrounding shades of red and maroon, notably the enormous, stiff red curtain that fills the right corner. Then shadows fall on the columns as Zurbarán again uses a dark vertical silhouette to divide the space. Beyond, there is a townscape which faintly resembles Guadalupe itself. On the porch of a building, Gonzalo de Illescas dispenses alms to the poor as a sign of Christian charity that balances his worldly endeavors.

BISHOP GONZALO DE ILLESCAS (*detail*)

The still-life passages in this painting are different from the ones found in Zurbarán's earlier works. Each object is carefully related to its neighbors rather than existing separately in splendid isolation. The books form a gentle slope that leads the eye to the bishop's letter and hence to the dramatic focus of the picture. The exceptions to the unified still-life composition are the apple and the book, which rest between the two darkened columns. In contrast to the unobtrusive still life on the table, they are an inexplicable distraction, unless our attention is being called to them for a symbolic purpose.

Zurbarán's use of symbols is usually quite transparent. In this picture, the skull and hourglass are typical examples of the uncomplicated symbolism that is usually encountered in his paintings. Is it justifiable, then, to regard the book and apple as anything more than a fascinating visual motif? Their obtrusive placement in the composition might be offered as an argument for a symbolic interpretation. For one thing, the apple is definitely out of place in this scene, for it does not logically belong to the writer's paraphernalia. But more suggestive still is the arrangement of the two objects, with the apple placed on top of the book. An analogy is found in the skull and hourglass, which are similarly set on a book rather than directly on the table. The meaning of this motif may be interpreted as the ultimate futility of worldly pursuits because they are obliterated by time and death. Perhaps, then, the apple is symbolically related to the book below it. The apple, in fact, does have a familiar symbolic meaning; it is the fruit that came from the tree of knowledge in the Garden of Eden. However, it does not merely stand for knowledge, but also for the Fall of Man. Thus its position on the book at a key point in the picture may suggest that worldly deeds, such as scholarship, are not sufficient to achieve salvation. In order to emphasize this point, a scene of charity has been placed in the background directly behind the apple and the book to show that good works are needed to achieve a state of grace.

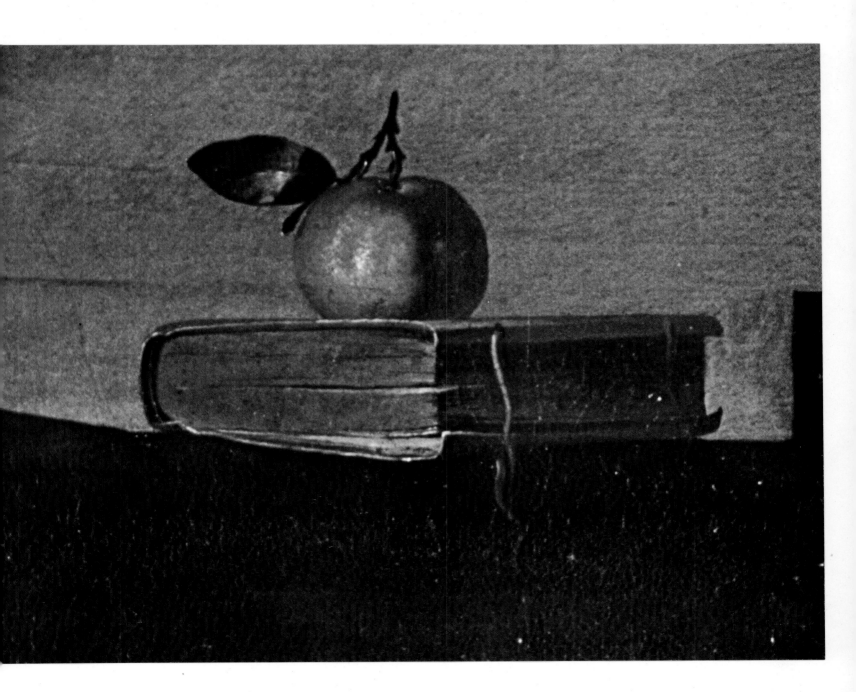

THE TEMPTATION OF SAINT

JEROME

1639

Oil on canvas, 7' 8 1/4" × 9' 6 1/2"

Chapel of Saint Jerome, Monastery of Guadalupe

The sacristy at Guadalupe terminates in a small chapel dedicated to Saint Jerome, the patron of the Jeronymite order. For this chapel, Zurbarán was commissioned to paint a small altarpiece and two large scenes from Saint Jerome's life. The execution of the altarpiece was assigned to the workshop, but the pictures of Saint Jerome were painted by Zurbarán and are among his masterpieces. On one wall is *The Flagellation of Saint Jerome* (fig. 38), which represents the punishment by Christ and the angels for his devotion to pagan authors. Opposite it is *The Temptation of Saint Jerome*, a vision that occurred while Jerome was doing penance in the Syrian desert.

As Jerome described the event, he was alone in the burning desert when he became obsessed with the vision of young Roman girls dancing. In order to calm his carnal desires, he abandoned his simple cell and retreated further into the wilderness, where "the rough mountains became my place for prayer and the dungeon for my miserable flesh." The two paintings thus represent the dual temptations of mind and body that Saint Jerome and his followers needed to overcome to lead Christian lives.

Zurbarán's conception of the scene only partially follows the text. The rough mountainous setting and the gaunt, weather-beaten appearance of Saint Jerome faithfully follow its specifications. However, his treatment of the temptresses is quite arbitrary. Although they were experienced as figments of the imagination, they are shown as if made of flesh and blood. Furthermore, they are singers and musicians, not dancers. These changes drastically slow the tempo and rhythm of the episode and make it as much a ritual as an historical event. The feverish motion of the imaginary dancers is replaced by a group of placid, decorously dressed musicians, who slowly advance toward Saint Jerome. His gesture of rejection is purposely overstated to show the triumph of faith over bodily temptation.

The effect of this mixture of the real and the unreal is strengthened by the calculated use of space and light. Zurbarán has limited the space to the foreground by placing dark gray rocks and a lighter gray sky behind the figures. These somber tones act as a foil for the highlighted forms of Jerome and the sirens. As a result, the details of Saint Jerome's rugged body become clearer at the same time as his artificial, theatrical gesture is stressed.

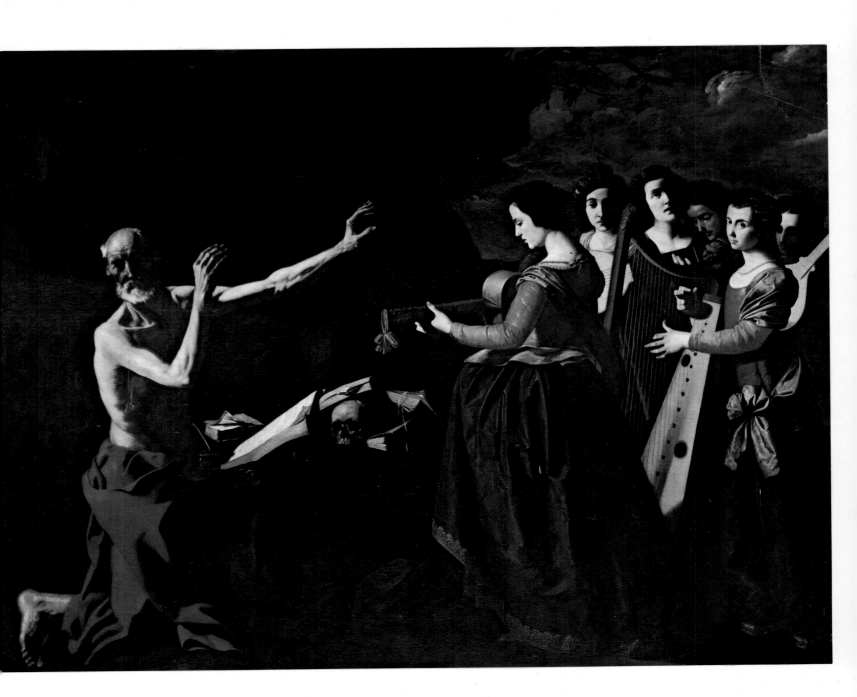

THE TEMPTATION OF SAINT

JEROME (*detail*)

The books and the skull that rest on the "desk" of natural rock play important parts in establishing the content and form of this painting. They are meant, first of all, to symbolize Saint Jerome as scholar and penitent. But they also contribute significantly to the mood of the picture. The tawny colors enhance the somber atmosphere of ascetic penance. And the objects themselves lend a grotesque touch to the scene. The skull, with its contrast of chalky white bone and darkened eye sockets, becomes an almost sinister presence. Zurbarán concentrates attention on the skull by laying the books in tiers upon it, until they form a kind of hood or bonnet. This ingenious still-life arrangement heightens the effect of the painting without interfering with the drama of faith overcoming temptation.

SAINT FRANCIS MEDITATING

Signed and dated 1639

Oil on canvas, 63 1/2 × 54"

The National Gallery, London

Saint Francis of Assisi was one of the most frequently painted subjects in Zurbarán's repertoire; over forty pictures of him by the artist or members of his atelier have survived. A large majority of these works show Saint Francis in meditation holding a skull, a Saint Francis Hamlet, as he has been called. This theme was made popular in Spain by El Greco, who virtually ignored scenes from the life of the saint which showed his innocent faith and kindliness and concentrated instead on presenting him as an ascetic hermit, despite the fact that there was no historical basis for this interpretation. Zurbarán probably based his conception of Saint Francis on works by El Greco and his school, which had been produced in great number and widely distributed throughout Spain.

Zurbarán varied the theme in several ways over the course of his career. The saint appears standing against either a dark background or a landscape; sometimes his hood covers his head, sometimes it rests on his shoulders. More importantly, he can be looking down at the skull, as if meditating upon death, or upward, as if communicating with God. This picture belongs to the second type and is the most moody and theatrical of them all. The means of expression could hardly be more direct—a strong shaft of light pierces the darkness and dramatically reveals the kneeling, gesturing figure of the saint. Under the brilliant illumination, the smallest details become visible—the stitching that holds the patchwork robe together, the torn and jagged edges of the cuffs, the smooth, reflecting surface of the skull. The light also emphasizes the sharp contour of the figure, particularly along its back, which rises in a gentle curve.

Although the painting has been called "sculpturesque," this definite outline defeats the illusion of the third dimension and seems to flatten the body by giving it an edge. However, the strong line is pictorially effective because it emphasizes the upward direction of the saint's appeal, which is completed by an elegant gesture of the hand. In the background, a nocturnal landscape painted with blacks, browns, and dark greens adds a note of melancholy.

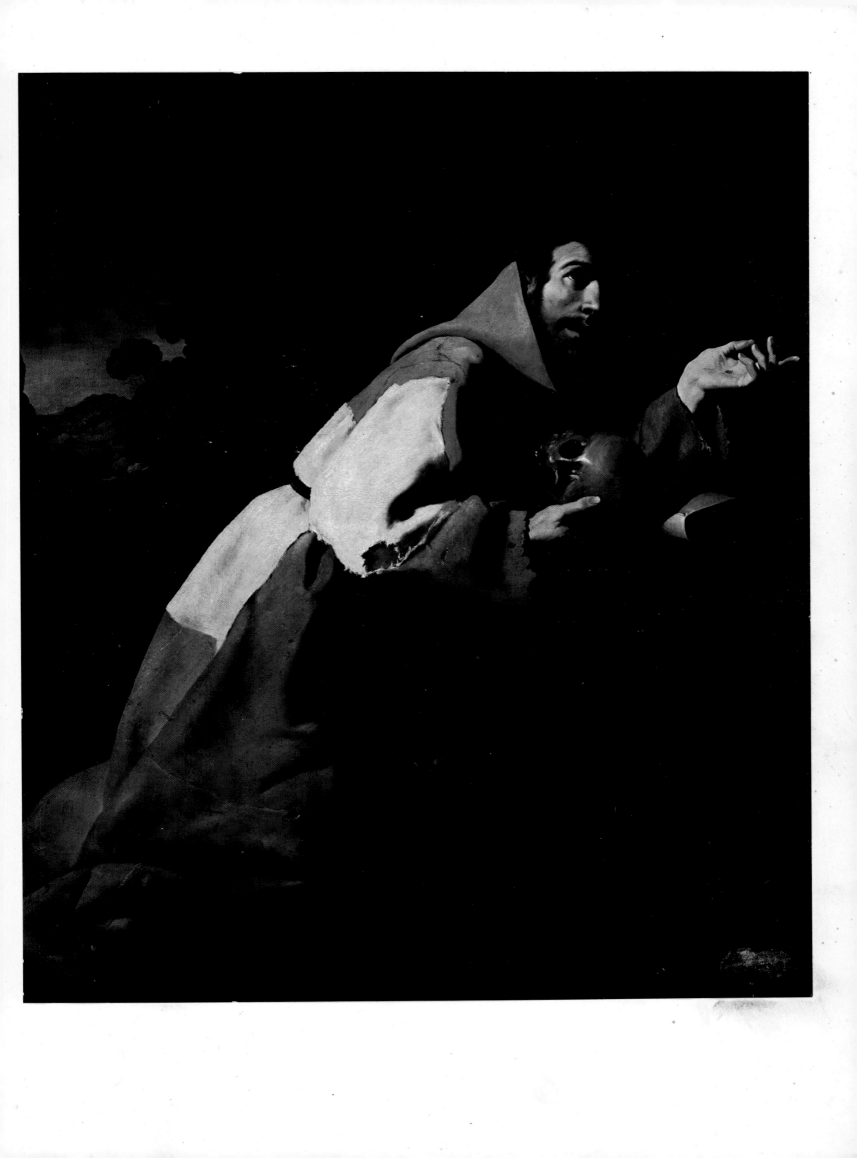

SAINT FRANCIS IN HIS TOMB

c. 1640

Oil on canvas, 81 1/2 × 42"

Museum of Fine Arts, Boston. James Pratt Fund

Among Zurbarán's many paintings of Saint Francis of Assisi, this one holds a special place for its bizarre theme. The saint stands immobile in a shallow niche. His brown habit covers his body except for the face, which looks upward with an expression of devotion. A powerful stream of light bears down upon him, sharply outlining his body and causing it to cast a shadow against the wall. The robe hangs straight, with long, parallel folds to emphasize the rigid verticality.

This strangely affecting statuesque figure was inspired by a Franciscan legend that was occasionally represented in the seventeenth century. In order to promote the belief in the incorruptibility of Saint Francis's body after his death, a pious tale of horror and suspense was invented. In 1449, Pope Nicholas V visited the monastery of Assisi and decided to explore the crypt of the church. At five in the morning, he descended with a small party of men and began to conduct a torchlight search of the darkened chambers. Suddenly the flickering light fell on the body of Saint Francis, which had been placed standing up on a slab of marble. His hands were clasped and covered by the wide sleeves of his habit, his eyes were raised toward heaven. Nicholas V fell to his knees before the miraculously preserved body. Then he carefully lifted a corner of the saint's robe to reveal a foot from which blood ran as if Saint Francis had just been stigmatized.

Zurbarán's version of the legend omits the novelesque elements of fearful suspense and startling revelation. Indeed, he has eliminated everything from the story but the miraculous image itself. As a result, we see Saint Francis as if we were members of the papal retinue, at the moment when light first played on the upright form. Zurbarán brilliantly contrasts the immobile body with the animated facial expression to produce the illusion of a man who is both dead and alive.

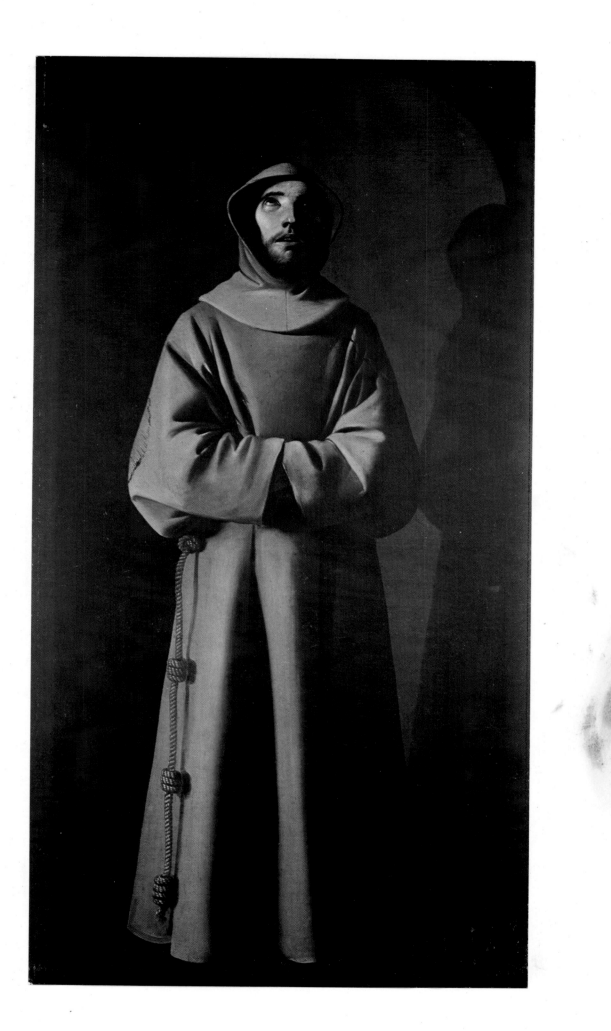

THE BLESSED HENRY SUSO

c. 1640–41

Oil on canvas, 82 1/4 × 60 5/8"

Museo Provincial de Bellas Artes, Seville

About 1640–41, Zurbarán received what appears to have been his last commission from a Sevillian monastery. It consisted of two altarpieces for the transept of the Dominican church of Santo Domingo de Portaceli. As subjects, the Dominicans chose two less famous members of the order, one of whom was the Blessed Henry Suso, a fourteenth-century German mystic. According to the contract, which was discovered by an archivist but misplaced before he could copy it, the Dominicans specified the contents of the painting in minute detail. Without this document to guide us, the painting presents a puzzling appearance. The youthful Henry Suso stands in the foreground, apparently incising the letter H on his chest with a long metal stylus. It has been supposed that he is inscribing the monogram of Christ, IHS, as a form of penance. Behind him, in a verdant landscape, there are two vignettes. On the right, a Dominican appears to be addressing a fellow monk, who is asleep. Behind them, an angel leads a horse down a hill. On the left, a Dominican sits on a rock and gazes into a pool.

The painting makes a considerable impact despite our imperfect knowledge of its subject. Its central motif is inherently gripping because it is an unusually explicit representation of bodily mortification. By drawing his habit aside, Henry Suso creates a frame in the middle of which the livid H glows intensely. The impassioned look on Suso's face transmits the feeling of exultation peculiar to a mystical experience in which bodily pain and spiritual rapture are combined. The peaceful, almost somnolent landscape contrasts with the emotional foreground. Zurbarán has constructed it of the usual elements— fuzzy, translucent trees, hills with rocky formations, and a distant mountain range. But the landscape has been projected with unusual breadth and shows how his command of the genre had increased with time. This looser technique and franker expression of emotion are signs of the direction that Zurbarán would follow in the coming years.

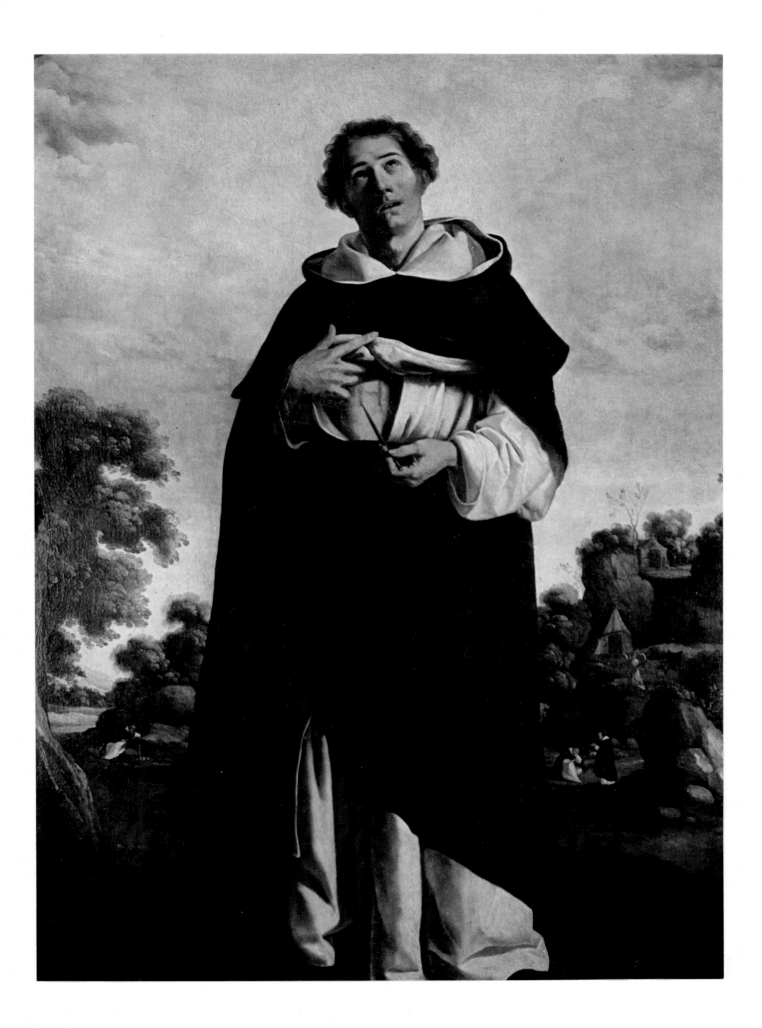

SAINT CASILDA

c. 1640–45

Oil on canvas, 67 3/8 × 42 1/8″

Collection Mrs. William Van Horne, Montreal

The taste for Zurbarán's paintings of female saints in contemporary costume reached its height in the 1640s. During this decade, he and his workshop produced them in large numbers, often in groups of a dozen or more paintings. Unfortunately, none of these series has come down to us intact. Their attractiveness made them a favorite target of collectors during the nineteenth century, and today the individual components are scattered throughout the Western world. A few of these cycles have been tentatively and partially reconstructed by means of identifying works with the same provenance. One group of these paintings came from the collection of Field Marshal Soult, who, with his usual eye for quality, chose some of the best examples. *Saint Casilda* belonged to this series, and she is undoubtedly one of Zurbarán's most accomplished creations in this special category.

The question of the saint's identity is troublesome. Confusion arises because her principal attribute, the roses that are gathered up in the folds of her dress, is shared by Saint Elizabeth of Hungary. And it is compounded because Zurbarán painted both of them in nearly identical poses. A splendid picture in the Prado has usually been called Saint Casilda, and this one Saint Elizabeth, though on the face of it the names could easily be exchanged. There is, however, one important difference between them. The young woman in the Prado painting wears a crown on her head, and the crown is a traditional attribute of Saint Elizabeth, who was the daughter of the king of Hungary. The other saint, however, wears only a diadem, like many of Zurbarán's virgin martyrs, and thus she should be identified as Saint Casilda.

Saint Casilda was a Moorish princess who had been converted to Christianity. After her conversion, she used to bring food surreptitiously to Christians held prisoner by her father. One day, so the legend goes, he discovered her as she was bringing them loaves of bread concealed in the folds of her dress. The king demanded to see what she was carrying and as she opened the folds of her skirt, the bread was miraculously converted into roses.

This painting epitomizes the allure and grace of Christian heroines wearing luxurious contemporary dress. The saint's face is young and pretty, with small, delicate features. Her hair falls freely over her shoulders and relaxes the formality of the picture. The body inclines slightly forward, which also loosens the rigid upright pose often used by Zurbarán for this subject. The warmth of the saint's personality is reflected in the unusual combination of soft colors. Her body is seen in near-profile, perhaps because she was part of a processional group. But this side view also permits Zurbarán to play the rich and varied colors of her costume against the gray background.

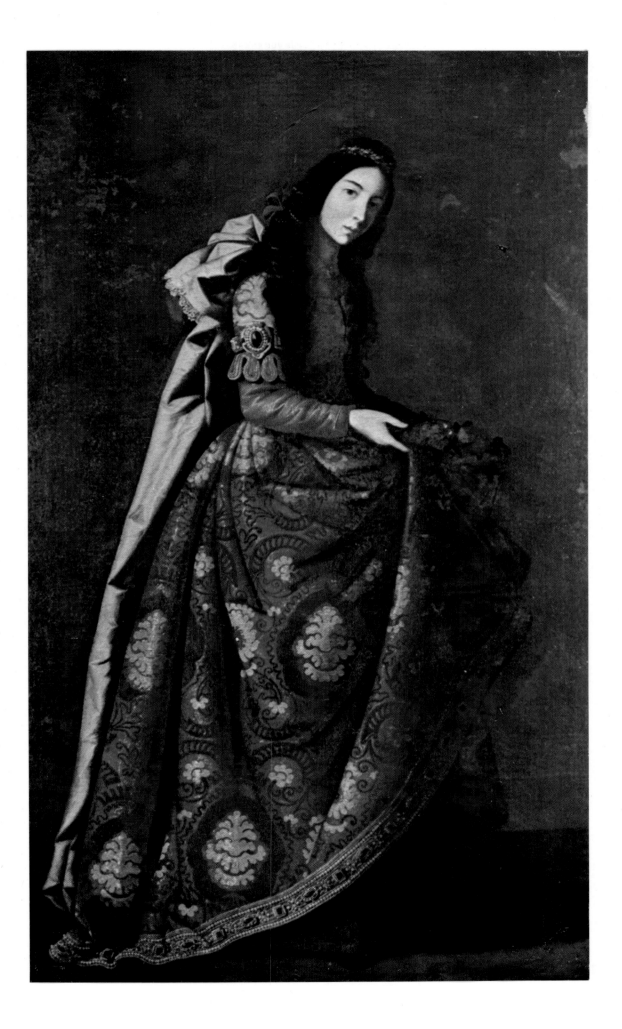

COLORPLATE 41

THE ANNUNCIATION

Signed and dated 1650

Oil on canvas, 7' 3 3/4" × 10' 2 1/8"

Philadelphia Museum of Art. The W. P. Wilstach Collection

This painting is a crucial work for defining the evolution of Zurbarán's later style, although its importance has been obscured by incorrect dating. It has usually been dated 1658, the year in which a picture of this subject attributed to Zurbarán was presented to the church of San Miguel in Peñaranda de Bracamonte, a village between Salamanca and Ávila. The correct date, however, is clearly written under Zurbarán's signature as 1650. The source of confusion is a smaller copy that is still in the church, and this picture, rather than the one in Philadelphia, was the gift to the church in 1658.

The importance of the revised chronology is implied by the fact that the painting was usually thought to be compatible with the very latest works by Zurbarán. And indeed the softer, paler colors, the more diffuse effects of light, and above all the milder expression of emotion are all characteristics of Zurbarán's last ten years as an artist. However, the change of style appears to have been essentially accomplished by the date of this picture. If this is so, then the customary notion that Zurbarán altered his style under the influence of Murillo and the pressure of his successful rivalry must be reconsidered. This conception was, in any case, too simplistic to explain a long and thoughtful process of development during which Zurbarán selectively retained some elements of the earlier style unchanged while he modified others.

The balance of tradition and innovation which is struck in Zurbarán's later works is illustrated in *The Annunciation*. He continues to imagine the human figure on a large scale, so large that it dominates the space. He also indulges his love of crisp, concrete details, here manifested in the books on the prie-dieu and the embroidered vest worn by the Archangel Gabriel. On the other hand, certain passages in the painting show new facets of Zurbarán's style. There is a greater sense of movement and unity in the composition and the perspective is more consistent. The encounter between the Virgin and Gabriel is more dramatically and psychologically convincing than it was, for example, in the painting for the Cartuja of Jerez in 1638–39 (colorplate 29). And Zurbarán has animated the *putti;* they actively gesture toward the scene and strike lively poses. Finally, the light has been modified around the figures to make the shadows softer and more transparent, though it maintains the customary brilliance when it strikes the table and the base of the column at the right.

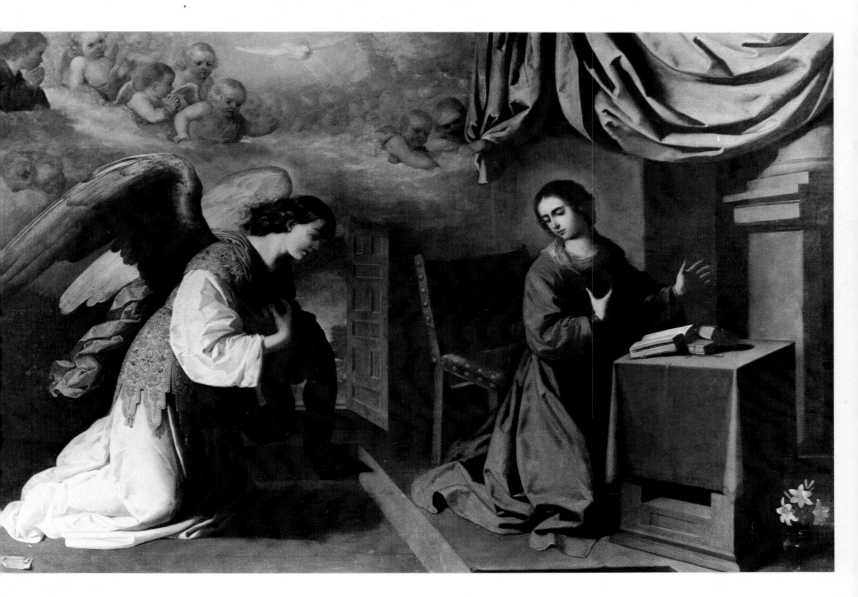

THE ANNUNCIATION (*detail*)

The Virgin Annunciate illustrates many of the new elements in Zurbarán's style after 1650. The stern and rustic female type that frequently played the part in earlier works has been replaced by a delicate girl with small, fine features. Her face expresses the humility and tenderness that we find in the Virgins who appear in the late paintings of the Madonna and Child. These qualities were partly the result of different techniques. Although Zurbarán continued to define the contours of his figures with a sharp, lucid outline, he also began to soften the transition from figure to space in certain passages. Here it is noticeable around the head of the Virgin, which gives off a radiant glow of sanctity. The light seems to filter through the Virgin's hair, causing it to fade into the atmosphere at the edges. A softer light also illuminates the face, which casts a hazy, translucent shadow on the left side. Zurbarán achieved these effects by altering his handling of paint. Instead of applying it with thickly loaded brushes that created deep, rich colors, he laid the paint on very thinly in order to leave the grain of the canvas partially visible. The texture of the weave softens the surface appearance and creates a filmy effect in places.

This procedure is remarkably similar to Velázquez's technique and raises the question of whether Zurbarán had seen any of his later pictures. Unfortunately, Zurbarán's activities are poorly documented in the early 1650s. Some evidence has been discovered to suggest a visit to Madrid in 1651–52, but even if such a trip had been made the timing would be too late to have affected this painting. Moreover, the style seems to have been the result of a gradual development, not a sudden revelation. Whatever the impetus, it allowed Zurbarán the opportunity to explore a mellower kind of religious experience.

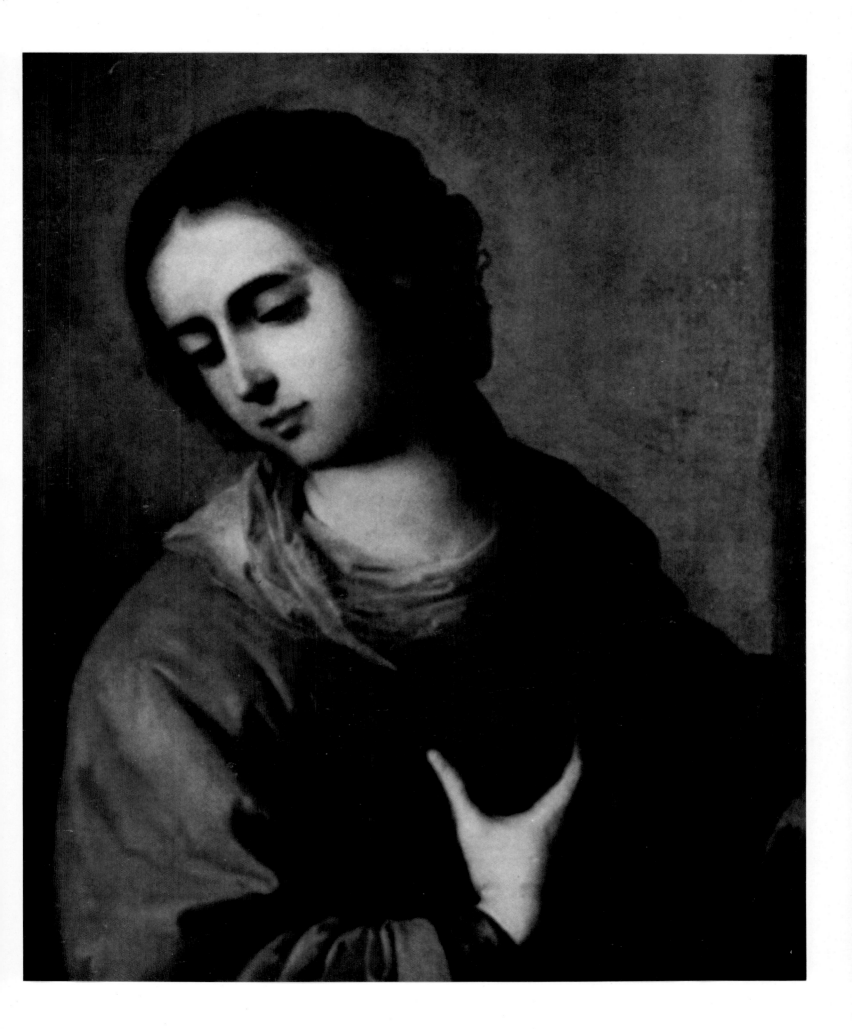

CHRIST CARRYING THE CROSS

Signed and dated 1653

Oil on canvas, 76 3/4 × 42 1/2"

Cathedral, Orléans

Christ Carrying the Cross is one of the most original and successful among Zurbarán's late paintings. The composition is immediately engaging; the monumental figure of Christ walks across the foreground of a panoramic landscape. It is an image of Christ without time or place. All of the accessory characters have been eliminated, all allusion to Jerusalem canceled by the Northern cast of the background. By removing Christ from the appropriate historical and geographical context, Zurbarán created a painting that must have struck his contemporaries by its timelessness. Christ has been cut loose from His historical moorings and set afloat in the mainstream of time to arrive at the present. This psychological gambit answered the need for a direct confrontation between divinity and humanity that developed in Seville after 1650.

Zurbarán has aimed to increase the sense of engagement by turning Christ's head toward the viewer so that His eyes meet our own. The expression on His face, half-masked in shadow, indicates suffering borne with quiet dignity and is calculated to arouse a sense of compassion and sorrow. Zurbarán intensifies the apparent weight of Christ's burden by bending the figure forward from the waist up. Nevertheless, he carefully avoids extremes of bodily and spiritual suffering. The painting creates more of a feeling of melancholy than of sorrow or grief. There are no traces of the violence and mockery that actually occurred at this moment. Instead, Zurbarán has used thin, pastel colors that are almost too pretty to express tragedy. The plum-colored robe is placed against a robin's-egg-blue sky that is mottled with light yellow patches and becomes a faint pink at the top. The light in the landscape is filtered through a haze that softens the greens and browns. Zurbarán has created an *intimiste* religious painting, shorn of drama and dramatic accessories. It seeks to communicate with whoever sees it, and to arouse his concern and sympathy for the suffering Christ.

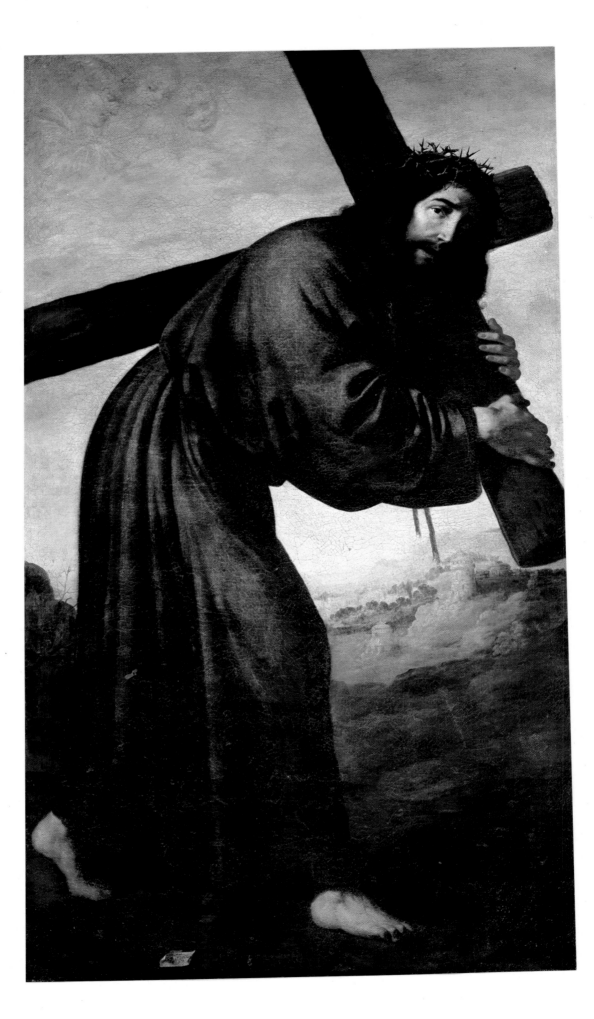

SAINT JAMES OF THE MARCHES

Signed; datable c. 1658–59

Oil on canvas, 9' 6 3/8" × 5' 5"

The Prado, Madrid

In May, 1658, Zurbarán left Seville for Madrid, where he would spend the last six years of his life. The principal reason for leaving his adopted city seems to have been the desire to seek employment in the capital. Zurbarán had, after all, been nominated "Painter to the King" in 1634 and, although the appointment was an honorary one, it nevertheless might have inspired the hope of using it to recover his artistic fortunes. His plan was unsuccessful, because we know that he died in poverty. But perhaps a commission that he received soon after his arrival afforded grounds for optimism.

The Franciscans in nearby Alcalá de Henares had decided to redecorate the chapel in their church dedicated to San Diego de Alcalá. In 1658, they engaged three painters to furnish the pictures, including Zurbarán and Alonso Cano, the antagonists in the Seville guild dispute of 1630. Zurbarán was assigned to paint the subject of Saint James of the Marches, an Italian Franciscan who lived during the fifteenth century. Saint James had acquired fame as an ascetic and a preacher, and it is in the latter role that he is depicted here. The subject of his message is symbolized by the glass of wine that he holds up—the mystery of the Eucharist. According to Catholic doctrine, the wine that is drunk at mass is the blood of Christ itself, not simply a token of it. During his lifetime, Saint James had been accused by the Inquisition of preaching this heretical view of transubstantiation but was subsequently cleared of the charge. By showing Saint James's devotion to the mystery, the picture not only proclaimed his orthodoxy but also served the purposes of Counter-Reformation propaganda by attacking the Protestant belief that the wine was only a symbol of Christ's blood.

Zurbarán's *Saint James of the Marches* is one of his finest pictures. In it he has achieved the grace of form and spirit that marks later Baroque painting in Spain. The easy, fluid movement of Saint James and his lively expression are signs of Zurbarán's continued growth as a painter. From a purely technical standpoint, it shows how fluent Zurbarán became in a new pictorial language. The confident pose, the well-defined spatial construction, the facile handling of paint, especially in the sketchy miracle scene in the background, are remarkably similar to the procedures of his two successors in Seville, Murillo and Juan de Valdés Leal (1622–1691). Zurbarán's use of color harmonizes with this gentler style. Soft beiges and grays predominate and lend a warm, quiet aura to the picture. Yet underneath these changes there are still glimpses of Zurbarán's earlier style to be had. The contrasts of light and shadow and the strongly defined outline that impart a sense of corporeality provide a firm foundation for the experiments in modifying his art.

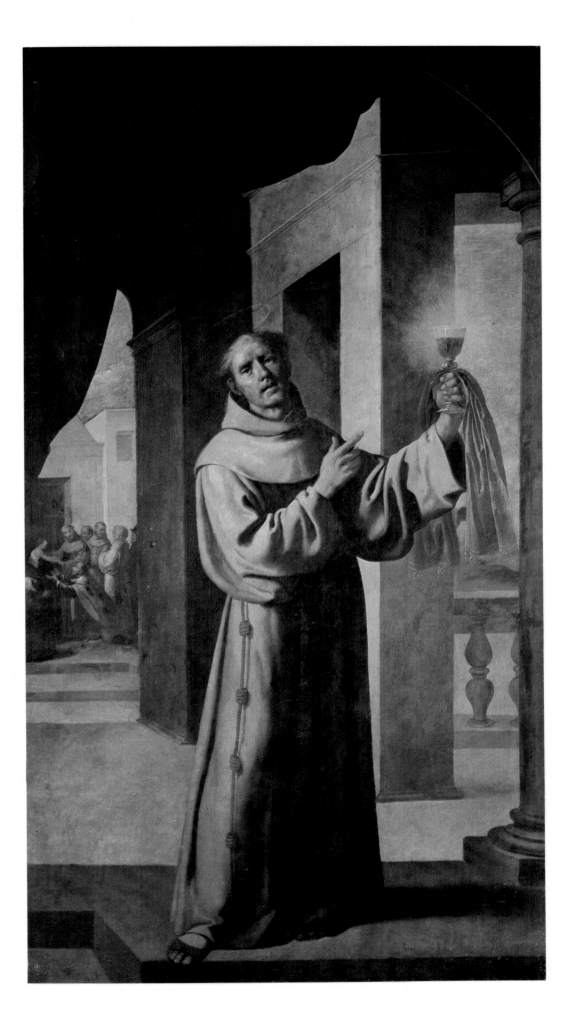

A DOCTOR OF LAWS

c. 1658–60

Oil on canvas, 76 3/8 × 40 1/2"

Isabella Stewart Gardner Museum, Boston

A Doctor of Laws is one of Zurbarán's rare formal portraits. The sitter, who has never been identified, wears academic robes of the University of Salamanca. Zurbarán has painted him impersonally; it is a portrait designed to tell us what the man is, not who he is, a portrait of position, not of personality. The body is held in an erect and dignified posture, but its contours are disguised by the long brown robe that falls straight to the floor. His face is an impassive mask, with a distant expression in the eyes. The only clues to his character are found in the hands; one is elegantly placed on the back of a chair, the other loosely holds a glove. From them we can gain an inkling of the innate grace that lies buried beneath the immobile exterior. But it is essentially a sober portrait painted in somber colors.

This painting, more than any other work by Zurbarán, suggests the influence of Diego Velázquez. It is not simply a question of the pose or the impassive expression, which had been used by Spanish court painters since the sixteenth century. There are other elements that point directly to Velázquez. In the first place, the motif of a glove dangling from a hand occurs in Velázquez's *Portrait of the Infante Don Carlos* (The Prado, Madrid), painted about 1624. But more convincing is the occurrence of certain technical similarities. The modeling is soft, the application of paint loose. Notable examples are the ungloved hand with fingertips that almost melt into the air, and the loose brushwork on the chair, where the strokes are laid down side by side without blending into each other. Passages like these are so markedly similar to Velázquez's style of painting that we must assume deliberate imitation by Zurbarán, who undoubtedly had the opportunity to study Velázquez's portraits when he was in Madrid in 1634 and again after 1658. Zurbarán may also have visited the capital in the early 1650s, and some scholars have linked the dating of the portrait to that still hypothetical trip. But this dating assumes that Zurbarán's late style was not merely formed but fixed by 1650, while in fact he continued to develop until the end. The advanced technique of the painting, especially the use of transparent shadows, seems to conform with the latest developments of Zurbarán's style.

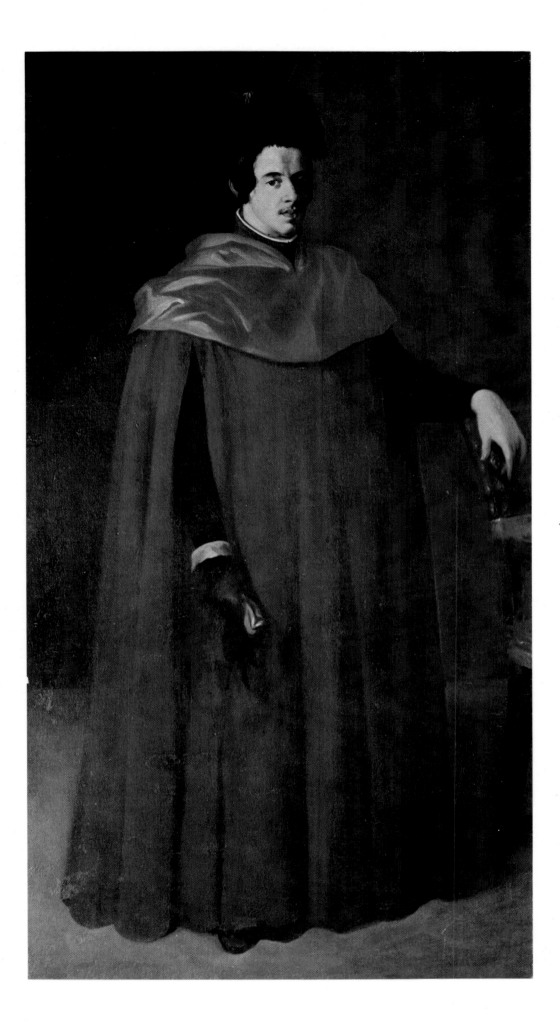

SAINT FRANCIS IN MEDITATION

1658–60

Oil on canvas, 25 1/2 × 20 7/8"

Alte Pinakothek, Munich

During his last years in Madrid, Zurbarán painted a number of Franciscan subjects, including *Saint Francis in Meditation*, a favorite theme of earlier years. In the previous versions, most of them painted between 1630–40, Zurbarán had projected a dramatic image of the saint penitential (colorplate 37), which followed the Baroque fashion for repentant saints. In the process, the unique and ingenuous Franciscan faith was made a secondary concern or forgotten entirely. When Zurbarán returned to the subject late in his life, he did so with a different conception and with a different style of painting. Indeed, the gap that opens between his 1639 version and the one painted twenty years later epitomizes the substantial evolution of his art during the period.

The *Saint Francis* of 1658–60 is a more authentically Franciscan painting. Although the skull, a penitential attribute, is still part of the *mise-en-scène*, the brooding asceticism of the earlier pictures has been replaced by the frank and tender devotion for which Saint Francis was renowned. In order to effect the new ideal, Zurbarán has rejected the primary convention of the earlier works— the vivid contrast of light and dark. A soft, even light illuminates the picture, and the shadows no longer obscure color, as the subtle halftones in the forehead and on the fingertips show. Warm shades of gray and brown gently complement each other; the transitions between color areas are gradually, not abruptly, made. Zurbarán is also remarkably free in his application of paint, as seen in the traces of brushstrokes in the sky. There is even a visible correction, something rarely found in Zurbarán's carefully executed paintings. Initially the right hand was in a higher position that interrupted the silhouette of the body, and its ghostlike trace has become apparent with time. The change has greatly improved the composition by retaining the outline of the body as a continuous, flowing line that contrasts with the upright posture.

Saint Francis himself has changed in appearance. Previously Zurbarán had imagined him with strong, plain features, but this Saint Francis has a handsome, refined face. This revision was made to conform with a new taste that required religious paintings to be sensually as well as spiritually appealing. In this work, Zurbarán reached his highest expression of this ideal and established the fact that he could attain a level of emotional and artistic refinement that younger Spanish artists would seldom surpass.

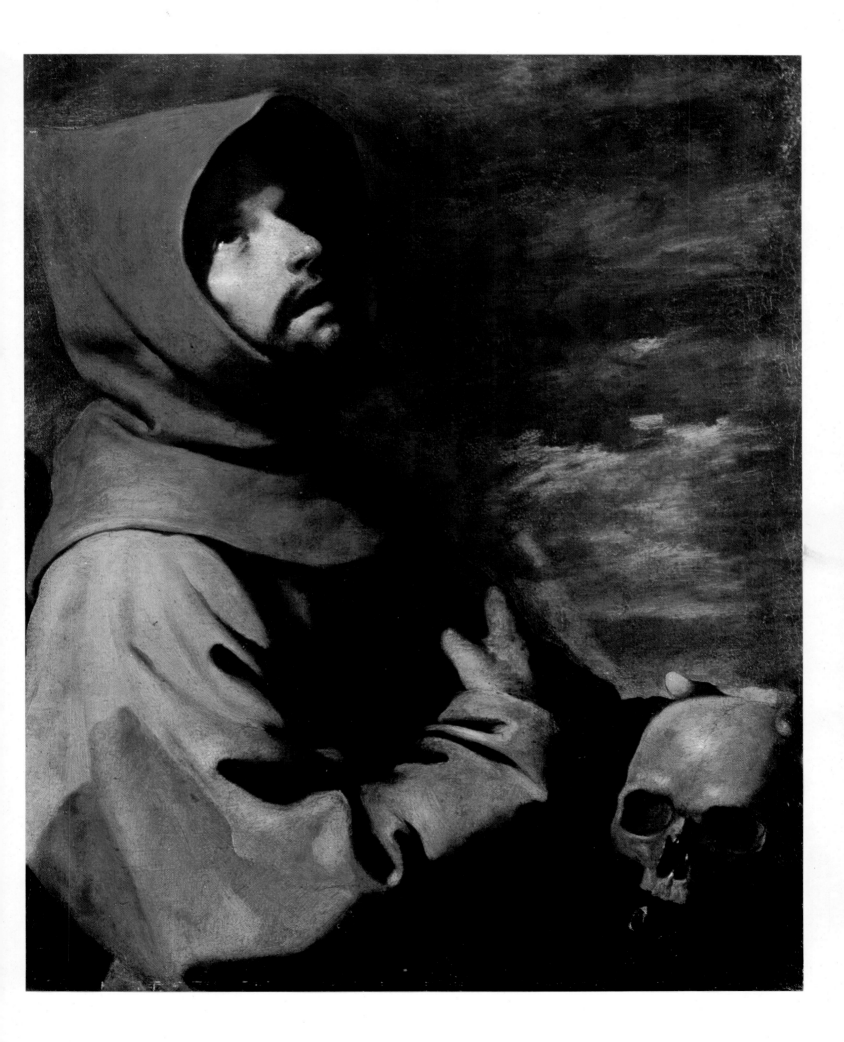

THE IMMACULATE CONCEPTION

Signed and dated 1661

Oil on canvas, 55 1/8 × 40 1/2"

Parish church, Langon (Bordeaux)

Zurbarán's paintings of the Immaculate Conception offer a view of his art in microcosm. He painted at least thirteen versions of the theme, with at least one from every decade of his career but the 1620s. His first known painting is an Immaculate Conception, and two among the last half-dozen of his works depict this theme as well. This painting, one of two dated 1661, was unknown until 1964, when it was discovered by a priest in the sacristy of the parish church in Langon, a town near Bordeaux. This late work helps to summarize Zurbarán's last statements as an artist.

Zurbarán has made a determined effort to be up-to-date in both content and style. The Virgin is the younger type preferred by late-seventeenth-century taste. Moreover, Zurbarán has eliminated all of the traditional attributes of the Immaculate Conception except the crescent moon, as Murillo often did in his paintings. Consequently, it was no longer necessary to paint a landscape beneath the figure where some of the Marian symbols could be placed, and the Virgin was free to float in the heavens as a self-explanatory image of her own purity.

In stylistic terms, Zurbarán has taken account of the taste for more lively compositions by showing the Virgin's cape unfurling like a sail in the wind. The effect is somewhat odd because the Virgin herself remains stationary, and by so doing defines precisely how far Zurbarán was able to adapt to changing artistic conditions. Unlike Murillo's *Inmaculadas*, which give the impression of upward motion, Zurbarán's figure is incapable of freeing herself from the pull of gravity. She stands in the heavens as she might have stood upon earth. But this lack of Baroque brio is offset by the brilliant colors. Zurbarán's gifts as a rich and imaginative colorist are placed on magnificent display here. The juxtaposition of the royal blue cape and the amber clouds that surround it makes the painting vibrate with chromatic energy. In contrast to these strong colors, there is a faint blue halo above the Virgin's head outlined by a ring of twelve stars. Beyond is a barely visible circle of *putti* heads, modeled out of the cottony substance of the clouds. The sensuality of these colors reveals a painter who still rejoiced in the powers of his art.

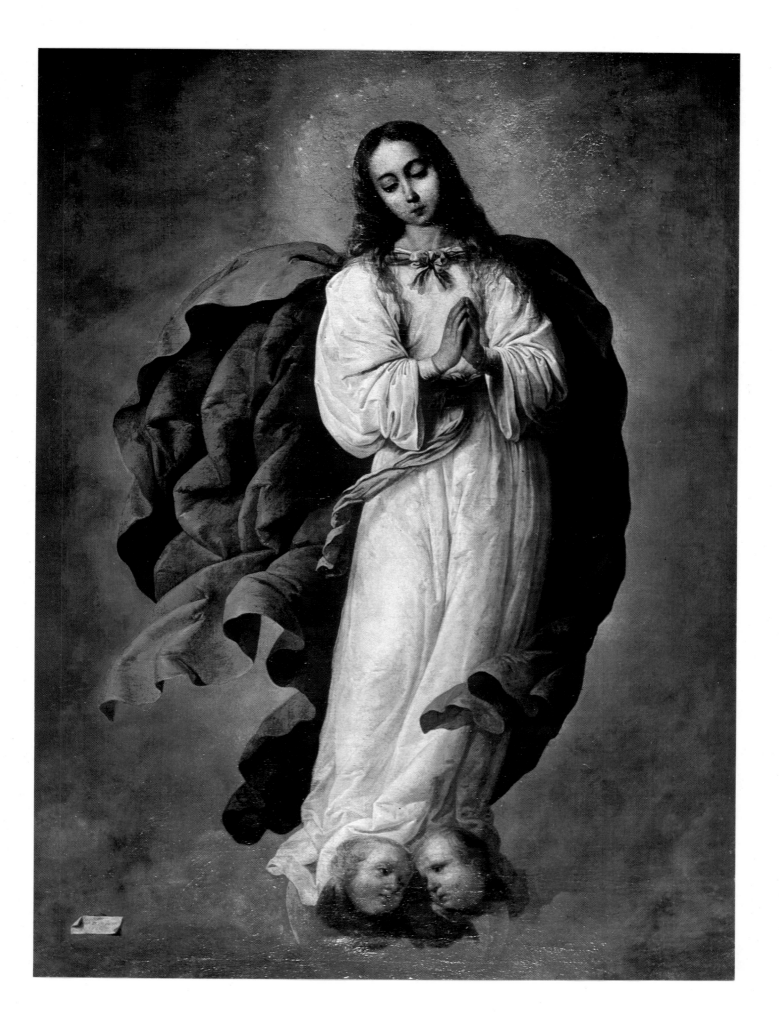

THE VIRGIN AND CHILD WITH
SAINT JOHN THE BAPTIST

Signed and dated 1662

Oil on canvas, 66 1/8 × 49 5/8"

Museo de Bellas Artes, Bilbao

During the last years of his life, Zurbarán painted six pictures based on the theme of the Virgin and Child, including two with the young Saint John. The number is significant because it demonstrates how the ideals of Zurbarán's patronage had changed over the years. This subject, with its homey intimacy, appealed to an audience that had lost interest in the heroic aspects of Catholicism. Images of suffering, spiritual contemplation, and ascetic renunciation were put aside in favor of scenes where religious feeling could be openly, even ecstatically, expressed. Zurbarán's position in this shift to a Late Baroque style clearly lagged behind the most advanced artists of the younger generation. Their energetic, buoyant compositions were beyond the reach of a painter who had always sought to ritualize and make eternal the continuing pageant of Catholicism. But his failure to keep pace with the vanguard does not imply that his efforts to absorb and express the new spirit were equally a failure. In a quiet way, his last works attain great expressiveness without sacrificing the nobility and dignity that, to him, were essential attributes of divinity.

In this painting Zurbarán adroitly balances the two conceptions of Christian art. A warm, intimate atmosphere is created by the use of unusually soft, muted colors. The dark brown background lightens to a filmy, tan haze around the figures. Soft light flows gently through the painting. The action is portrayed with the same gentleness; Christ extends His hand to the adoring Saint John, who regards Him with tender devotion. But despite these concessions to the new spirit of Catholic art the painting does not attempt to close the gap between man and God, as Murillo might have done. For Zurbarán there is an important difference between the two, which he emphasizes in small but important ways. Once again the figures are large, especially the Virgin, whose bulky robes cover the center of the painting. Zurbarán continues to idealize the Virgin rather than to show her as a strongly individualized person. And the triangular composition has a classical formality, which was derived from a print by Albrecht Dürer that served as Zurbarán's model (fig. 56). There are also traces of his continuing interest in painting details with the same care as the central figures. The shaggy appearance of Saint John's furry robe and the lamb at his feet are perfectly differentiated, and the still life of apples and pears in a pewter plate is taken as an opportunity for another concentrated study of shape and form.

This is Zurbarán's last known picture; he died two years after finishing it. By then, even his greatest efforts at modernity may have looked outmoded to a public that was demanding a more flamboyant and theatrical style. The qualities of sincerity, sobriety, and dignity that Zurbarán had infused into his art had lost their importance and it was not until two centuries later that a new audience was prepared to admire the means by which he had achieved them.

BIBLIOGRAPHICAL NOTE

Because most of the writing on Zurbarán is not in English, a critical bibliography is appended to guide the reader through the literature and to indicate the sources which have been consulted in preparing this book.

Twentieth-century interest in Zurbarán began with a major exhibition at the Prado in 1905, accompanied by a short catalogue by Salvador Viniegra, *Catálogo oficial ilustrado de la Exposición de las obras de Francisco de Zurbarán* (Madrid: J. Laceste, 1905). A few years later the first monographs appeared: José Cascales y Muñoz, *Francisco de Zurbarán: su época, su vida y sus obras* (Madrid: Fernando Fé, 1911; English edition, 1918) and Hugo Kehrer, *Francisco de Zurbarán* (Munich: Hugo Schmidt, 1918). Their importance has waned in the face of the significant advance in knowledge during the last quarter century. Large gaps in Zurbarán's biography have been filled by the patient archival research of María Luisa Caturla: "Zurbarán en Llerena," *Archivo Español de Arte* (Madrid), XX, 1947, pp. 265–84; *Bodas y obras juveniles de Zurbarán* (Granada: Universityof Granada, 1948); "Zurbarán en el Salón de Reinos," *Archivo Español de Arte*, XVIII, 1945, pp. 292–300; and *Fin y muerte de Francisco de Zurbarán* (Madrid: Dirección General de Bellas Artes, 1964). The identification and classification of Zurbarán's oeuvre was carried out in two important monographs with catalogues raisonnés: Martin S. Soria, *The Paintings of Zurbarán* (2d ed., London: Phaidon, 1955) and Paul Guinard, *Zurbarán et les peintres espagnols de la vie monastique* (Paris: Les Editions du Temps, 1960). Guinard's is the more comprehensive, including workshop pieces as well as originals, and prefaced by a brilliant study of Zurbarán's development in the context of Spanish monastic painting.

New works by Zurbarán are continually being discovered, and some of the most important finds since Guinard's 1960 catalogue are included in: Paul Guinard, "Zurbarán en la exposición de Paris," *Goya* (Madrid), no. 54, 1963, pp. 355–64 *(Saint Joseph and the Christ Child Walking in a Landscape*, Saint-Médard, Paris—first identified by Pierre Rosenberg) and "Aportaciones críticas de obras zurbaranescas," *Archivo Español de Arte*, XXXVII, 1964, pp. 115–28 (a summary of several recent discoveries); Gilberte Martin-Mery, "Una 'Inmaculada' de Zurbarán, recobrada," *Archivo Español de Arte*, XXXVIII, 1965, pp. 203–6 (*Immaculate Conception*, Parish church, Langon); and José López-Rey, "An Unpublished Zurbarán: 'The Surrender of Seville'," *Apollo* (London), LXXXII, 1965, pp. 23–25 (Duke of Westminster, Saighton Grange). Guinard's article, "Zurbarán: état des problèmes," *Information d'Histoire de l'Art* (Paris), V, no. 5, 1960, pp. 127–37, outlines the major questions still to be answered, while Juan A. Gaya Nuño, "Bibliografía crítica y antológica de

Zurbarán," *Arte Español* (Madrid), XXV, 1963–66, pp. 18–68, summarizes the literature up to 1963. In 1964, a major exhibition was held in Madrid to commemorate the three-hundredth anniversary of Zurbarán's death. The catalogue of the *Exposición Zurbarán en el III centenario de su muerte* (Madrid: Dirección General de Bellas Artes) contains valuable essays by two leading "Zurbaranistas," María Caturla ("Vida y evolución artística de Zurbarán") and César Pemán "El taller y los discipulos de Zurbarán"). The tercentenary occasioned dozens of essays and articles, the most important of which are mentioned below.

The reconstruction of many church and monastic commissions was the subject of Paul Guinard's important article, "Los conjuntos dispersos o desaparecidos de Zurbarán: anotaciones a Ceán Bermúdez," *Archivo Español de Arte*, XIX, 1946, pp. 249–73; XX, 1947, pp. 161–201; XXII, 1949, pp. 1–38. César Pemán was responsible for discovering the original disposition of the altarpiece at the Cartuja of Jerez de la Frontera: "La reconstrucción del retablo de la Cartuja de Jerez de la Frontera," *Archivo Español de Arte*, XXIII, 1950, pp. 203–27; "Zurbarán en la hora actual," *Revista de Estudios Extremeños* (Badajoz), XVII, 1961, pp. 271–84; and "Miscelánea zurbaranesca," *Archivo Español de Arte*, XXXVII, 1964, pp. 93–105. Xavier de Salas, "La fecha de la historias de la Cartuja (de Triana) y alguna minucia más sobre Zurbarán," *Archivo Español de Arte*, XXXVII, 1964, pp. 129–38, introduced important indirect evidence in support of a c. 1625 date for this commission. Various aspects of the Guadalupe cycle are discussed by César Pemán, "Zurbaranistas gaditanos en Guadalupe," *Boletín de la Sociedad Española de Excursiones* (Madrid), LV, 1951, pp. 155–87; María Luisa Caturla, "Sobre la ordenación de las pinturas de Zurbarán en la Sacristía de Guadalupe," *Archivo Español de Arte*, XXXVII, 1964, pp. 185–86; and Fray Arturo Alvarez, "Madurez de un arte" (Los lienzos de Guadalupe), *Mundo Hispánico* (Madrid), no. 197, 1964, pp. 51–52, with important documentation.

Special themes within Zurbarán's art are analyzed by Paul Guinard, "Zurbarán, pintor de paisajes," *Goya*, nos. 64–65, 1965, pp. 206–13 (landscapes); Elizabeth Trapier, "Zurbarán's Processions of Virgin Martyrs," *Apollo*, LXXXV, 1967, pp. 414–19; and José López-Rey, "Zurbarán as Portrait Painter," *Apollo*, XCIII, 1971, pp. 120–25. María J. Sáez Piñuela, "Las modas femeninas del siglo XVII a través de los cuadros de Zurbarán," *Goya*, nos. 64–65, 1965, pp. 284–89, is a valuable essay by an historian of costume.

Many writers have been fascinated by Zurbarán's use of prints as compositional sources, though on occasion their zeal has led to improbable suggestions. The pioneer was Martin S. Soria, "Some Flemish Sources of Baroque Painting

in Spain," *The Art Bulletin* (New York), XXX, 1948, pp. 249–59; XXXI, 1949, pp. 74–75. José M. Pita Andrade, "El arte de Zurbarán en sus inspiraciones y fondos arquitectónicos," *Goya*, nos. 64–65, 1965, pp. 242–49, summarizes the most important sources, while Alfonso E. Pérez Sánchez, "Torpeza y humildad en Zurbarán," *Goya*, nos. 64–65, 1965, pp. 266–75, suggests some Italian forerunners. The origins of Zurbarán's style are traced to Caravaggio by Halldor Soehner, "Forschungs- und Literaturbericht zum problem des spanischen Caravagismus," *Kunstchronik* (Nuremberg), X, 1957, pp. 31–37 and to Florentine proto-naturalists by Sabine Jacob, "Florentinische Elemente in der spanischen Malerei des frühen 17. Jahrhunderts," *Mitteilungen des Kunsthistorischen Institutes in Florenz* (Berlin), XIII, 1967, pp. 115–64.

The complex questions of Zurbarán's relationship to his contemporaries still require further study. The hypothesis of a link to Sánchez Cotán, first proposed by Caturla, is pursued by Emilio Orozco Díaz, "Cotán y Zurbarán," *Goya*, nos. 64–65, 1965, pp. 224–31. Velázquez and Zurbarán are discussed by María Luisa Caturla, "Velázquez y Zurbarán," in *Varia velazqueña*, vol. I (Madrid: Dirección General de Bellas Artes, 1960), pp. 463–70 and by César Pemán, "Velázquez, el pintor sevillano en Madrid y los pintores sevillanos en el Madrid de Velázquez," in *Velázquez; Son temps, son influence* (Paris: Arts et Métiers Graphiques, 1963), pp. 25–31. And the unclear connections between Zurbarán and Murillo

are discussed by César Pemán, "La restauración de 'La Visión de San Antonio' de Murillo, y el estilo murillesco," *Archivo Hispalense* (Seville), XXVII, 1957, pp. 45–49.

Much work remains to be done in classifying the work of Zurbarán's followers. However, his son Juan is fairly well known, thanks to articles by María Luisa Caturla, "Juan de Zurbarán," *Boletín de la Real Academia de la Historia* (Madrid), CXLI, 1957, pp. 265–87 and by César Pemán, "Juan de Zurbarán," *Archivo Español de Arte*, XXXI, 1958, pp. 193–211.

Finally, the revival of interest in the artist in the nineteenth century has been traced by Paul Guinard, "Zurbarán et la 'decouverte' de la peinture espagnole en France sous Louis Philippe," in *Hommage à Ernest Martinenche* (Paris: Editions d'Artrey, 1939), pp. 23–33 and "Zurbarán en France," *Revista de Estudios Extremeños*, XVII, 1961, pp. 363–77. A good general description of Louis Philippe's Galerie Espagnole and its influence on French painters is by Eveline Schlumberger, "La Galerie Espagnole de Louis-Philippe," *Connaissance des Arts* (Paris), September, 1961, pp. 56–65, while the formation of the Galerie in Spain is documented by Paul Guinard, *Dauzats et Blanchard peintres de l'Espagne romantique* (Paris: Presses Universitaires de France, 1967). Zurbarán is seen through the eyes of a fine twentieth-century critic in Christian Zervos, "Revisions: Francisco Zurbarán," *Cahiers d'Art* (Paris), II, 1927, pp. 85–92.

LIBRARY
ART CENTER COLLEGE OF DESIGN
PASADENA, CALIF.
33115446

158